SLR PHOTOGRAPHERS HANDBOOK

by Carl Shipman

CONTENTS

Front Cover: Hang-glider pilot conveying greetings to G. Washington is a slide sandwich. Glider was photographed in Arizona; G. Washington and friends at Mt. Rushmore. Candle supplied its own light for portrait with macro lens.
Inside Covers: Printed approximately 18% gray so you can use them as a metering aid.

Publisher: Bill Fisher; editor: Bill Fisher; art director: Josh Young; book design: Don Burton; typography: Chuck Barlean, Cindy Coatsworth, Mary Kaye Fisher, Frances Ruiz; photography: Carl Shipman

ISBN: Softcover, 0-912656-59-X; Hardcover, 0-912656-72-7
Library of Congress Catalog Card No.: 77-10176
H.P.Book Number: Softcover, 59; Hardcover, 72
©1977 H.P.Books, P.O. Box 5367, Tucson, AZ 85703, 602/888-2150
Printed in U.S.A.

HOW AN SLR WORKS

Every photo has technical ingredients which the photographer manages as well as he can. This was taken with an 80-200mm zoom lens set at about 160mm focal length to compose the picture from where I was allowed to stand. Fast shutter speed was used to stop motion. Sunlight comes at an angle that gives some modeling of the horse's muscles. I managed to click the shutter at the right instant and didn't jiggle the lens very much. Before taking the shot, I had set exposure by metering on the ground so the sky background wouldn't "fool" the exposure meter. Today, when I look at this photo, I don't think about all those details. I remember the sunshine and relive a pleasant day.

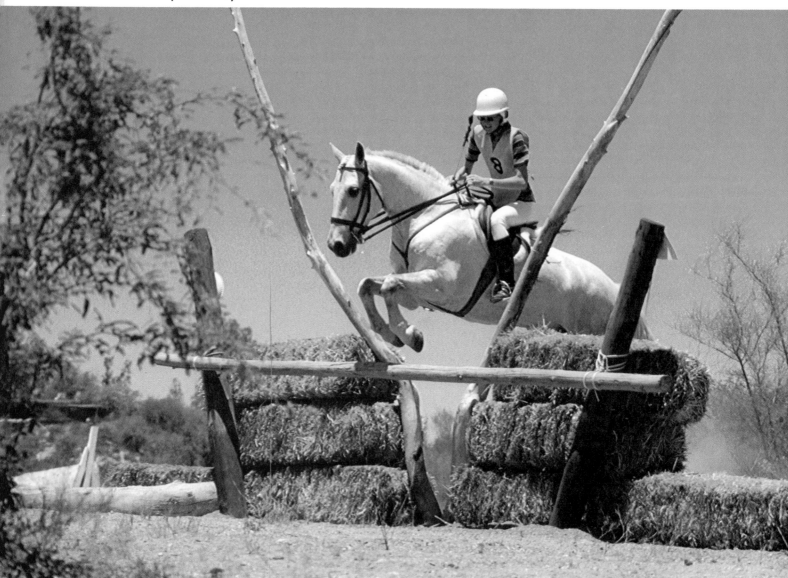

Single-lens-reflex (SLR) cameras allow viewing through the lens and then expose film through the same lens. You see the image that will later expose the film. This is done by a movable mirror which intercepts light from the lens and directs it to the viewing window of the camera. Then the mirror moves up out of the way, so you can take the picture.

Just in front of the film is a movable shutter or curtain made of metal or cloth which prevents light from reaching the film—a *focal-plane shutter*. To expose film, the camera mechanism opens the focal-plane shutter for a measured length of time.

Inside the lens is a variable *aperture* or opening which controls the amount of light passing through the lens. This is sometimes called a *diaphragm*.

WHAT 35mm MEANS

Film used in 35mm cameras is 35 millimeters (mm) wide. It has sprocket holes on both sides of the film. A sprocket inside the camera has teeth which fit into the holes and move the film through the camera.

We call cameras which use this film *35mm cameras*.

A millimeter is part of the metric system of measurement. One inch is the same length as 25.4 millimeters. As a rule of thumb, remember *25mm per inch*.

CONVERSION FORMULAS		
$\dfrac{\text{Millimeters (mm)}}{1000}$	=	meters
$\dfrac{\text{Millimeters (mm)}}{25.4}$	=	inches
$\dfrac{\text{Centimeters (cm)}}{100}$	=	meters
$\dfrac{\text{Inches}}{39.4}$	=	meters
$\dfrac{\text{Feet}}{3.28}$	=	meters

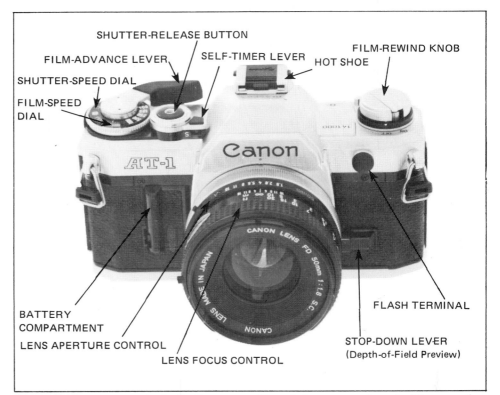

35mm SLR cameras are basically the same, with variations among brands. These are the fundamental controls and features. Some have more, some have less.

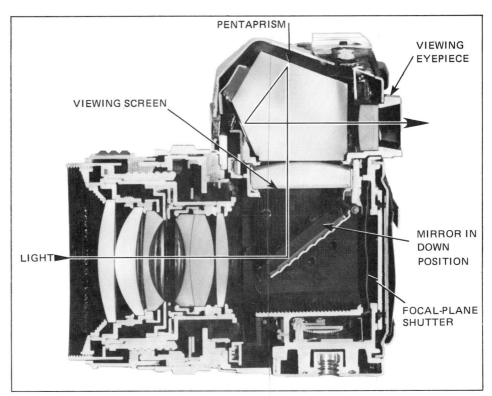

Cutaway photo of Pentax K-type camera shows mirror in down position, intercepting the image that will later fall on film. When shutter operates, mirror swings up out of the way; blocks your view through the viewfinder.

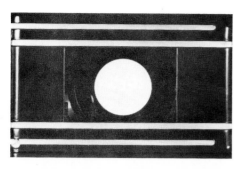

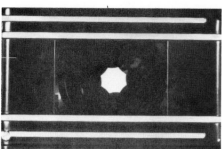

Looking toward lens from back of camera, this is what the film "sees" when the shutter is open. Modern SLR's leave the lens aperture wide open while you are viewing, so you get maximum viewing-screen brightness. This is shown in top picture. When the shutter operates, lens aperture is automatically *stopped-down* to smaller size for correct exposure of film; lower photo.

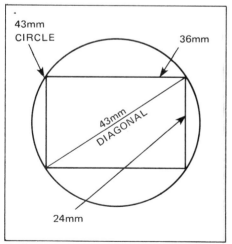

Ordinary lenses for 35mm cameras make a circular image as shown. But only a rectangle, 24mm by 36mm, actually exposes the film. The rectangular film frame is produced by a rectangular opening in the camera body—opened by the camera's focal-plane shutter.

HOW TECHNICAL DATA IS PRESENTED

When you progress beyond ordinary snapshots, you are likely to need "numbers" to help set up the camera. These numbers result from math and formulas that are not always easy to solve.

Technical data you may need is presented in 3 ways:

Look-up tables give the answers where the method is practical. You don't have to do any arithmetic. Each table is accompanied by an example to show you how to use it.

Graphs are used in this book more than in most photo books because a curve compacts data into a convenient form and has no gaps as you sometimes find in a data table. If you are not accustomed to extracting numbers from graphs, two minutes with the instructions on page 30 will show you how. Each graph has an example to guide you in its use.

Formulas are used to aid understanding or to find answers when tables or graphs are not practical. Each formula is accompanied by a worked-out example and none are very complicated.

In many cases, a formula is given for reference but you don't have to use it because the information is also presented in a table or graph.

SOME COMMONLY USED TERMS

Open-aperture or *full-aperture viewing* means the lens aperture is wide open when you are looking through the viewfinder to focus and compose the scene. This gives maximum brightness and makes viewing easier.

Automatic aperture or *automatic diaphragm* means the camera lets you view the scene with the lens aperture wide open and then automatically closes or *stops down* the lens aperture to a smaller size just before exposing the film. The smaller aperture used to take the picture is called *shooting aperture,* or *taking aperture.*

Manual aperture is not automatic. Open the lens aperture by rotating a control ring on the lens to view at maximum brightness. Then stop down to shooting aperture by manually rotating the aperture-control ring on the lens before you take the picture.

Preset Lenses require manual control of aperture but have a second control ring on the lens to aid in setting the desired aperture quickly and without looking. The second control ring, sometimes called a *preset ring*, is manually positioned to the desired aperture setting. But this ring does not actually control aperture size. It merely serves as a stop for the main control ring which does adjust aperture. With the preset ring set to a certain aperture size, the main control ring can be turned to larger aperture for viewing the scene and then rotated to the selected aperture by turning it until it reaches the stop selected in advance by the preset ring.

Through-the-lens metering, also called *behind-the-lens metering,* means the camera has a built-in light meter which measures the amount of light that actually exposes the film, after it has come through the lens. All modern SLR cameras have this feature.

Exposure is the effect of light falling on film, made visible by development. Exposure depends on how bright the light is and also how long it falls on the film.

Exposure controls determine the amount of exposure. There are two controls: *Aperture size* governs the amount of light passing through the lens. *Shutter speed* governs how long the shutter remains open

to allow light to reach the film.

Open-aperture or *full-aperture metering* is light measurement by the camera's built-in light meter while the lens aperture is wide open, even though the picture will be taken at smaller aperture. This requires the camera light meter to anticipate the amount of light that will come through the lens later, when the lens is stopped down to take the picture.

Stopped-down metering is light measurement behind the lens, when the lens is stopped down to shooting aperture. It measures the actual amount of light that will be used to expose the film.

Automatic SLR cameras automatically set one of the two exposure controls for you, after you have first set the other control. The automatic SLR chooses its setting based on measuring light from the scene.

Non-automatic SLR cameras require you to set both of the exposure controls manually. Some SLR's offer either automatic or non-automatic operation, depending on the setting of a switch or control.

Viewfinder displays or *exposure displays* are seen in the viewfinder and use a moving needle or flashing lights to show if the camera exposure controls are set for correct exposure, underexposure or overexposure. Viewfinder displays show the scene being photographed, include a *focusing aid* to help you find best focus, and show shutter speed and/or aperture settings. If the camera is automatic, it shows you the control setting it makes. If manual, it usually displays one or both of the control settings you make.

Shutter priority means shutter speed is the most important exposure control. You set shutter speed first and then use whatever aperture size is necessary to get proper exposure. Some automatic cameras operate with shutter priority—you select shutter speed and then the camera sets aperture.

Aperture priority means aperture size is most important and is set first. Then you use whatever shutter speed gives correct exposure. Some automatic cameras operate with aperture priority—you set aperture and then the camera sets shutter speed.

ASA film speed is a number printed on film cartridges and cartons. It states the amount of exposure the film needs. After you dial the film-speed number into your camera, the camera exposure calculator can figure exposure control settings and display them in the viewfinder.

PREPARING THE CAMERA TO TAKE PICTURES

Habit is more reliable than thinking when you are doing routine operations. Form the habit of following these steps in order. Do them each time you use the camera and you will avoid many problems.

1. Remove the lens cap and examine the lens. If you own more than one lens, notice which is on the camera. If the front surface is dirty, clean it as shown on page 22.

2. Check the battery in the camera. They fail suddenly. Your camera instruction booklet will show how. Some battery-check procedures require changing the film-speed setting on the camera. If you change it, be sure to put it back to the former setting as soon as you have completed the battery check.

3. Look at the frame counter. If it indicates S, the camera back has been opened since taking the last picture so you can do no harm by opening it again.

If the frame counter shows any number, you probably have film in the camera. Don't open the back until you figure out what the situation is.

If it shows 20, you may be at the end of a 20-exposure cartridge. Some cameras will allow 21 or 22 exposures on a 20-exposure cartridge, depending on how the camera was loaded. If you can expose frame 22 and still advance the film, a 36-exposure cartridge is in the camera.

If it shows 36 or higher, you are at the end of a 36-exposure cartridge.

Before opening a camera, form the habit of glancing at the frame counter. This Nikon F-2 is ready to shoot frame 27. It has film in it!

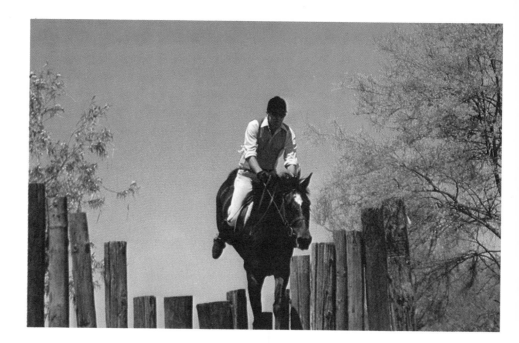

Practicing at photography brings humility. Here, I framed it wrong, clicked the shutter at the wrong time, got poor lighting. When you make pictures like this, throw them away!

1/Drop film cartridge in place. Depress film-rewind knob, turning it, if necessary, so it goes all the way in. Then pull the film-end across the camera and insert into one of the slots of the take-up spool. Usually the spool has a knurled flange so you can turn it with your thumb while inserting the film. If the spool has a small projection near the sprocket holes of the film, it is intended to protude into the second and third sprocket hole—which helps hold the film in the slot.

2/Using the knurled flange on take-up spool, or film-advance lever, advance film until sprocket holes on *both* sides of film has engaged teeth on sprocket in camera. Film should be taut across back of camera so film cartridge lies flat.

3/Just before closing camera back, look at the film cartridge to verify that you have loaded the kind of film you want. Close the back and *immediately* set the film-speed dial to the correct film speed.

4/Then advance film, operating the shutter each time, until the frame counter reaches the first mark past 0, which is frame 1. While advancing, *be sure* to look at the film-rewind knob. If it is turning, you have loaded film properly and it is moving through the camera. *If it is not turning, open the back to see what's wrong.*

Holders for the film-carton end, as on this Nikon, seem trivial but they are very useful—particularly if you own more than one camera. It's easy to get confused. If you do forget what film you have loaded, and don't have a reminder on the camera, the film-speed setting will give you a clue.

When you made the last exposure on a cartridge, you *should have* rewound the film right then. Did you? Turn the rewind knob clockwise and see. If it rotates freely, the camera is either empty or the film has been rewound. Either way, it's safe to open the back.

4. Open the back and inspect the interior of the camera. Clean it with a soft brush if needed.

5. Select an unopened carton of film. Look at it to be sure it's what you intend to use. Open it and load the camera as shown in the accompanying photos.

6. Before closing the camera back, look at the film cartridge. Notice what kind of film it is and the ASA film-speed number. If you have loaded the wrong kind of film, it's not too late to take it out.

Check to see that the film has been wound onto the take-up spool so it lies flat across the back of the camera and the light-trap edge of the film cartridge is not tipped up. If it is tipped up, the camera back may not close properly. Wind a little more film onto the take-up spool and the cartridge will be correctly positioned.

7. Immediately after closing the camera back, set the film-speed number into the camera, using the film-speed dial. This avoids operating with the wrong film speed and getting bad exposures.

8. If you shoot part of the roll now and part later, you may forget what kind of film you are using. Do

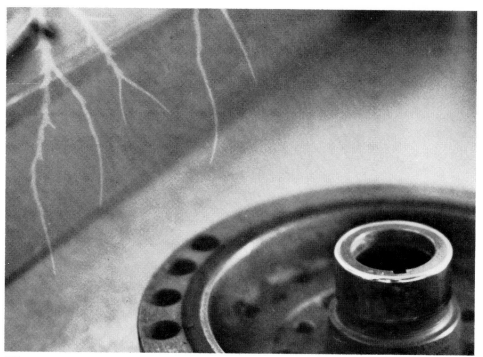

When you rewind film, don't turn the crank fast, particularly if the humidity is low. You may get static electricity discharges inside the camera which makes "lightning" tracks like these.

whatever necessary to remember. Write it down. Write it on a piece of tape and stick it on camera or case. Some cameras have a holder for the end of the film carton. Tear it off and install it in the holder. Some have a film-reminder dial you can set to show film type and speed.

VIEWFINDER

When you look into the viewfinder window or *eyepiece,* you see the same image that will later expose the film, when the mirror moves up. The image you see is formed on a ground-glass plate called a *viewing screen* or *focusing screen.* Because you see exactly what will later expose the film, you can compose the picture and judge focus with great accuracy.

Viewfinder Magnification—Camera specs state the size of the image you see with the standard lens on

the camera—usually a 50mm or 55mm lens. This is given as a decimal such as 0.95. This means that the image you see appears to be 95% as large as the subject would be if viewed directly, instead of through the camera lens.

Viewfinder magnification should be close to 1.0 so the image appears life-size, or nearly so. This gives a "real-world" feeling when you are looking through the viewfinder and allows using the camera with both eyes open—a skill worth developing if it doesn't come naturally. It helps you track moving subjects not visible in the viewfinder; it helps you move around without removing the camera from your eye and keeps you from stumbling into things or walking out into traffic.

Even if you view with one eye closed, magnification of approximately 1.0 keeps you aware of the distance between you and your subject and you are less likely to walk over a cliff or into moving machinery while composing the photo.

FOCUSING AIDS

Judging focus by noticing image blur on the viewing screen is often satisfactory but there are more precise ways. Most viewing screens have some sort of *focusing aid* in the center of the matte or ground-glass screen.

Split Image—Two prisms, set into the viewing screen as shown in the accompanying sketch, cause a line in the image to separate so the two halves of the line move in opposite directions as the image goes out of focus. When the line is not broken, focus is best. This focusing aid is called a *biprism.*

The human eye is better able to distinguish separation of lines in an image than general blurring due to being out of focus, so a focusing aid gives a more positive indication of focus than a plain matte screen.

If the biprism is oriented so it splits vertical lines, and there are only horizontal lines in the image, it doesn't give you any help. Turn the camera 90 degrees for focusing so the biprism splits the horizontal lines. After focusing, turn the camera any way you want it to take the picture.

Some viewing screens have a biprism oriented at 45 degrees so it has some effect on both vertical and horizontal lines in the image. For maximum aid in focusing, you can tilt the camera to put the lines at 90° to those in the picture.

Microprism—On a textured or plain surface, such as foliage or a wall, there are no clearly visible straight lines to split with a biprism. For such surfaces, a *microprism* is a better focusing aid.

These consist of an array of tiny 3- or 4-sided pyramids whose intersections work like small biprisms. When the image is in focus, you are unaware of the microprism. When the image is out of focus, it breaks up into a grid pattern caused by all the tiny pyramids. If the camera jiggles a small amount, as it always does when hand-holding, the image seems to

The image you see in an SLR is formed on a ground-glass screen in the top of the camera. Some brands have removable pentaprisms so you can change the viewing screen. Here, the pentaprism is removed and you can see the ground-glass screen directly. Circular part in center of viewing screen is a focusing aid.

A *split-image* focusing aid uses a *biprism* which is two wedges of glass tapering in opposite directions. If the image is not in focus, the biprism splits lines in the image and separates the two halves.

This removable viewing screen from a Nikon has a biprism in the center. Notice how it splits the line on the surface below it. In the camera, this is the indication of poor focus.

A *microprism* is an array of tiny pyramids. They make the image fuzzy when out of focus, sharp when in focus. Many focusing aids combine a biprism in the center with a surrounding microprism ring.

scintillate when out of focus.

Combined Focusing Aids—Some viewing screens have a circular biprism surrounded by a microprism collar so you can use either focusing aid depending on the scene.

Prism Angle—The angle made by the surfaces of biprisms and microprisms is important. Large angles give a very strong focusing indica-tion. With a biprism, large angles cause lines to split suddenly and separate a large amount when the image is only slightly out of focus. With a microprism, large angles cause the image to "break up" more noticeably.

However, large prism angles don't work when the lens aperture is smaller than a certain size. De-pending on where your eye is, one of the biprism or microprism faces will become black. Move your eye and a different face be-comes black. This is called focusing-aid *blackout*.

The focusing aid supplied as standard will work satisfactorily with the standard lens that comes with the camera.

It pays to make the best composition you can, when shooting the picture. Study the viewfinder image as though it was a print in your hand. Be sure things are in focus that should be. Check the edges of the frame.

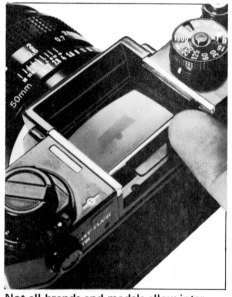

Not all brands and models allow interchanging viewing screens. Among those that do, some have removable pentaprism housings so you change screens from the top—such as this Canon F-1. Some brands are designed to change the screen through the lens opening, after removing the lens.

INTERCHANGEABLE VIEWING SCREENS

Several SLR's use interchangeable viewing screens. With some, changing the screen is a simple operation you can do. With others, it must be done by a factory service agency.

A wide variety of viewing screens is available for different applications. These include biprisms and microprisms with different prism angles, screens that are entirely ground glass or entirely clear, and screens with ruled grids to help in composing the picture when shooting architecture or copying documents.

Typical interchangeable screens and their recommended applications are shown on page 11.

VIEWING SCREEN IMAGE SIZE

A few cameras show the entire film frame on the viewing screen. Most crop the edges of the image a little bit, displaying something like 92% or 95% or the picture area. This means you don't see all the way to the edges of the actual image on film.

When shooting negative film that will later be enlarged during printing, this is not a disadvantage. If you compose a good image within the boundaries of the viewfinder, you will get the same image on the print with only a little more around the edges. If you do your own printing, you can crop the edges if desired and it is common to crop even more.

When shooting color-slide film, there is an advantage in not seeing the edges of the frame. Slide mounts intrude into the picture area approximately the same amount. Therefore if you compose right up to the edges of the viewfinder, you will usually get everything on the *mounted* slide that you saw in the viewfinder.

INTERCHANGEABLE SCREENS FOR PENTAX M-SERIES CAMERAS

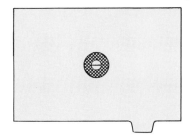

SC-1, the standard screen for the MX, has a central biprism surrounded by a microprism in a ground-glass field. It s three-way focusing capability makes it useful with nearly any lens or subject. Both focusing aids are suitable for lenses with maximum aperture up to ƒ-4 or ƒ-5.6, depending on the lens.

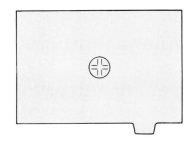

SD-1 is an all-matte screen with central cross-hairs. Recommended for photographing through microscopes and telescopes, also for any high-magnification setup such as with extension tubes or bellows.

SA-1 is basically the same as SC-1, except the focusing aid is microprism only. Prism face angles are suitable for lenses with maximum aperture up to ƒ-4 or ƒ-5.6, depending on the lens.

SE is all-matte with no focusing aid. Use with lenses of maximum aperture of ƒ-5.6 or smaller or any application where a plain ground-glass focusing screen is preferred.

SA-3 uses a microprism focusing aid with larger prism face angles so focusing is more definite with lenses of larger maximum aperture. Useful for ƒ-1.2 to ƒ-2.8 lenses, Blacks out at smaller apertures, depending on the lens.

SG is an all-matte screen with etched lines at 6mm intervals. Useful in architectural photography, particularly when using the SMC Pentax shift lens. Also useful as an aid in composing or an aid in positioning multiple exposures.

SB-1 is basically the same as SC-1, except the focusing aid is biprism only. Prism face angles are suitable for lenses with maximum aperture up to ƒ-4 or ƒ-5.6, depending on the lens.

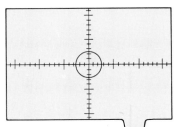

SI is an all-matte screen with vertical and horizontal ruled scales. These are useful in comparing subject size and magnifications when photographing with bellows or extension tubes.

This shows the selection of interchangeable screens available for current Pentax M-series cameras along with guidelines for their use. Other brands offer similar choices. With Nikon, you can choose from a mind-boggling array of 19 different screens.

VIEWING AIDS

Most SLR's can use a variety of attachments on the viewing eyepiece.

Dioptric Correction Lenses — Fit over the viewing eyepiece and put your eyeglass correction into the camera viewing optics. Then you can use your camera without wearing your glasses. This is a convenience because glasses get in the way and usually prevent you from seeing the entire viewfinder screen. But if you depend on your glasses

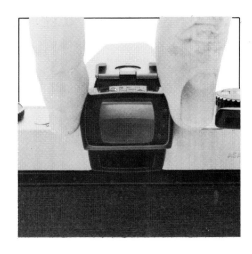

Correction lenses are available for most brands to put your eyeglass prescription into the viewfinder optics. This allows shooting without wearing your glasses. Typically, the correction lens just slips over the normal viewing window.

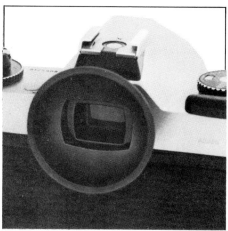

Rubber eyecups are inexpensive and worthwhile. They exclude stray light, which makes viewing easier. They cushion your contact with the camera. If you wear glasses, a rubber eyecup helps prevent scratching the lens.

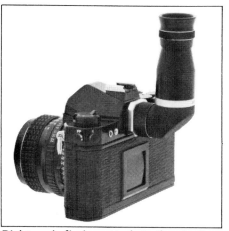

Right-angle finders attach to the viewing window and rotate so you can view from above as shown here, or from the side, or even from below if you ever need to.

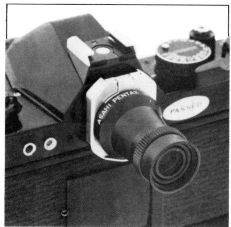

Magnifier attachments help precise focusing. They fit on the viewfinder window but flip up out of the way when you want to view the entire screen rather than the magnified central portion.

when not looking through the camera, you may find it annoying to take them off to look through the camera and put them on again to look at the real world. It is possible to learn to use your camera while wearing glasses and, for some, it's the best solution.

The "strength" or *power* or a lens is stated in *diopters,* including eyeglasses. To order a dioptric correction lens for your camera, ask for your eyeglass prescription for distant vision. SLR manufacturers offer a range of correction lenses to accommodate most users. The best way to choose one is by trying several at a camera shop.

Right-Angle Finders—Attach to the viewing eyepiece to make viewing possible or more convenient when the camera is in awkward locations, such as at ground level. Also useful when the camera is on a tripod or copy stand at eye level, pointing downward.

Magnifiers—Attach to the viewing eyepiece and enlarge the center section of the focusing screen. These help you find exact focus but prevent seeing the entire screen. The magnifier is in a hinged mount so you can flip it up out of the way when you want to see the entire image.

EYEPIECE COVERS

Automatic cameras measure the light and set one of the exposure controls automatically. Light can enter the camera the normal way through the lens and also through the viewing eyepiece. When your eye is close to the eyepiece, not enough light enters to affect the exposure reading. If you are using an automatic camera with your eye away from the viewfinder, use a cover to exclude light. Compose the scene, get the camera ready to shoot, then cover the eyepiece. Some automatic cameras come with a plastic slip-on cover. Some cameras have a built-in eyepiece blind or shutter which can be closed by a control on the camera. If there is no other protection, cover the opening with your hand or a piece of black photographic or electrician's tape.

Most automatic cameras set exposure just before the shutter operates. If your eye is away from the viewfinder at that instant, exposure will be affected by stray light coming in through the viewfinder window. To prevent an incorrect exposure reading, cover the window. Some automatic cameras come with a slip-on cap like this. Some have an internal blind which you close using a control on the camera.

HOW A FOCAL-PLANE SHUTTER WORKS

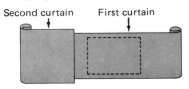

Second curtain First curtain

(1) Ready to make an exposure. Film frame is covered by first curtain.

Opening in camera body determines size of film frame.

(2) First curtain begins to travel across frame, opening frame to image from lens.

(3) First curtain travel completed. Film frame is fully open to light.

(4) Second curtain begins to travel across frame, closing frame to image from lens.

(5) Second curtain travel completed. Film frame covered by second curtain. Exposure completed. Advancing film to next frame resets shutter to (1) ready to make another exposure.

This drawing shows operation of a two-curtain focal-plane shutter, which travels horizontally. When exposure time begins, the first curtain is released to start its travel. As it moves, the first curtain passes across the film frame, allowing light to fall on the film. When the first curtain has completed its travel, the film frame is fully opened as far as the first curtain is concerned. When exposure time ends, the second curtain is released to begin its travel and close off light to the film.

Exposure time is measured from *release* of the first curtain to *release* of the second curtain. This drawing shows an exposure time long enough that the second curtain does not begin to move until after the first curtain has reached the end of its travel.

WHAT THE SHUTTER DOES

Most SLR's use a focal-plane shutter. This is a curtain of cloth or metal, inside the camera, very close to the surface of the film.

To expose the film, the shutter is opened for a certain amount of time. A control on the camera, called the *shutter-speed control* or *dial,* is used to select the length of time the shutter is open.

The range of available shutter-speed settings varies among models. Often it is from one full second to 1/1000 second. Some cameras extend this range in both directions. You will rarely need shutter speeds shorter than the camera provides, but it is common to use longer times. I'll tell you how to do that in a minute.

In the language of photography, *faster* shutter speed means *shorter* exposure time. *Slower* speeds mean *longer* exposure time.

Most available shutter speeds on the dial are fractions of a second, such as 1/500. Because there is limited space on the dial, the numerator of that fraction is omitted and the dial just says **500**. You will quickly adapt to that.

PRECISION IN PHOTOGRAPHY

When you are trying to do some thing really well, there's a great temptation to try to do it *exactly* and with great precision. In photography, most camera settings and procedures use numbers. This gives a false impression that photography is an exact science, done well by getting the numbers exactly right. Not so! Films vary, developing chemicals change strength, clocks are not accurate, sunlight changes constantly, and many other variables are unavoidable.

As a rule of thumb for anything you do with a camera, if you get within 20% of exactly right, that's close enough. When looking at the resulting photo, you usually can't see any difference between setting a control right-on and getting it within 20%.

STANDARD SHUTTER-SPEED SERIES

Standard exposure changes—or steps—are multiples of two. That is, doubling and then doubling again. The shutter-speed series works that way:
1/2000, 1/1000, 1/500, 1/250, 1/125, 1/60, 1/30, 1/15, 1/8, 1/4, 1/2, 1, 2, 4, 8 seconds.

Each increase is intended to double the exposure time and each is one exposure step. Going the other way, from 1/30 to 1/60, for example, reduces exposure time by one step.

All shutter-speed numbers don't exactly double to get the next higher value because some are "rounded off" to make the numbers easier to remember and work with. For example, the next steps longer than 1/125 and 1/15 are not exactly double, but close enough.

Shutter speeds longer than 1 second are:
1 2 4 8 15 30 60 seconds, and so forth.

If you like to work in dim light, the slowest shutter speed offered by the camera is important. Virtually all SLR's time their own exposures for as long as 1 second. Some time for longer intervals, such as 30 seconds. It is convenient to let the camera do it.

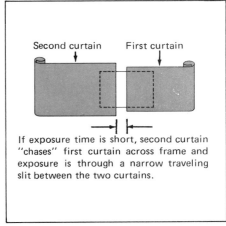

Second curtain First curtain

If exposure time is short, second curtain "chases" first curtain across frame and exposure is through a narrow traveling slit between the two curtains.

For short exposures such as 1/500 second, the second curtain follows so closely behind the first curtain that the entire frame is never open to light all at the same time. The frame is exposed by a traveling slit of light formed by the narrow gap between the two curtains.

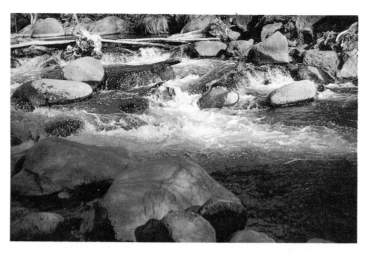
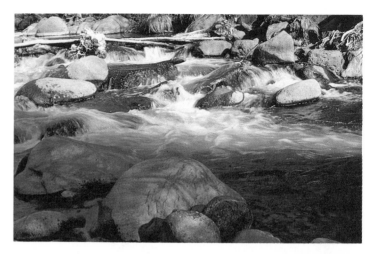
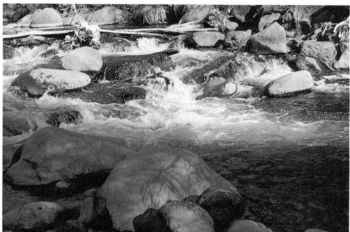

Shutter speed is an *artistic* control. Shutter speeds were 1/500, 1/60, 1/15, and 1/2 second.

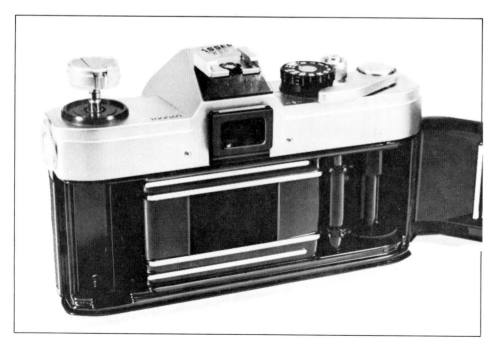

This is a cloth focal-plane shutter that travels horizontally.

MAKING LONGER EXPOSURES

If you need an exposure longer than the shutter-speed dial on your camera offers, there are several ways.

Most cameras have a setting labeled B on the shutter-speed dial. This derives from *bulb*, a holdover from the old days when the photographer squeezed a rubber bulb to open the shutter and released it to close the shutter.

With a modern shutter-speed dial set at B, the shutter opens when you depress the shutter button and stays open for as long as you hold it depressed.

It's not always convenient to keep your finger on the shutter button, and you may jiggle the camera so the image is blurred. Some cameras have a shutter lock, usually a

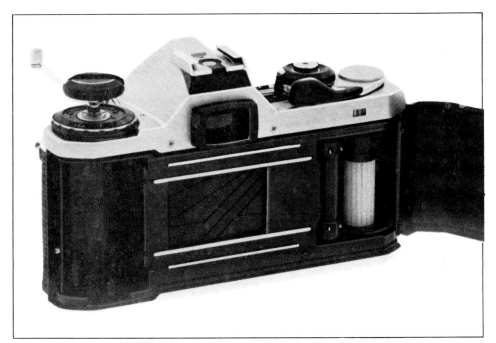

This is a metal focal-plane shutter that travels vertically.

most cameras, this is the best way to make a time exposure because you have the least chance of moving the camera. With the shutter-speed dial set at B, operate the plunger in the cable release to open the shutter. Lock it with the set screw or collar. At the end of the exposure time, loosen the set screw or operate the collar and the shutter closes again.

USES OF TIME EXPOSURES

The usual reason to keep the shutter open for a long time is because the light is dim. Allowing dim light to strike the film for a longer time puts more exposure on the film.

An unusual reason is to keep moving objects from recording as images on the film. During a 30-second exposure, for example, moving cars and people walking will not be in one location on the film long enough for their images to be visible. Stationary objects, such as buildings and trees, receive full exposure at one location on the film and their images are visible. This is a photographic trick, but it is sometimes very useful.

lever near the shutter button, which you move one way to lock the shutter and the other way to release it.

When locked, this control prevents accidental operation of the shutter button. If you depress the shutter button and then flip the control to lock it, the button remains depressed and the shutter remains open. This is a handy way to make *time exposures.* At the end of the desired exposure time, flip the control to unlock the shutter button and the shutter closes.

A few SLR models have a shutter-lock control which only prevents accidental operation and can not be used to make time exposures.

SLR cameras accept a flexible cable release which I advise using anytime the camera is on a tripod. This screws into a threaded center-hole of the shutter button or into a threaded collar around the button, depending on camera brand. Depress a plunger on the end of the cable release and it operates the shutter. Because the cable is flexible, there is no rigid connection between your fingers and the

camera so you are less likely to jiggle the camera.

When you buy a cable release, buy the *locking* type. Typically, these have a set screw or a locking collar at the operating end. With

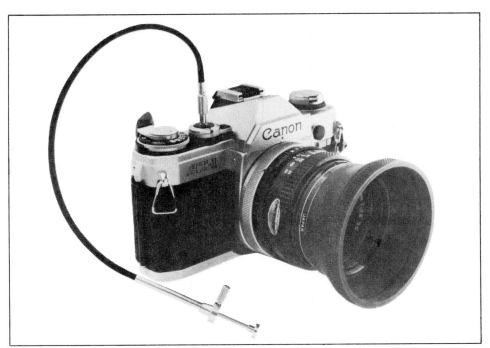

For time exposures, most SLR's use a locking cable release with the shutter-speed dial set on B. Depress the plunger to open the shutter, turn the setscrew to hold the plunger depressed. To end exposure, release the setscrew.

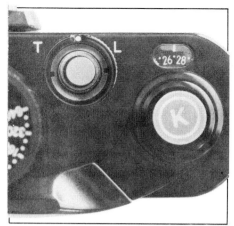

Some models of Nikon make time exposures a different way. Rotate the collar surrounding the shutter button until the dot aligns with T. Operate the shutter button to open the shutter. Remove your finger—you don't have to hold it down. To close the shutter, rotate the collar back to the center position.

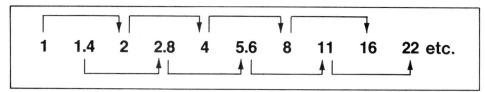

It's easy to write or remember the *f*-number series. Start with the numbers 1 and 1.4. Then double them alternately, as shown here.

STANDARD *f*-NUMBER SERIES

The aperture-control ring on a lens is marked with a series of numbers called *f-numbers* or sometimes *f-stops*. An *f*-number specifies a certain light-gathering ability. Any lens set at *f*-4 will admit the same amount of light as any other lens at *f*-4, no matter what kind of lens it is.

The standard *f*-number series is intended to double the amount of light passing through the lens at each step-increase of aperture size —each larger aperture setting admits twice as much light. There are 2 peculiarities about the series:

Larger f-numbers mean smaller apertures.

The f-numbers do not double from step to step, but the amount of light does.

The series is:

1 1.4 2 2.8 4 5.6 8 11 16 22 32

Larger and smaller *f*-numbers than shown here are possible but very unusual among lenses for SLR cameras.

You can construct this series just by remembering the first two numbers—1 and 1.4—and doubling them alternately as shown in the accompanying drawing.

In this series, *f*-1 is the largest aperture and admits the most light. *f*-32 is the smallest and is a tiny hole. No common lenses have this complete range of *f*-stops.

Please notice there are some approximations in this series also. *f*-11 is not exactly double *f*-5.6, but close enough.

For Math Fans—The multiplier in the *f*-number series is the square root of 2 because *f*-number is defined in terms of aperture diameter but the amount of light that can pass through a hole is determined by the area. To make a hole with twice as much area, diameter must be multiplied by $\sqrt{2}$.

$$f\text{-number} = \frac{F}{D}$$

D is diameter of the lens opening

F is lens focal length. See page 27.

DETENTS ON CONTROLS

Camera controls such as the aperture control and the shutter-speed dial have click-stops or *detents* that you feel as you rotate the control. These are simply aids in setting the controls exactly on a marked number.

Aperture controls usually have detents between the marked *f*-numbers. These are half-steps, sometimes called *half-stops*. Normally you can set a lens aperture anywhere, whether it is on a detent or not.

Shutter-speed dials normally must be set *exactly* on a marked shutter speed. When set between two marked speeds, the camera will usually work at one or the other but you don't know which so you may get incorrect exposure.

FRACTIONAL *f*-STOPS

Some photo literature recommends aperture settings in 1/3 stops, but there is no precise way of finding 1/3 stops on the lens. You can use 1/2 stops with sufficient accuracy, or you can guess at 1/3-stop settings.

Sometimes exposure calculations give *f*-stops that are between marked numbers on your lens. This table will help translate fractional *f*-numbers into settings on the lens.

VALUES OF FRACTIONAL *f*-STOPS			
f-Number	+1/3 Stop	+1/2 Stop	+2/3 Stop
0.7	0.8	0.87	0.9
1.0	1.1	1.2	1.3
1.4	1.6	1.7	1.8
2.0	2.3	2.5	2.6
2.8	3.3	3.5	3.7
4	4.6	4.9	5
5.6	6.5	6.9	7
8	9	9.8	10
11	13	13.9	15
16	18	20	21
22	26	28	29
32	37	39	41
45	52	55	59
64	74	78	83

WHAT FILM SPEED MEANS

ASA film speed is a number published by the manufacturer of the film, marked on the film carton and also on the film cartridge. It is a message from the film maker to tell your camera how much exposure the film needs.

Films with a low ASA speed such as 25 need a lot of exposure and are called *slow* films.

Films with a high ASA number such as 400 need much less exposure and are called *fast* films.

Intermediate film speeds are 100 and 125.

ASA stands for American Standards Association, a group in the United States which publishes American Standards or USA Standards. The name of the organization was changed in 1969 to American National Standards Institute (ANSI) but because ASA was already well-established as an identification it is still used to identify these film speeds.

ASA film speeds are used around the world. Another way of stating film speed, developed in Germany, is called *DIN*. The accompanying table shows how to convert from one to the other. Most films are marked both ways.

THE ASA FILM-SPEED SERIES

Film speeds are easy. Start at ASA 25 and double or halve in both directions:
12 25 50 100 200 400 800 1600 3200 and so forth.

A higher film-speed number means the film is more sensitive to light and therefore needs less exposure. ASA 100 film is *twice* as sensitive as ASA 50 and therefore needs *one step less* exposure.

FILM SPEED RATING	
ASA	DIN
12	12
25	15
50	18
100	21
125	22
160	23
200	24
400	27
800	30
3200	36

Two commonly used film-speed rating systems are ASA and the German DIN system. They agree at 12. ASA goes up in steps by doubling. To make the same step-increases, DIN adds 3 units.

Not all films are manufactured with speed numbers on the standard series shown above. Most films are a standard speed, or 1/3 step faster, or 2/3 step faster.

I consider the film-speed series that includes ASA 25, 50, 100, and so forth as the standard series because these numbers appear on many camera shutter-speed dials with the intermediate numbers represented by dots. An equally valid point of view is to say the film-speed series is not big jumps such as from 25 to 50, with intervening fractions of a jump. Instead, the series is made up using the small intervals giving each number equal importance: 6, 8, 10, 12, 16, 20, 25, 32, 40, 50, 64, and so forth.

You can construct the entire series by starting with three small numbers, 6, 8 and 10, then double them leap-frog style to get the rest of the numbers.

It's useful, one way or another to carry the film-speed numbers in your head so you can figure things like this: ASA 80 is 1/3 step slower than ASA 100.

HOW TO HOLD THE CAMERA

Every picture you take will be improved if you put the camera on a sturdy tripod or other firm support. Often you can't do that, or don't want to bother. More pictures are harmed by jiggling the camera while hand-holding than any other cause.

If you hand-hold the camera, don't use a shutter speed that's too slow. Here's a rule:

When hand-holding your camera, the slowest shutter-speed-dial setting you should use is the lens focal length in millimeters, or the next faster setting. For a discussion of focal length, see pages 27 to 34.

Examples: If you are using a 500mm lens, set the shutter-speed dial to **500**—an exposure time of 1/500 second. If you are using a 200mm lens, there is no shutter speed of 1/200, so use the next faster setting: 1/250 second.

This rule is conservative and often broken. With a 50mm lens, it calls for a shutter speed of 1/60. Nearly anybody can use 1/30 and with a little care you can use 1/15.

ASA	12	•	•	25	•	•	50	•	•	100	•	•	200	•	•	400	•	•	800	•	•	1600	•	•	3200
		16	20		32	40		64	80		125	160		250	320		500	650		1000	1250		2000	2500	

There isn't room on camera film-speed dials to write out all the numbers. Some are written out and some are represented by dots on the scale. Here's what the dots mean.

Learn to operate camera-body controls with your right hand, lens controls with your left hand—with a few exceptions. Hold the camera snugly against your face and cup the lens in your left hand when shooting.

To make a vertical shot, I prefer to rotate the camera so the shutter button is at the top.

Some people do it the other way and operate the shutter button with their right thumb.

Always look for something to lean against or brace your elbows on for stability. Unless you have the camera on a tripod.

It depends on your technique in holding the camera and operating the shutter button.

Even breathing can spoil your picture when hand-holding. Try taking a full breath, let some of it out, then don't breathe while you click the shutter. Learn to *squeeze* the shutter button without moving the camera. Practice helps.

Look For Firm Support—The world is well equipped with things to help you hold the camera steady. Lean against a wall or tree. Press the side of the camera firmly against a telephone pole or the corner of a building. Rest your elbows on a railing or the back of a chair. If you are standing, press your elbows against your body. Hold the camera firmly against your face.

Some photographers carry a "bean bag." Place the bag on a solid support. Cradle the camera in the bag and use a cable release for "hands off" picture-taking.

Use a Tripod—For landscapes or any subject that doesn't move fast and doesn't require its photo made

in a hurry, *use a tripod.* Tripods are inconvenient to carry around; so are skis and fishing tackle. All are essential to the activity.

More Math—The rule about hand-holding is stated more precisely by using a mathematical term. The *reciprocal* of any number is that number divided into one. The reciprocal of 3 is 1/3.

When hand-holding the camera, try to use a shutter speed which is the reciprocal of lens focal length, or faster. If you are using a 250mm lens, use 1/250 second or a shorter time.

Because shutter-speed dials omit the numerator of the fraction, 1/250 shows up as **250** on the dial. Nevertheless, it is intended to be a fraction.

CHOOSING A TRIPOD

The basic rule is: If it's too heavy, it's just right. Everybody is looking for the exception to that rule, but nobody has found it yet.

There are three kinds of tripods for still cameras: Small table-top

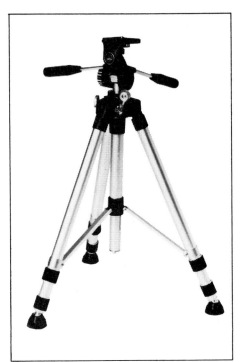

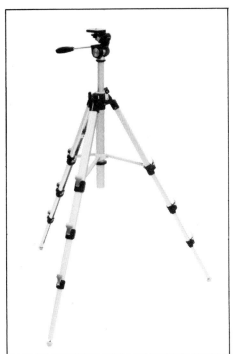

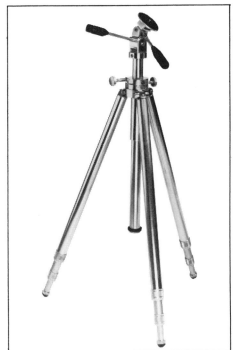

Kalt Super Ranger extends to 78-1/2 inches on tubular legs with rubber-covered lock-rings and center-post braces. Feet are self-leveling without extendable spikes. Geared center post with lock. Handle at left in this view rotates with camera platform for vertical frame. Handle at back controls pan and tilt and locks tilt. Knurled knob on side locks pan.

Samigon U-Channel Elevator Tripod is made with U-shaped legs. Leg locks are simple levers and are easy to operate. Center-column brace helps stability. Uses geared center-column drive, extending to 64-1/2″. Single handle controls pan and tilt. Lock knob on side of head allows camera platform to rotate for vertical frame.

Star-D Professional D-26 Tripod uses tubular legs with knurled lock-rings, not rubber covered. Center post is lifted or lowered by hand, locked by knurled metal knob on collar. Other knob on collar locks pan. At camera platform, one handle controls pan and tilt. The other handle rotates camera for vertical frame. Rubber leg tips have extendable spikes. Center column reverses.

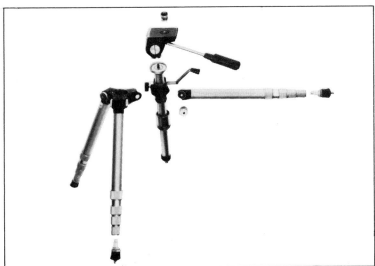

Slik® System Tripods come apart and use an amazing variety of add-on and interchangeable accessories. This model uses single handle for pan and tilt plus control on side of pan head to release camera post allowing camera rotation on camera platform. Reversible center post is friction-drive with lock. Has extendable spikes for dirt or grass. Lock rings on tubular legs are not rubber covered on this model.

Samigon Portable Tripod has 11 tubular sections in each leg and closes to only 8-1/2″. Legs telescope like a car-radio antenna. One handle controls everything, including rotation of camera platform for vertical frame. At full extension of 41-3/4″, tripod is a little wobbly and should be used with cable release. However, it only weighs 1-1/2 pounds!

Here's a random selection of tripods on the market—intended mainly to persuade you that all tripods are not the same. A good tripod lasts for years, so shop carefully to get one that meets your needs and preferences.

units that fit in a camera case or your pocket. Lightweight "brief-case" units used by travelers and backpackers. Ordinary tripods. The first two sacrifice some rigidity for convenience in carrying.

To select an ordinary tripod for general use, shop carefully. Here's a checklist:

• Controls should work smoothly, lock securely and be large enough for your hands. Controls with sharply knurled surfaces will make your fingers sore after a long day—particularly in cold weather. Rubber-covered controls are best but you can tape over the sharp knurling.

• Legs should have rubber tips plus spikes that extend for use in dirt or grass.

• Camera-mounting screw should be large enough to grip and easy to get at. Avoid tiny screw heads that you have to work with the tips of your fingers.

• There should be one control for horizontal camera rotation (pan) and another for tilt. The tilt control should allow a full 90 degrees so you can tip the camera to get the long dimension of the frame vertical.

• With center post extended, the camera should be at least as high as your head when you are standing. If you are six-feet tall and buy a five-foot tripod, you won't like it.

• Center post should reverse so you can hang the camera between the tripod legs, near ground level. Or else the tripod head should be removable with a way to attach it to the bottom of the center post.

• When set up with a camera, the tripod should be sturdy. Test with a camera and long-focal-length lens such as 200mm, or longer. Focus on a distant object. Touch the camera or tripod head lightly with your hand. If the object moves in the viewfinder, the tripod wiggled. Try another.

Using Extra Weight—Even the best tripods can vibrate, usually due to the mechanical motions of shutter and mirror in the camera. You can

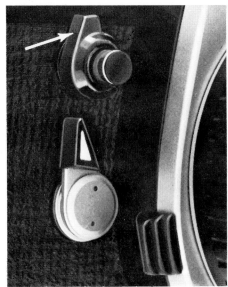

Location of mirror lock-up control varies. On this camera, you rotate the lever (arrow) surrounding the depth-of-field preview button. If you use very-long-focal-length lenses, or shoot at high magnifications, a mirror lock-up control is important.

feel these slight movements in the camera when you hand-hold it. Because fingers and palms are resilient, hand-holding the camera tends to damp out vibrations and minimize the effect of camera-generated clunks and bumps.

Not so with a tripod. Metal doesn't absorb vibrations, it tends to vibrate in sympathy with the source. Vibration due to wind or transmitted through the earth or building will reach the camera. One way to reduce the effect is to hang a weight from the tripod head. If you carry a gadget bag, figure a way to suspend it from the apex of your tripod. Some photographers carry a bag of sand or lead shot for this purpose.

MIRROR LOCK-UP

Three mechanical events happen inside SLR's just before exposure. Any of them may cause vibration that persists into the exposure interval and reduces picture sharpness. They are: Lens diaphragm

closes down to selected shooting aperture. Mirror moves up. First shutter curtain opens.

Two of these can be done in advance, so any vibration is over before the instant of exposure.

Many SLR's—usually higher-priced models— have a *mirror lock-up control.* If your camera is so equipped, I recommend locking up the mirror before each shot, whenever you have the camera on a tripod or other firm support. When you are using telephoto lenses or lens accessories for high magnification, mirror lock-up is a virtual necessity for sharp pictures. When the mirror is up, you can no longer view the subject, so mirror lock-up is practical only when the camera is on a rigid support. Compose the picture and get everything ready to shoot *before* locking up the mirror.

SLR mirrors are cushioned at the end of upward movement to minimize camera vibration. Some use a rubber pad; some use a special air damper. The best cure is to lock up the mirror in advance, so it doesn't move at all.

Mirrors are usually not cushioned on downward travel but this happens after the picture is made, so a clunk doesn't matter. Most of the noise and action you feel in the camera is due to mirror return rather than its upward travel.

With most cameras, you can also stop down the lens before shooting. This is a less-important source of vibration than the mirror, but do it anyway when you are locking up the mirror.

Some SLR's are designed to stop down the lens automatically when you lock up the mirror, so you get both benefits.

CAMERA SELF-TIMER

The ordinary use of a self-timer is to get yourself in the picture. Prepare the camera to shoot, rotate the self-timer lever, start the countdown, dash around in front and smile. In 5 to 10 seconds, the shutter will click.

Another use of the self-timer is

to reduce camera movement. It's a better way to trip the shutter than your finger, when you have the camera on a tripod. It takes a little longer and non-photographers will think your behavior is strange because you didn't run around in front of the camera, but it's a small price to pay for a sharper photo.

WHEN TO WORRY ABOUT CAMERA MOVEMENT
• If you are shooting at a lower shutter speed than the reciprocal of lens focal length.
• If you are using a long-focal-length telephoto lens.
• If you are using accessories to get higher than normal magnification of the image.
• If you plan to enlarge the photo.

HOW TO MINIMIZE CAMERA MOVEMENT
• Switch to film with a higher ASA film-speed rating so you can use faster shutter speeds.
• Use a tripod or other rigid camera support.
• Hang a weight from the tripod head.

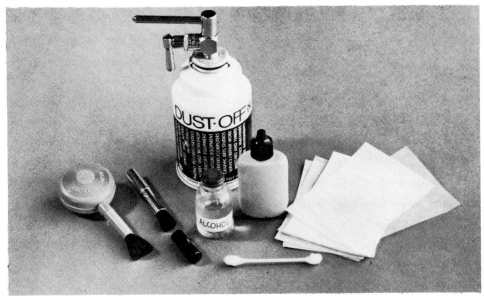

Camera care requires a few essentials: One brush for camera and lens bodies, another for glass surfaces; some way to make squirts of air; lens tissue and cleaning fluid; cotton swabs.

Anytime you are worried about camera movement, trip the shutter with a cable release or the camera's self-timer. Self-timers like this work by rotating the lever downward. On release, it winds back toward the top where it trips the shutter.

• Stop down the lens before shooting.
• Lock up the mirror before shooting.
• Use a cable release or camera self-timer to release the shutter.
• If you are using a physically long lens, use a second tripod to support the lens.
• Don't shoot when heavy vehicles are passing by—they vibrate the ground.
• Don't set up on a flexing or vibrating floor, particularly in the upper levels of a building.
• If you are really serious about it, ask the manufacturer of your camera which shutter speeds cause least camera vibration. Some will tell you.

CAMERA CARE
You need the following:
• A soft brush to clean the body exterior and interior and lens barrels. Use it to get into crevices. *Never use this brush on any glass surface.*
• A special soft lens brush to clean the glass surfaces of lenses and the viewing window of the camera. *Never use this brush on anything but glass surfaces.*
• A rubber squeeze-bulb blower to make a jet of air—used to blow away particles of dirt on glass surfaces and in crevices. Sometimes this blower is combined with a lens brush. Or you can use "canned air" under pressure—available in camera stores.
• Special lens-cleaning fluid available at camera stores.
• Special lens-cleaning tissues available at camera stores. Be sure to get tissues labeled for camera lenses, not eye glasses because those intended for eye glasses are often impregnated with silicone—good for your specs but not for the camera-lens coatings.
• A front cap for the lens on your camera. Both front and back caps for your other lenses.
• A gadget case to protect your camera equipment when traveling or when it is put away in your closet. Store your equipment away from dirt, temperature extremes and high humidity.

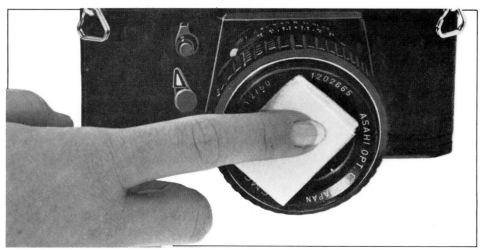

First blow dirt away. Then *lift* off as much dirt as possible with a brush. If you still see dirt or smears, use fluid applied to lens-cleaning tissue and work from the center of the lens outward. Be very gentle.

Blower brushes are handy because they work two ways. Be very careful when working around the focal-plane shutter, so you don't damage it.

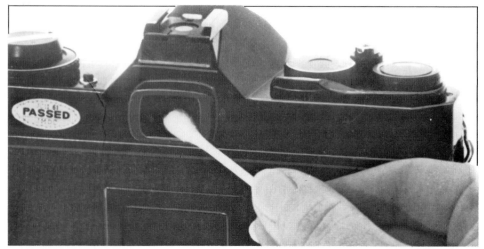

A cotton swab moistened with lens-cleaning fluid is a good way to get the corners of the viewing window clean.

The best care is to keep dirt away from camera and lenses and use your equipment regularly.

To Clean a Lens—With front and rear caps in place, brush the lens body and wipe with a soft cloth to remove dirt and grime.

Remove the front cap and blow away visible dirt particles. If any remain, use your lens brush to remove particles by *lifting* the particle upwards. Don't sweep particles across the glass surface or you will cause small scratches.

If smears are still visible, use lens-cleaning fluid and tissues. Apply one drop of fluid to the tissue, not onto the lens surface. With the moistened tissue, start at the center of the glass surface and work in a circular pattern to the edge. Don't clean unless you can see something on the surface.

Replace front cap and remove the rear cap. If you see dirt, remove it the same way. When properly used and cared for, rear glass surfaces rarely require cleaning. Replace rear cap. Clean viewing window the same way.

To Clean the Camera Body—Use the brush you have reserved for lens barrels and camera bodies to brush the exterior surfaces and into nooks and crannies. When you open the camera back to load film, inspect the camera interior. Use a puff of air or your camera-body brush to remove any foreign matter. Occasionally, I clean the pressure plate on the camera back cover using lens tissue and lens-cleaning fluid.

When you have a lens removed for cleaning, avoid the temptation to also clean the mirror in the camera body. The reflecting surface is a thin and fragile deposit of metal *on the front side* of the mirror. Don't touch it with your fingers and don't try to clean it with tissue and fluid. If you see a dust speck, you can brush it off very gently, using your lens-glass brush. If the mirror requires anything more than one gentle swipe with a soft brush, have it cleaned at a camera service shop.

Storage—If you store a camera body without a lens in place, use a body cap to cover the lens opening. This keeps dirt off the delicate mirror surface and out of the camera mechanism.

Protect from Water—Camera bodies are not waterproof. Avoid using them in the rain, get as much shelter as possible if you do, and wipe off water immediately. A clear plastic bag with a hole cut for the lens can serve as makeshift protection. Or you can buy ready-made plastic rain shields for cameras.

Think you have a malfunction?— Get your camera checked by a repair agency authorized to work on your brand.

CAMERA CASES AND BAGS

When you buy a new SLR, you will be offered an "Eveready" case which holds the camera with a middle-sized lens installed.

They are good protection against minor bumps and scratches. If you carry your camera on the car seat, a case will help keep it clean. These cases have a drop front so you can get ready to shoot quickly, but not as fast as if you had no case at all. Sometimes the drop front will show in the lower edge of the picture. If you are taking quite a few pictures, take the drop front off— if it is removable.

If you intend to use the camera casually, with a single lens, and not carry a lot of film or accessories along, this type of case will serve well. As soon as you buy a couple of extra lenses, some filters and other accessories to solve photographic problems, you'll want a larger carrying case or bag so you can tote along your entire arsenal. Then you'll be sorry you bought the small case.

When you get a gadget bag large enough to carry all of your photographic equipment, you will probably decide it's too heavy when loaded up and wish for a medium-sized carrying case which you will fill with items selected for each photo excursion.

"Surplus" stores sell canvas carrying bags which work fine to carry camera gear. You don't look like a rich photographer, which is often desirable.

In my opinion, the essentials are: A shoulder strap wide enough to be comfortable with a rubber pad that doesn't slip off your shoulder. Sturdy construction so it doesn't come apart with a heavy load. Enough pockets and dividers so your gear isn't all jumbled together.

Hard or Soft?—Camera carrying bags come in all sizes and all degrees of fancy. A major decision is between hard cases which give more protection to contents at a higher price and soft cases which cost less but don't protect the gear as well. Soft cases weigh less. You decide.

X-ray Protection—Carry-on luggage is inspected by X-ray at airports in the United States. On some overseas flights, all luggage is inspected by X-ray. You are legally

"Eveready" camera cases have a drop front so you can quickly get ready to use the camera. Not as quick as no case at all, though.

Soft camera cases with a shoulder strap are convenient and light weight but don't offer much protection to the contents.

Hard cases, such as this Vivitar model, offer most protection to equipment but weigh more.

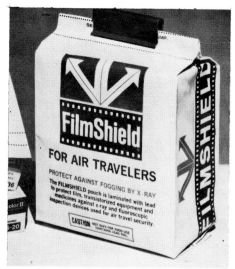

Sima Products Corp. manufactures lead-laminated bags and wrapping material to protect undeveloped film against fogging due to X-rays at airport security-inspection stations.

entitled to a visual inspection of hand luggage, instead of the X-ray inspection but sometimes it's a hassle to get it.

Of course X-rays expose film. That's how the doctor takes a picture of your innards. Signs at airports say the inspection machines don't produce enough radiation to harm film. This is probably true if the machine is properly adjusted and if the film goes through only one time. On a long trip, it may go through several times.

Some camera cases now have a special compartment for film with a liner that reduces penetration of X-rays. Also you can buy bags made of material which reduces X-ray penetration. When the X-ray level is a small amount higher than it shoud be, these can help. If the X-ray machine is really zapping your film, nothing can help.

MOTOR DRIVES AND AUTO-WINDERS

The distinction between a motor drive and an auto-winder is fuzzy. Both advance the film automatically between shots. Current versions of both will fire single shots or shoot many frames in one continuous burst.

Usually a motor drive has a con-

trol to set the number of frames to be exposed in one burst. If you set the control to 7, for example, the camera will expose 7 frames continuously and then shut off. Auto winders normally don't have this control.

Auto winders are operated by the shutter button on the camera. After you take each picture, the winder automatically advances the next frame. With some models, if you keep the camera shutter button depressed, it makes pictures continuously at about half-second intervals.

Motor-drive units are operated by a pushbutton on the motor drive, with a switch to select single shots or continuous operation. With some brands, you can disregard the motor drive and operate the camera manually even though the motor drive is still attached and turned on. This is convenient. You may not want to use battery power in the motor drive for every shot.

Before buying a motor drive or auto-winder, find out *exactly* how it operates. Some makers have more than one model, so you have a choice. Auto-winders capable of continuous operation usually have

a maximum speed of about 2 frames per second. Some motor drives also operate at about 2 frames per second but more expensive units go faster—such as 4 or 5 frames per second.

No mechanical film-advancer can move film faster than the shutter speed will allow. That is, you can't advance film at 2 frames per second while shooting at a shutter speed of 1 second. Find out what the motor drive or auto-winder does at slow shutter speeds. Currently available units will wait politely while the camera makes each exposure, then move the film quickly for the next. You can have the unit set for 2 frames per second but it will work more slowly if it has to wait for the camera.

Motor drives and auto-winders connect to the bottom of the camera, usually attached to the tripod socket. With some brands, it is necessary to remove the camera's bottom plate. On others you remove a small access cover. Some thoughtfully designed units have a holder for the camera access cover so you don't lose it. Small motor drives use self-contained batteries. Large and fast units sometimes have a separate battery pack

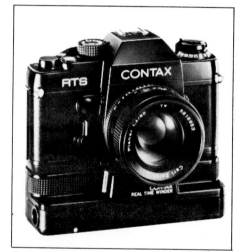

Contax RTS camera with Real Time Winder shoots single shots or continuously at approximately 2 frames per second. Winder attaches quickly to bottom of camera.

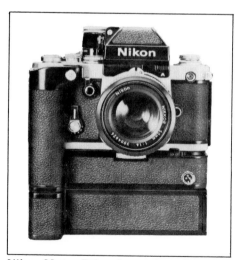

Nikon Motor Drive shoots single frames or continuously at up to 5 frames per second, with simple attachment to bottom of camera. Motor drives use up 36 frames of film in a hurry, so camera backs are removable to install bulk-film magazines holding 250 frames of film.

you wear on your belt.

Simpler, lower-priced versions have slower operating speed and can expose only 36 frames of film in a standard film cartridge. More expensive models work faster and some can use a special film magazine that replaces the camera back. These special magazines hold 250 frames of film. Cartridges are loaded in the darkroom with film spooled off a larger bulk roll.

Motor drives are commonly used by professional photographers, typically for fashion and sports. The advantage of making many frames of a moving model in fashion photography is to catch just the right combination of pose, facial expression and drape of garments.

In sports, the object is to be ready and shoot several shots quickly when sudden action develops. The photographer can shoot frame after frame without taking his eye from the viewfinder. There is no guarantee that continuous shooting will catch a peak of action or a brief moment of high drama. If it is a peak you are after, you may be better off making single shots using your keen instincts.

Sophisticated motor drives, used with an automatic camera can solve difficult problems. These are available with clockwork mechanisms—*intervalometers*—to expose frames steadily at selected intervals of time such as one second, one minute, an hour or a day. This can be useful or necessary to photograph flowers opening, weather developments, and similar things.

Motor drives with remote control allow the photographer to be distant and perhaps unobserved from the scene of the photograph. Devices like photocells or mechanical trips can be used to operate the camera when the intended subject is present—such as a wild animal.

In unattended photography with a motor drive, a camera which measures the light and sets exposure automatically can be used.

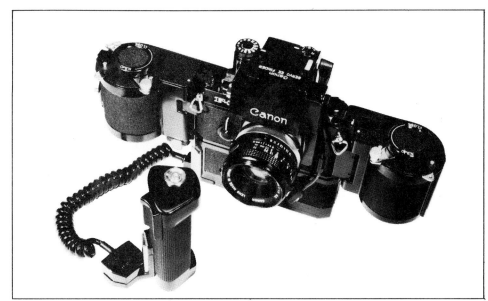

Canon F-1 camera with motor drive, a 250-frame back, and a special Servo EE viewfinder attachment to give the camera automatic-exposure capability. With this setup you can do unattended photography with an interval timer or remote-control device.

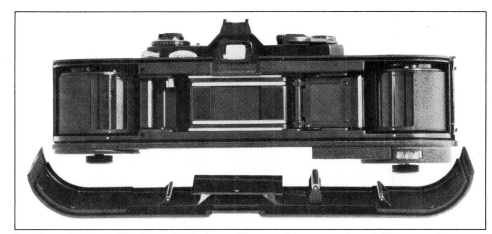

Interior of Pentax 250-frame back shows film cartridges at each end. These can be loaded in the darkroom and closed to keep out stray light until loaded into bulk magazine.

Bulk-film loaders with automatic frame counters are available to load 250-frame cartridges to fit in 250-frame camera backs.

LENSES

A major advantage of the SLR is interchangeable lenses. You can select from a long list of available lenses with different capabilities.

LENS MOUNTS

The lens attaches to the camera body quickly and conveniently, using one of 3 types of lens mount: **Screw-mount lenses** are threaded to match threads in the camera body. They install by screwing the lens into the camera. It takes several revolutions.

Bayonet-mount lenses slip over a mating flange or fixture on the camera body and mount with a twist of about 60 degrees. The entire lens rotates during mounting, but less than one revolution.

Breechlock lenses mount without rotating the lens itself. A ring on the back of the lens fits over a mating flange on the camera body and only the breechlock ring is turned to attach the lens. The ring turns only part of a revolution.

Screw-mount lenses thread into the camera body, requiring multiple rotations of the lens to complete the mounting operation.

Bayonet-mount lenses have three projections which mate with three cut-outs on the camera body. Mounting the lens is accomplished by turning the lens body about 60 degrees.

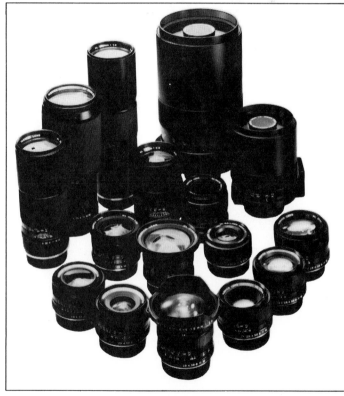

Camera manufacturers and accessory lens-makers offer a wide range of interchangeable lenses for your SLR. These are Yashica lenses with focal lengths ranging from 15mm to 1000mm. Because Yashica and Contax use the same lens mount, Yashica and Zeiss T* lenses are interchangeable.

Breechlock lenses mount by mating the knurled collar on the back of the lens with a mounting flange on the camera body. Then the knurled ring is rotated a fraction of a turn. The lens body itself does not rotate.

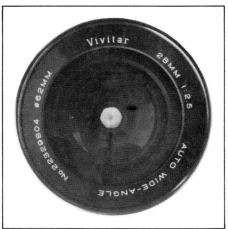

Some makers give you a lot of information on the engraved lens-identification ring. Clockwise from the top: The manufacturer's name. The focal length—28mm. The maximum aperture size—1:2.5 means its an f-2.5 lens. *Auto* tells you its an automatic lens allowing full-aperture viewing and metering. *Wide-angle* is helpful information for beginners although most photographers would infer that from the focal length. The lens serial number is given for identification and for your records. *Ø62MM* means the lens accepts filters and other front-mounting accessories with a diameter of 62mm. This is a very important bit of information but some lens makers leave it off.

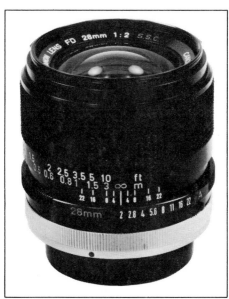

Canon does a helpful thing in lens engraving. On the aperture-control ring, in a different color, Canon shows lens focal length. Particularly if you use two cameras, it's handy to see at a glance what lens is on the camera. This is a 28mm lens with a maximum aperture of f-2.

LENS SPECIFICATIONS

The two main specifications of a lens are maximum aperture given as an *f*-number and focal length stated in millimeters (mm). Other information about the lens may be included in the nomenclature engraved on the metal ring surrounding the front glass element.

MAXIMUM APERTURE OR LENS SPEED

If a lens is specified as *f*-1.4, that is the largest aperture available. By rotating the aperture-control ring, smaller *f*-stops may be selected down to the smallest aperture setting—normally *f*-16 or *f*-22.

Lenses with larger maximum aperture are sometimes said to be *faster* than lenses with smaller maximum aperture. This assumes the lens is actually set to its largest aperture size so the most light reaches the film. In this case, a shorter exposure time is required, so the lens contributes to a "faster" exposure.

From a strictly technical point of view, the advantage of a lens with a large maximum aperture is that it allows you to take pictures in dim light. There are also some artistic reasons to use an aperture size that is larger than necessary to make the picture—discussed later.

Lenses with larger maximum aperture have larger glass elements, a larger lens body or tube, weigh more and cost more.

FOCAL LENGTH

Focal length has a technical definition and some practical, visible effects on your pictures.

Technically, it is the distance between a certain point in the lens and the film in the camera, when the lens is making a focused image of a distant subject which we say is at infinity. The symbol for infinity, ∞, is engraved on lens focusing controls. In photography, it means any long distance.

FOCUSING A LENS

When a lens is focused on a subject at infinity, the glass elements of the lens are mechanically positioned as close to the film as the camera design will allow.

To focus on subjects *nearer* than infinity, the lens is mechanically moved *farther* from the film. The glass elements of the lens travel along an screw thread inside the lens body, called a *helicoid*. When the lens is moved outward and reaches the end of the helicoid, it is focused on the nearest subject possible, without special accessories.

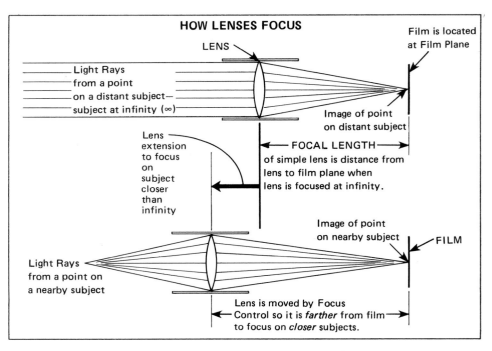

HOW LENSES FOCUS

Light Rays from a point on a distant subject—subject at infinity (∞)

LENS

Film is located at Film Plane

Image of point on distant subject

FOCAL LENGTH of simple lens is distance from lens to film plane when lens is focused at infinity.

Lens extension to focus on subject closer than infinity

Light Rays from a point on a nearby subject

Image of point on nearby subject

FILM

Lens is moved by Focus Control so it is *farther* from film to focus on *closer* subjects.

FOCUSING LIMITS

All lenses intended for general use will focus to infinity. The near limit of focus varies among brands and types. Long-focal-length lenses will not focus as close to the camera as short-focal-length lenses.

For example, a 200mm lens may have a minimum focusing distance of about 6 feet but a 50mm lens may focus to 18 inches. The closer you can get to your subject, the larger the subject's image becomes on film in your camera. If other factors are equal when choosing between two lenses of the same focal length, choose the closest-focusing one.

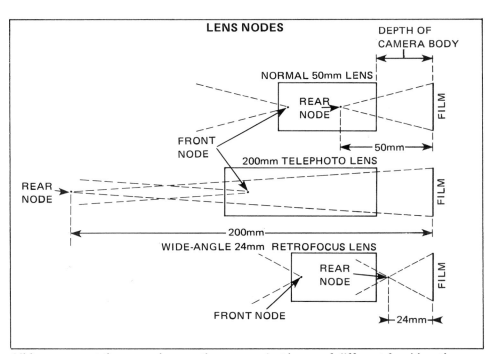

LENS NODES

All lenses mount the same place on the camera, but lenses of different focal length require different distances between the rear node of the lens and the film. This is done optically, by positioning the rear node where it needs to be.

TYPICAL NEAR-FOCUS LIMITS	
FOCAL LENGTH	NEAR-FOCUS LIMIT (meters)
20mm	0.25
35mm	0.3
50mm	0.6
50mm macro	0.2
100mm	1
100mm macro	0.4
200mm	2
400mm	4
800mm	14

Some recent lenses focus in a slightly different way. One design, called *Floating Element,* not only moves all of the glass elements when focusing, it also changes the position of some of them in respect to the others. The ones that change position are called *floating.*

Some use *rear focusing* in which the front glass elements of the lens don't move but rear glass elements do. These move inside the lens barrel so the overall length of the lens barrel does not change during focusing.

In both of these cases, you can think of the lens as described earlier—the glass elements move away from the film to focus on nearer subjects.

HOW LENSES WITH DIFFERENT FOCAL LENGTH FIT ON THE SAME CAMERA

All lenses designed to fit a certain camera must meet a basic requirement: When focused at infinity, the distance between lens and film must equal the focal length of the lens. For this purpose, distance is measured from an optical location of the lens, called the *rear node.*

Some of this lens-to-film distance is in the camera body—between the lens-mounting surface and the film plane. The distance is sometimes called the *flange focus* and, of course, it's the same no matter what lens is installed.

The distance between lens-mounting surface on the camera body and the film plane is typically about 50mm, depending on camera brand.

With lenses from about 40mm to 55mm focal length, no special lens designs are required to get the correct total distance between rear node and film. These are called *normal* lenses.

A telephoto lens of 200mm focal length requires 200mm between lens node and film (about 8 inches) and many such lenses aren't that long. Because the rear node is an *optical* location, it can be placed almost anywhere in the optical path by the lens designer. Locating the rear lens node 200mm in front of the film may require the node to be out in front of the lens. If so, that's where the lens designer puts it.

Wide-angle lenses with short focal length have the opposite problem. A 20mm-focal-length lens, for example, requires 20mm between the rear lens node and the film, when the lens is focused at infinity. If the camera body is 50mm deep, the rear node must be located behind the lens, inside the camera body.

The practice of locating the lens nodes where they must be—in front of or behind the lens—has some practical consequences when these lenses are used with accessories to get larger-than-normal image size.

Essential lens accessories! Use a lens front cap whenever you are not taking pictures. Use a lens rear cap when the lens in not mounted on a camera.

Use a body cap whenever you don't have a lens mounted on the camera.

Lenses of different focal lengths, designed to fit on the same camera body and use the same flange focus distance, are called *parafocalized*.

Lens Pupils—You can tell if a lens has its rear node moved forward or backward by holding it at arms length and looking at the disc of light at each end of the lens—called lens *pupils*. The pupil seen looking into the front is called the *entrance pupil*. The pupil seen looking into the back of the lens is called the *exit pupil*.

A telephoto lens has the rear node moved forward so it can fit on the camera body and the entrance pupil is visibly larger than the exit pupil.

Wide-angle lenses are the other way. The rear node is moved toward the film and the exit pupil is larger than the entrance pupil. Wide-angle lenses of this design are sometimes called *reversed telephoto* or *retrofocus* lenses.

FIELD OF VIEW

A lens "sees" a circular part of the scene and makes a circular image in the back of the camera. The film records a rectangular part of the *image circle*.

The *field of view* is simply the circular part of the scene that the lens "sees."

ANGLE OF VIEW

When a lens is used on a slide projector, light comes through the lens and makes an image on the

You can identify this as a telephoto lens because the entrance pupil is larger than the exit pupil.

Wide-angle or retrofocus lenses have exit pupils larger than entrance pupils.

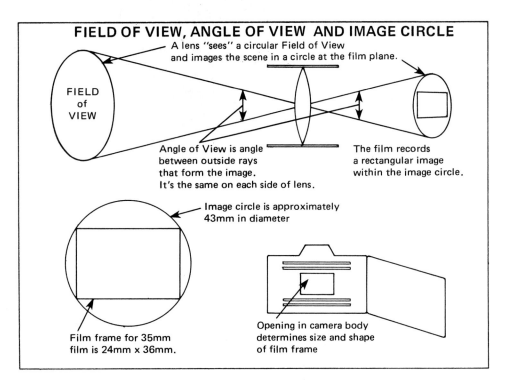

FIELD OF VIEW, ANGLE OF VIEW AND IMAGE CIRCLE

A lens "sees" a circular Field of View and images the scene in a circle at the film plane.

FIELD of VIEW

Angle of View is angle between outside rays that form the image. It's the same on each side of lens.

The film records a rectangular image within the image circle.

Image circle is approximately 43mm in diameter

Film frame for 35mm film is 24mm x 36mm.

Opening in camera body determines size and shape of film frame

made by the outer edges of the cone of light rays coming into the lens.

Lens focal length is a number marked on each lens. Focal length determines angle of view.

Examples: A 500mm-focal-length lens has an angle of view of only 5°.

The standard or "normal" lens supplied on most 35mm SLR's has a focal length of 50mm or 55mm. A 50mm lens has an angle of view of 46°.

Wide-angle lenses have focal lengths shorter than 50mm. A 20mm lens has a 94° angle of view.

In photography, when talking about lens focal lengths, we are usually thinking about the angle of view given by different focal lengths.

How Angle of View is Specified— Strictly speaking, a lens has only one angle of view as just defined. However, the image made on film is a rectangle—wider than it is tall.

Considering the film frame horizontally, it doesn't include all of the circular image made by the

screen. Without a slide in the projector to define a rectangular light pattern, the image cast by the lens is a circle—usually larger than the screen. In a darkened room, you can see a cone of light emerging from the lens to make the circular image.

When a lens is used on a camera, light travels in the opposite direction—from scene to lens. Nevertheless, light rays make the same cone-shaped pattern as they travel to the lens. Light rays outside of this cone don't enter the lens.

Lens *angle of view* is the angle

HOW TO READ CURVES

If you are accustomed to "reading curves," skip this. A curve or graph is a way of finding one number of a pair when you know the other number. Call one number X and the other Y.

Using the Situation A curve, let's find the value of Y when X is 4. Make a vertical line from 4 on the X scale or axis, as shown. Where this vertical line intersects the "Situation A" curve, project a horizontal line over to the Y scale. As you can see, the value of Y is 1. It also works backwards. If you know Y is 1, reverse the procedure to find that X is 4.

With a different lens or equipment setup, Situation A may not apply but Situation B does apply. Use the curve labeled Situation B to find that Y = 3-1/2, when X = 5.

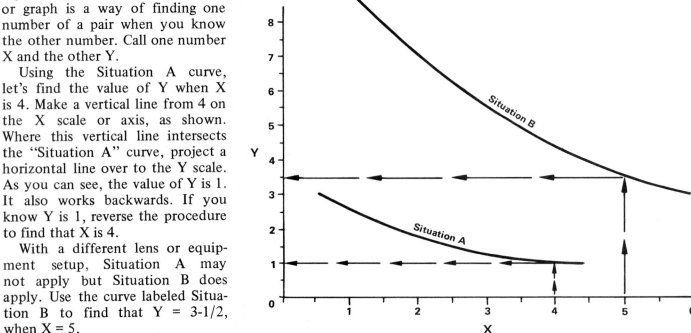

lens because part of the image circle is cut off by the sides of the frame. Therefore if we consider just what is included horizontally in the picture, we don't see everything in the lens angle of view.

Some people think it is more accurate or "honest" to state the angle of view actually used to make the horizontal part of the film frame. This is always less than the "circular" angle of view.

Considering the film frame vertically, a still smaller angle of view is included in the picture.

Because the rectangular film frame fits closely inside the image circle in the camera, the *diagonal* of the film frame corresponds to the actual "circular" angle of view of the lens.

Some lens specifications give three angles of view: Diagonal, Horizontal and Vertical. If only one angle of view is given, it is always the diagonal angle—the true "circular" angle of view of the lens.

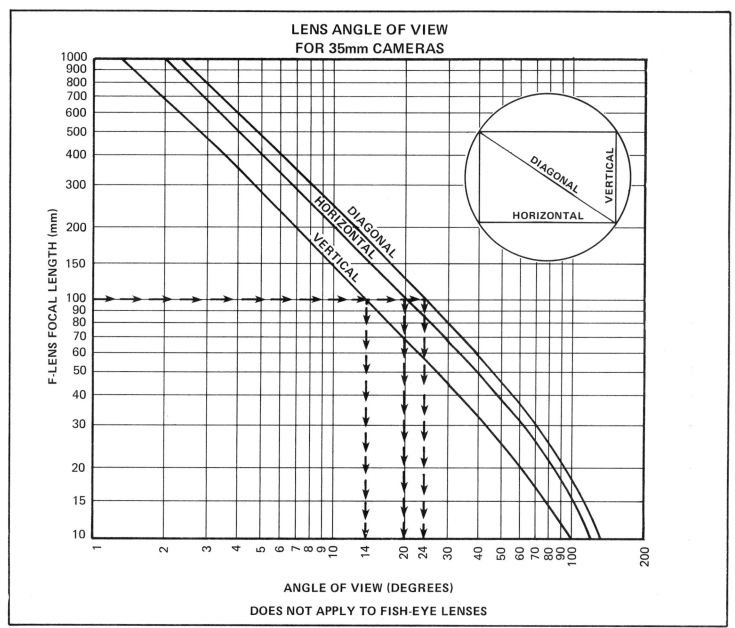

LENS ANGLE OF VIEW FOR 35mm CAMERAS

ANGLE OF VIEW (DEGREES)

DOES NOT APPLY TO FISH-EYE LENSES

HOW TO USE THE LENS ANGLE-OF-VIEW GRAPH—Project a line horizontally from lens focal length (F) to intersect all three curves. From each intersection, drop a perpendicular to the degree scale along the bottom. Read all three angles.

In the example shown, lens focal length is 100mm; vertical angle of view is 14°; horizontal is 20°; diagonal is 24°. Most lens specifications give *diagonal* angle of view if only one angle is given.

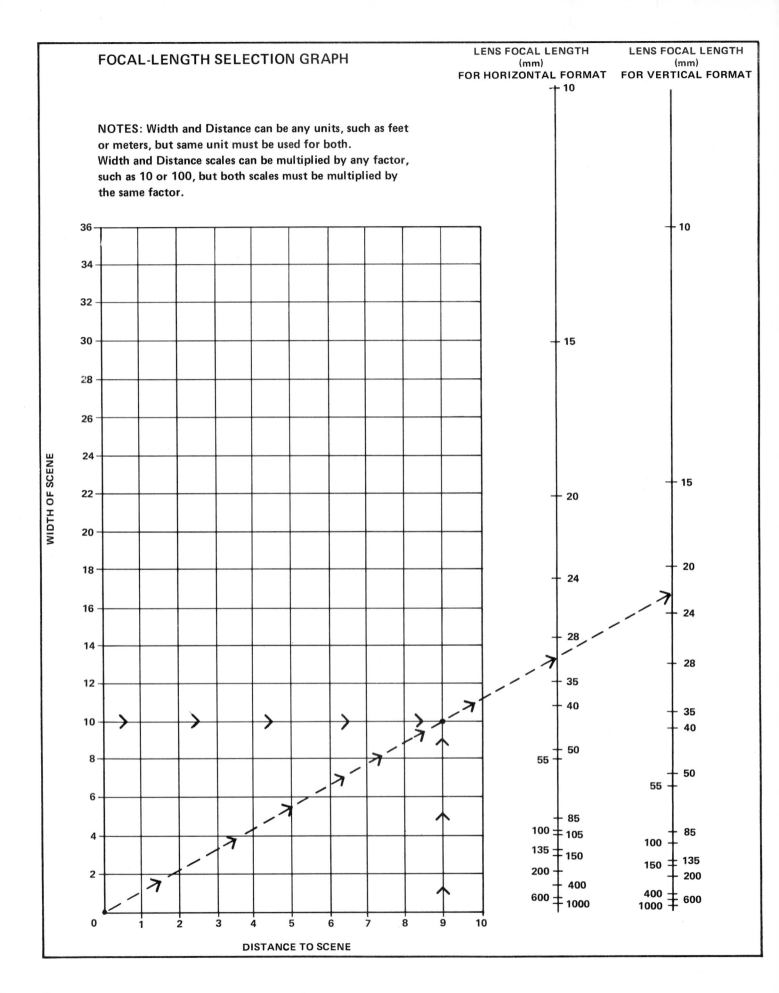

FOCAL-LENGTH SELECTION GRAPH

NOTES: Width and Distance can be any units, such as feet or meters, but same unit must be used for both.
Width and Distance scales can be multiplied by any factor, such as 10 or 100, but both scales must be multiplied by the same factor.

WIDTH OF SCENE

DISTANCE TO SCENE

LENS FOCAL LENGTH (mm) FOR HORIZONTAL FORMAT

LENS FOCAL LENGTH (mm) FOR VERTICAL FORMAT

HOW TO PICK THE RIGHT FOCAL LENGTH IN ADVANCE

It's frustrating when you don't have the right lens for a scene you want to shoot.

Once I lightened my load during a hike through Carlsbad Cavern by deciding to take only a 50mm lens, tripod and camera. I spent the whole trip wishing for a wider angle of view.

HOW TO USE THE FOCAL-LENGTH SELECTION GRAPH

To decide on a lens focal length in advance, estimate the horizontal width of the scene you intend to shoot and the distance from camera to that scene.

On the graph, find the point corresponding to width of scene and distance to scene. Construct a straight line between the zero point of the graph (lower left corner) and the point just located. Extend the line so it passes through both scales on the right side.

If you will be holding the camera normally, using a horizontal-frame format, read lens focal length off the scale for horizontal format. If you will be holding the camera for a vertical shot, use the vertical-format scale.

EXAMPLE: You intend to photograph a 10-foot-wide mural and you can't stand farther away than 9 feet. Find that point on the graph—indicated by the dot. Draw a line from zero through the dot and extend to both focal-length scales. For a horizontal shot, a lens between 28mm and 35mm focal will do. Use 28mm. If you must use vertical format, you need a 20mm lens. This assumes that the height and width of the subject will fit in the film frame.

EXCEPTIONS: Graph does not apply when lenses are used with close-up attachments, extension tubes or bellows. Does not apply to fish-eye lenses. Does not apply to macro lenses used at magnifications greater than about 0.1.

CATEGORIES AND USES OF LENSES

When you have several lenses and become familiar with their use, you will choose a lens focal length for its photographic effect when planning and setting up for a photograph.

WIDE-ANGLE LENSES

These have focal lengths of 35mm and shorter with larger angles of view at shorter focal lengths. They are useful in photographing interiors where you want to get a lot of a room in a single shot. They are useful when you can't get enough distance between camera and subject to use a normal lens. They make pleasing outdoor and scenic shots when you want to include a vast expanse of distant landscape, or something like a small flower with a lot of surrounding vegetation.

NORMAL LENSES

40mm to 55mm. These give a view with about the same feeling of perspective we get in real life. They are good general-purpose lenses and suitable for many photographic situations. The difference between a 35mm lens and a 50mm lens is small and some photographers use a 35mm as their "normal" camera lens.

Wide-angle lenses are usually fairly small and compact. As focal length gets shorter, larger front-element diameters are required to keep a maximum aperture of reasonable size.

MEDIUM TELEPHOTO

85mm to 200mm. These are needed when you can't get close enough to your subject to fill the frame when using a normal lens. They are handy for sports and nature photography. Because they have a smaller angle of view, they are used to isolate and photograph an interesting part of a wide view, leaving out most of the uninteresting part.

LONG TELEPHOTO

300mm and longer. These lenses normally require a tripod or equivalent steady mount to avoid blurring the picture due to camera shake. As lens focal length is made longer, lens diameter must increase to preserve the same maximum aperture. A 400mm f-2 lens is a giant compared to an 50mm f-2 lens. Most long lenses sacrifice maximum aperture size to reduce weight, size and cost. Maximum apertures of f-5.6 and smaller are common, limiting usefulness except in daylight or with very long exposures. These lenses will reach out a long way to capture an image, but image quality may be deteriorated by the long air path between lens and scene.

ZOOM LENSES

Most interchangeable lenses have a fixed focal length with a fixed angle of view and magnification. *Zoom lenses* have an additional control allowing you to change the focal length, within limits.

Zoom lenses typically operate in the short-to-medium focal-length range such as 35mm to 70mm, or in the medium-to-long range such as 100mm to 200mm.

The main advantage is zooming to fill the frame with subject at different distances, without changing camera location. This is handy and sometimes essential for shooting action and sports, when you don't have time to change lenses back and forth.

The main disadvantage of zoom lenses is smaller maximum aperture than fixed-focal-length lenses. You

Normal lenses, usually sold with the camera, are 50mm or 55mm focal length although some manufacturers offer lenses as short as 40mm for the normal lens.

Telephoto lenses become physically longer as focal length increases. If they have large maximum aperture, the lens front elements become very large. This is a 200mm f-4, which is a good general-purpose telephoto lens.

may not be able to use a zoom lens satisfactorily in dim light. Also, zoom lenses are physically larger and cost more than ordinary lenses. Picture quality is slightly worse than fixed-focal-length lenses give, but the difference may be invisible.

Zoom Lenses with Macro Setting— Some zoom lenses are offered with a special control setting to allow close focusing and therefore a larger image on film. This is advertised as a "macro" setting but it isn't. *Macro* means the image on film in the camera is larger than real life. Before buying a zoom lens for its "macro" capability, find out exactly how much image magnification it gives at the special setting. It will be more than you can get with a normal 50mm lens, but much less than life-size. The special setting is handy for photographing bugs and flowers, but is not really a macro capability.

Macro Lenses — Fixed-focal-length macro lenses are also offered by several manufacturers in 50mm and 100mm focal lengths. Their very long focusing movement allows

moving the lens far enough away from the film to focus on very close subjects. Without accessories, a typical macro lens will make an image half as large as life-size. These lenses use extension tubes between lens and camera to give a larger image—life-size or larger-than-life.

Macro lenses are very useful and should be considered by every SLR owner.

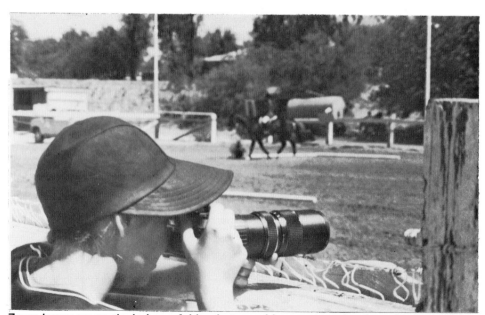

Zoom lenses are particularly useful in photographing sports and action where you don't have time to change lenses to get different focal lengths. This Samigon 80-200mm zoom lens was used to make the photo of the jumping horse on page 2.

A macro lens mounted directly on the camera usually gives magnifications up to 0.5, meaning the image on film is half as large as the object photographed. Note how this lens design provides a built-in lens hood.

Some macro lenses provide life-size images without an adapter between lens and camera. This 90mm Vivitar gets all the extension it needs by moving outward on a very long internal screw thread, called a *helicoid*.

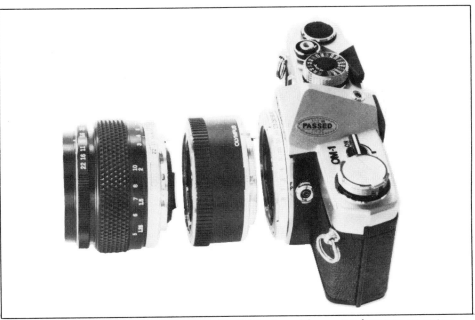

If the macro lens gives a magnification of half life-size with no attachments, an extension tube between lens and camera can be used for magnifications up to life-size. For greater magnification, use more extension tubes.

Fish-eye lenses that record a circular image can't use lens hoods or any front lens attachments because the attachment will intrude into the field of view. This 15mm fish-eye makes a rectangular image on film, therefore doesn't record the entire circular image made by the lens. A permanent lens shade is cut away at the corners of the image, where the full field of view is actually used.

This view, made with a rectangular-image fish-eye lens, shows typical fish-eye distortion of architecture.

FISH-EYE LENSES

A special lens design called *fish-eye* has a very wide angle of view—typically 180° but some are even wider— which means the lens "looks over its shoulder." They create "fish-eye" distortion: Any straight line that does not pass through the center of the picture is bowed away from center. They are very short focal length ranging from about 6mm to 17mm.

Circular fish-eye lenses—make a circular image within the film frame. That part of the rectangular film frame not occupied by the circular image is black in a print. These are the shortest focal lengths.

Full-frame fish-eye lenses—fill the entire frame with an image, therefore part of the circular fish-eye image is cropped by the straight sides of the frame.

Because of the very wide angle of view, fish-eye lenses can not be used with filters or accessories mounted on the front of the lens. The accessory frame will intrude into the field of view, making the image dark around the edges, called *vignetting*. Most fish-eye lenses have built-in filters on a turret inside the lens. A control rotates the desired filter into the optical path.

TELE-EXTENDERS

Tele-extenders fit between an ordinary lens and the camera body. They are an inexpensive way to multiply lens focal length. A 2X multiplies focal length by 2; a 3X multiplies focal length by 3. Thus

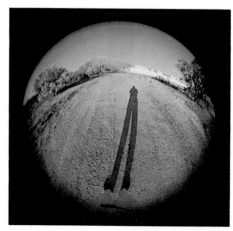
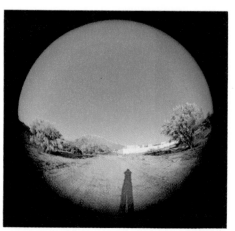

Fish-eye lenses distort by curving outward all lines that do not pass through the center of the image. In fish-eye scenic views, you can minimize the distortion by placing the horizon at the center.

DIFFERENT LENSES USED AT SAME CAMERA LOCATION

28mm

50mm

100mm

200mm

400mm

When focal length of the lens is changed but camera location is not, all photos have the same perspective. Except for image size, the shots made with longer lenses are *identical* to the same portion of the larger views taken with shorter focal lengths. Angle of view and image magnification change, perspective does not.

a 50mm lens can be converted to 100mm or 150mm by these accessories.

There are two penalties. The tele-extender, sometimes called *tele-converter*, also multiplies the *f*-number setting. If you have a lens set at *f*-4, a 2X tele-extender makes it behave as though it were set at *f*-8, admitting two steps less light to the film. Unless there is a lot of light, such as sunlight, this is often a problem.

Accessory *tele-extenders,* sometimes called *tele-converters* fit between lens and camera body, multiplying focal length of the camera lens.

WHEN CAMERA LOCATION CHANGES, PERSPECTIVE CHANGES

50mm

100mm

200mm

400mm

In these photos, camera location was changed to keep the model about the same height in the viewfinder with lenses of different focal length. This changes perspective and the apparent distance between the foreground and the background. Longer focal lengths seem to "compress" distance.

An advantage of tele-extenders which is sometimes useful is that they preserve the close-focusing capability of the camera lens. If you are using a 50mm lens that can focus to 18 inches from the film plane, it will still focus that close with a tele-extender installed. Using a 3X tele-extender, for example, gives a lens of 150mm focal length that will focus to 18 inches. Most camera lenses with 150mm focal length won't focus that close.

Tele-extenders usually reduce image quality compared to a good-quality lens of the same focal length. You may get a better image with a 100mm lens than with a 50mm lens used with a 2X extender. The difference is sometimes hard to see and many photographers use tele-extenders.

Not suprisingly, you get better image quality with tele-extenders which cost more. Nikon offers two tele-extenders optically designed to work with Nikkor lenses without noticeable degradation of the image. One is for short-focal-length lenses; the other for long.

If you buy tele-extenders, be sure they preserve all of the automatic features of your camera.

SHIFT LENSES

Special lenses for architecture shift the lens sideways or up and down to control perspective when shooting buildings and room interiors. Usually 28mm or 35mm focal length. See page 47.

TILT AND SHIFT LENSES

A few makers offer lenses which both shift the lens and tilt it so the face of the lens is not parallel with the film plane. These are useful for architecture and special effects. See page 48.

HOW TO CHOOSE A SET OF LENSES

You can build a useful set by doubling or halving the focal length of a lens you already own.

If you buy an SLR with the normal lens of about 50mm, the next longer focal length with a significantly different angle of view is 100mm or 105mm. The next shorter focal length to consider is approximately half—24mm or 28mm.

Starting with a 50mm lens, you can make this shopping list:
15mm, 24mm or 28mm, 50 or 55mm, 100mm, 200mm, 400mm,

Here I was lucky enough to get some ghost images of the lens aperture due to sunlight falling on lens. Trail of ghosts falls along a line between center of image and the sun's position—even though sun is out of view.

Shot into the sun with a poor-quality lens. Severe flare scattered light rays all over this picture. Ship's hull should be a deep rich black.

and on up if you need super-long lenses.

Some photographers prefer a 35mm instead of a 50mm. Using that as the normal lens, the shopping list becomes:

18mm, 35mm, 85mm, 135mm, 300mm.

It's better to buy lenses near your normal focal length first, rather than make big jumps. If you own only a 50mm lens and buy a 15mm, you are not likely to use the 15mm lens very well and you may be disappointed in what you find to do with it.

FLARE AND GHOST IMAGES

Every air-glass surface allows some incident light to pass through and reflects some back in the direction it came from. On the front of a lens, reflections merely reduce the amount of light coming into the camera to expose the film. On interior surfaces of a lens with several glass elements, reflections may bounce around from surface to surface and finally end up as a diffused spot of light on the film, called *flare*.

Because there is more light from bright objects in the scene, flare happens mainly to bright objects and sometimes appears as a sort of halo around a bright spot.

Misdirected light rays land on the film in places where they shouldn't, causing dark areas to appear lighter and often dimming or obscuring facial features in a portrait made against strong light. Sometimes flare scatters all over the film frame without being obvious except for an overall reduction in image sharpness and contrast between light and dark.

Sometimes reflected light rays inside the lens make an image of the lens aperture—usually a five- six- or eight-sided figure seen as a train of aperture images, called *ghosts.*

Lenses with focal lengths of 55mm or shorter allow you to get too close to your subject and still make a portrait in good focus. These were both made with a 50mm lens. Photo at left with lens about 2 feet from subject makes poor portrait. Photo at right shot from about 6 feet away and enlarged. Focal lengths from 85mm to about 135mm make good portrait lenses because they allow you to fill the frame with your subject's head without having to get too close.

LENS HOODS OR SHADES

Stray light from bright sources near the edge of the field of view are particularly likely to cause flare and ghosts. Often these stray light rays can be kept out of the lens by using a lens hood, sometimes called a *lens shade.* A hood can never harm your picture unless you use the wrong size so it intrudes into the field of view. It is nearly always beneficial. Use a hood designed for the angle of view of the lens on the camera.

The idea is to block all light rays except those used in forming the image. Rectangular lens hoods are better than circular ones because the film frame is rectangular. Rectangular hoods which attach to the lens by bayonet fittings are positioned automatically to conform to the shape of the frame. Those which screw in place usually rotate on their mount so they can be oriented properly. Look through the viewfinder to be sure the hood is not cutting into the corners of the frame. If you don't have a hood, use your hand, a hat, or anything you can find to keep the glare directly off of your lens. Just make sure your improvised shade does not cut into the picture.

LENS COATINGS

Don't buy a new lens unless it is coated. Lens coating reduces the amount of light reflected from an air-glass surface.

Coating on a lens' front surface admits more light and makes the lens "faster." Coating on interior surfaces reduces flare and ghost images.

A single-layer coating does most of the job. Multiple layers offer worthwhile improvement in some cases. Lens coating is an expensive process which increases cost.

Rubber lens hoods fold back on themselves so you can usually put the camera in its case without removing the hood. Rigid metal lens hoods offer some protection to the lens in case you accidentally bump or drop the camera.

There is no simple answer to the question: Aren't multi-coated lenses better? Single-layer coating is a necessity for most users and all modern lenses have at least a single coating. The case for multi-coating is not that clear. If you can afford it, it's an improvement but probably not a necessity.

LENS ABERRATIONS

There is no perfect lens. A well-designed modern lens is a compromise to reduce lens imperfections—called *aberrations*—to an acceptable amount.

REDUCING THE EFFECT OF ABERRATIONS

With modern lenses of good quality—offered by major SLR manufacturers—aberrations are sufficiently well corrected so the average viewer will usually be unaware of them. For special cases, some makers offer lenses with special correction of one or more of the aberrations.

Ordinary lenses, for example, are likely to show poor flatness of field when photographing a perfectly flat subject such as a newspaper, or photographing stamps at high magnification. For this purpose, lenses specially corrected for flatness of

NAME OF ABERRATION	EFFECT	USER CORRECTION
SPHERICAL ABERRATION	Image not sharp with any film or subject	Shoot at smaller than maximum aperture
CHROMATIC ABERRATION	Image not sharp with any film. Color fringes visible on color film.	Same
ASTIGMATISM	Out-of-focus effect at edges of picture. Changes when you operate focus control but you can never get all parts of image in good focus.	Same
COMA	Off-axis points on subject have tails like comets when viewed under high magnification. To unaided eye, edges of picture are fuzzy.	Same
CURVATURE OF FIELD also called FLATNESS OF FIELD	When photographing flat surface such as stamp or newspaper, center is sharp but edges are out of focus.	Same
DISTORTION	Straight lines in scene appear curved.	None

field are available. The manufacturer's description will normally call your attention to this special correction.

Color images appear brighter and sharper if chromatic aberration is reduced. All modern lenses are well corrected for chromatic aberration. Still better correction is made by use of a lens element made of *fluorite*—a crystal found in nature which is now man-made in the size and quantity needed to manufacture special lenses. Lenses with a fluorite element are more expensive, but the improvement in color photos is apparent.

All photos are sharper if spherical aberration is reduced. This aberration happens because glass elements in the lens are all manufactured as segments of a sphere. One correction is to use a non-spherical element—called *aspherical*. Aspherical lenses are labeled as such by the manufacturer. They are also more expensive but worth it if you want the best.

Spherical aberration becomes worse as a lens is focused on subjects closer to the camera. An improvement for nearby subjects has been developed by several lens makers, called *floating element* or something similar. One lens element, or group of elements inside the lens barrel is shifted in position while the entire lens is moved in and out for focusing. Lenses with floating elements cost only a small amount more and are worth the extra cost to nearly everybody.

No matter what lens or lens type you use, the effect of most aberrations is reduced if you shoot at smaller aperture than wide open. This is practical in most shooting situations, and worth doing.

DIFFRACTION

When light rays pass by an opaque edge, such as the edge of the aperture in a lens, those rays close enough to graze past the edge are affected in a peculiar way. Their direction of travel is changed to make the resulting image larger on the film, and the image is made up of tiny alternating bands of light and dark.

The effect of diffraction is a general lack of sharpness everywhere in the image.

Light rays which do not pass close to a mechanical edge are not diffracted. Therefore the amount of diffraction depends on the size of the aperture. Larger openings have more center area where light rays can pass through without diffraction.

Image diffraction is reduced by using larger aperture.

OPTIMUM APERTURE

Two conflicting factors—aberrations and diffraction—lead to opposing requirements on aperture size. Aberrations are reduced by smaller aperture; diffraction is reduced by larger aperture.

Most lenses make the sharpest image when set about midway between the largest and smallest aperture size.

You can't always do that due to exposure requirements of the film, and because aperture size has still another effect on the picture—depth of field.

DEPTH OF FIELD

Most photos of a subject with depth, such as a landscape, are not in sharp focus everywhere. There is a band or zone of acceptable focus called *depth of field*. This is simply the distance between the nearest and farthest objects which are in acceptable focus.

Example: If the nearest object in good focus is 20 feet from the camera and the farthest object in good focus is 30 feet away, the depth of field is 10 feet.

Depth of field is increased with any lens by using smaller aperture— larger f-numbers.

Theoretically, any lens will give maximum depth of field when set at its smallest aperture. Practically, reducing aperture size also increases diffraction. The bad effect of diffraction may overcome the good effect of increased depth of field

Depth of field is the zone of good focus. You can often put it where you want it by adjusting camera controls. The effect is sometimes subtle, sometimes obvious, but nearly always important to your pictures.

at very small apertures.

As a rule, adjust the lens for the depth of field you need and don't worry about aberrations or diffraction. Too much or too little depth of field is the most noticeable of these defects, so avoid it at virtually any cost.

DEPTH OF FIELD AS A PHOTOGRAPHIC CONTROL

In some photos, it is essential that all parts of the subject be in sharp focus.

In photos where the principles of art apply more directly, it is often desirable to put part of the scene in good focus and cause part of it to drift out of focus. In a portrait against a "busy" background, for example, the portrait is always improved by throwing the background out of focus so it is less distracting to the viewer.

HOW TO FIND DEPTH OF FIELD

You need to know how much depth of field you have with a particular aperture setting. Because SLR cameras allow viewing and focusing at maximum aperture, you *do not* see the depth of field that will actually appear on the film when the lens is stopped down to take the picture.

By Looking—To see depth of field at shooting aperture, stop down the lens to that aperture size and then view the image in the viewfinder. This is the best way when possible, but it is not always possible because sometimes the light is so dim when viewing stopped down that you can't see the image clearly.

Use the Scale on the Lens—Lenses have a depth-of-field scale which is used with the focused-distance

scale to read depth of field at a particular aperture setting. Accompanying photo shows how.

Use Look-Up Tables—You can also find depth of field in tables for lenses of various focal lengths, focused at various distances, set at various apertures. Such tables are complicated, bulky and rarely useful. Most camera manufacturers will send you depth-of-field tables for their lenses. I have never consulted one, so I did not include any in this book.

Calculate it Yourself—A compact substitute for published depth-of-field tables is the calculation which follows. It quickly gives you approximate figures for virtually any lens.

Extreme accuracy is not necessary and probably not possible except by lab measurements which must be repeated for each lens at

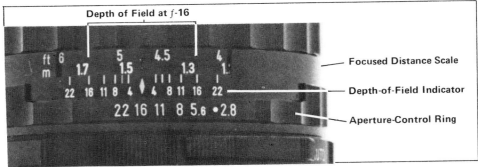

Depth of Field at f-16

Focused Distance Scale

Depth-of-Field Indicator

Aperture-Control Ring

How to read the depth-of-field (d.o.f.) indicator scale: Notice that the d.o.f. scale repeats on both sides of the diamond-shaped index mark, so there are pairs of numbers such as 4-4, 8-8, and so forth. Depth of field is indicated by the distance between the pair of numbers which is the same as the f-number setting of the lens. This lens is set at f-16, so you read depth of field between 16 and 16 on the d.o.f. scale, as shown. From the d.o.f. scale, read across to the focused distance scale to get depth of field in meters or feet. At f-16, depth of field is from a near distance of about 4.2 feet to a far limit of about 5.6 feet—a total depth of about 1.4 feet. Everything on either side of this range will be visibly out of focus.

each aperture. Even with super-accurate data, nothing in particular happens at the exact near and far limits of the zone of good focus. The picture is slightly less fuzzy on one side and slightly more fuzzy on the other side of any published limit of depth of field.

Depth-of-field limits are a matter of personal judgment, eyesight, and the viewing distance of slides or prints. Therefore *any method* of determining depth of field is probably as good as any other because all are approximations.

STANDARD OF SHARPNESS

All methods for determining depth of field rely on some standard of sharpness to define the good-focus limit.

A common way to define this limiting sharpness is to assume a point subject which perfect focus will reproduce as a point on the film. Imperfect focus will cause the point to become a disc or circle on the film—called the *circle of confusion*. Any chosen value for the size of this circle is arbitrary, but experience suggests reasonable values.

One standard is to specify the size of the circle as 1/1000 of the lens focal length (F). Others use a

smaller diameter such as 1/1500 or 1/2000, which automatically reduces depth of field. It doesn't change the camera or the picture—only the standard by which we calculate depth of field.

The following equations and graphs are based on a circle of confusion equal to 1/1000 of F.

HYPERFOCAL DISTANCE

The methods given to calculate depth of field also use a concept called *Hyperfocal Distance*. At each lens aperture setting there is some focused distance for a lens such that the depth of field extends to infinity. The near limit for depth of field is half the focused distance of the lens. That focused distance is the Hyperfocal Distance.

Example: A lens set at f-8 is focused at 20 feet. Depth of field extends from 10 feet to infinity. For that lens aperture setting, the Hyperfocal Distance is 20 feet. It will be different at other aperture settings.

HOW TO CALCULATE DEPTH OF FIELD

Two methods are presented here. The first uses simple formulas in a step-by-step procedure. The alternate is to use two curves and avoid

the mathematics. Either method applies except when lenses are used *with accessories* for larger-than-normal images in the camera. If you are using such accessories, see page 146.

Step One—Figure Hyperfocal Distance (H) for the aperture setting and focal length of the lens you are using.

$$H = \frac{F}{f}$$

where H is in meters, F is Focal Length in millimeters, and f is the f-number setting of the lens.

Example: You are using a 50mm lens set at f-4.

$$H = \frac{F}{f}$$
$$= \frac{50}{4}$$
$$= 12.5 \text{ meters}$$

Step Two—Now that you know Hyperfocal Distance, you must also know the distance to the subject (S). This is the focused distance of the lens and you can read it off the lens scale after focusing. Or you can measure it. Find S in meters.

Then calculate the Near Limit of good focus and the Far Limit. Depth of Field is the distance between them.

$$\text{Near Limit (meters)} = \frac{H \times S}{H + S}$$

$$\text{Far Limit (meters)} = \frac{H \times S}{H - S}$$

Depth of field =
Far Limit − Near Limit

Example: With the 50mm lens set at f-4, H is 12.5 meters as already calculated. Subject is 4 meters from the camera.

$$\text{Near Limit} = \frac{12.5 \times 4}{12.5 + 4}$$
$$= \frac{50}{16.5}$$
$$= 3 \text{ meters}$$

$$\text{Far Limit} = \frac{12.5 \times 4}{12.5 - 4}$$
$$= \frac{50}{8.5}$$
$$= 6 \text{ meters}$$

Depth of Field = 6 meters − 3 meters
$$= 3 \text{ meters}$$

When calculating Far Limit, if S is equal to or larger than H, the denominator becomes zero or negative. This means the Far Limit is at infinity or beyond.

HOW TO USE THE HYPER-FOCAL DISTANCE GRAPH

To find Hyperfocal Distance, locate the *f*-number setting of the lens on the left scale. From that point, project a horizontal line to intersect the line labeled with the focal length of the lens. From that intersection, drop a perpendicular line to the scale along the bottom and read Hyperfocal Distance in meters.

In the example, a 50mm lens set at *f*-4 has a Hyperfocal Distance of 12.5 meters.

HOW TO USE THE DEPTH-OF-FIELD GRAPH

To find depth of field, locate two points: Hyperfocal Distance on the left scale, and the focused distance on the Focused Distance curve as read using the bottom scale. In the example shown, a lens with a Hyperfocal Distance of 25 meters is focused at 17 meters.

Draw a straight line connecting those two points and extend the line to intersect with the Far Limit curve. The constructed line intersects at three lines. Drop perpendiculars from the three intersections to read Near Limit, Focused Distance and Far Limit.

Depth of Field is Far Limit minus Near Limit. In this example, Far Limit is 50 meters, Near Limit is 10 meters, Depth of Field is 40 meters.

Plane of best focus is at 17 meters, where the camera is focused. Notice that this is less than one-third of the way into the depth of field.

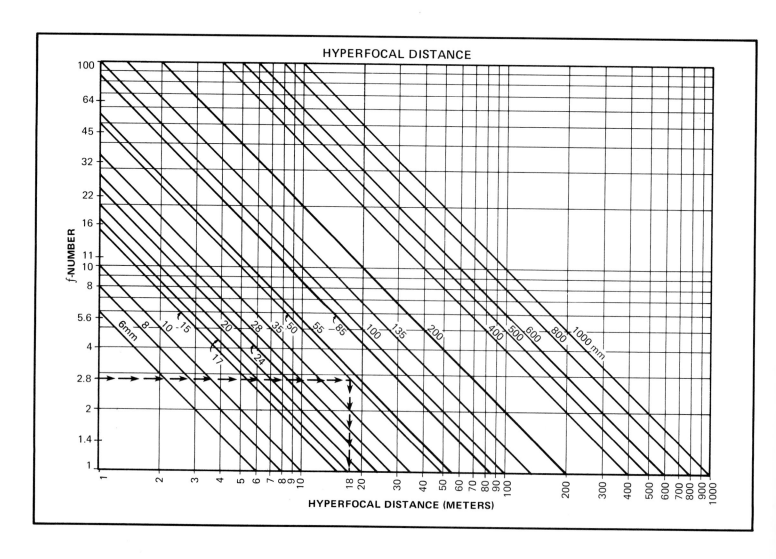

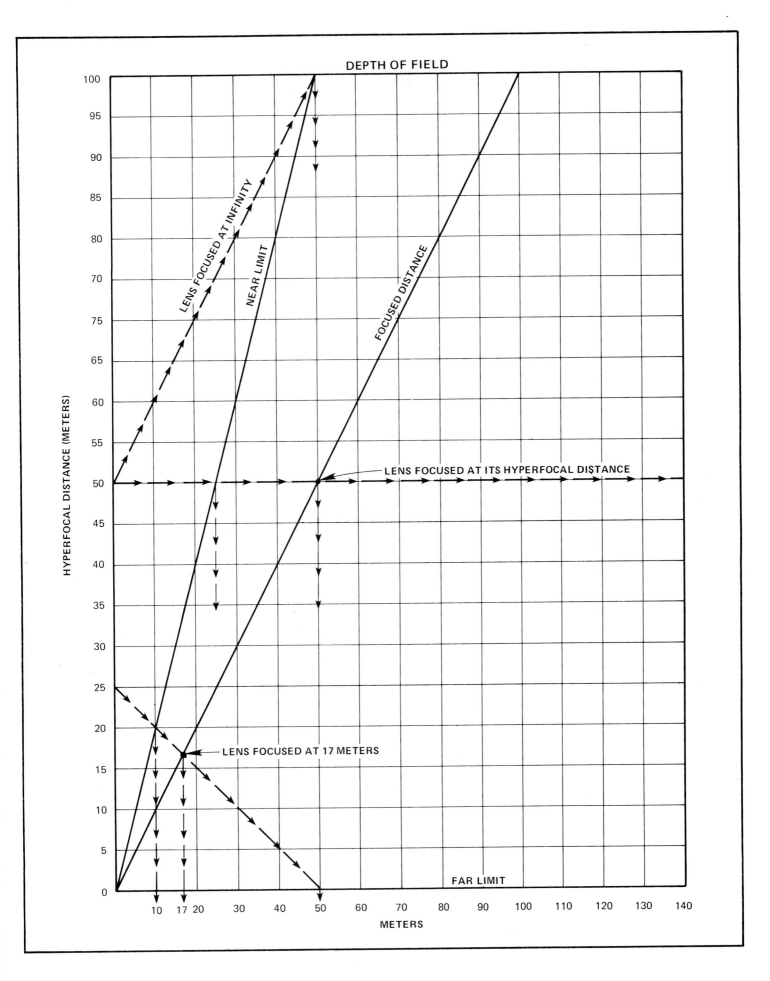

DEPTH OF FIELD

WHERE IS BEST FOCUS?

Somewhere within the depth of field is best focus. Obviously, it is the distance at which the lens is focused because the picture gets fuzzier in both directions from there.

In the depth-of-field example just shown, the camera is focused at 4 meters. The near limit is 3 meters and the far limit is 6 meters. Best focus is one third of the way into the depth of field—at 4 meters.

You can use this as a rule of thumb when focusing on *nearby* subjects using large aperture—the situation which usually gives insufficient depth of field. For example, if you are photographing a chair a short distance away, and you want the front edge and the back edge of the chair to have equal sharpness in the photo, focus on a point about one-third of the way between front and back.

This rule of thumb does not apply when subject distances are relatively long, such as 50 feet. In this case, best focus is *less than* one-third of the way into the depth of field.

It also does not apply when lens accessories are used to get higher magnification than normal. In these cases, subject distance becomes very short—inches or fractions of an inch. Depth of field becomes very short also. Best focus is about halfway into the depth of field.

IF YOU FOCUS AT THE HYPERFOCAL DISTANCE

The hyperfocal distance for any lens changes depending on the aperture setting of the lens. If you focus at the Hyperfocal Distance, whatever it is, a curiosity results. The Far Limit is infinity and the Near Limit is *half* of the Hyperfocal Distance. This is shown by the construction for a lens focused at its Hyperfocal Distance.

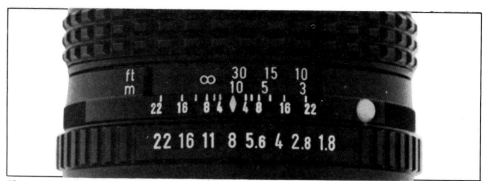

Shortcut method to set a lens at its hyperfocal distance is to align ∞ with the *f*-number setting of the lens where it appears on the d.o.f. scale. Use the *f*-number that indicates the far limit of depth of field. If this doesn't agree with hyperfocal distance as calculated by the methods of this book, it's because the lens maker uses a different standard of sharpness.

IF YOU FOCUS AT INFINITY

Still another "mysterious" property of Hyperfocal Distance: If you focus at infinity, as shown on the graph, the Near Limit is *equal* to the Hyperfocal Distance. This is true at *any* Hyperfocal Distance.

When focused at infinity, the *practical* depth of field is between the Hyperfocal Distance and infinity.

HOW TO GET MAXIMUM DEPTH OF FIELD

Focus on the Hyperfocal Distance. The lens will tell you what it is. After setting the exposure controls so you know what *f*-stop you will be using, crank the lens over to focus on infinity. Using the depth-of-field scale on the lens, find the Near Limit for the *f*-stop you are using. This is the Hyperfocal Distance. Refocus to the Hyperfocal Distance and you have maximum depth of field—from one-half the Hyperfocal Distance all the way to infinity.

Shortcut Method—You know the infinity symbol, ∞, on the lens focus control will be at the Far Limit of depth of field whenever you are focused on the Hyperfocal Distance. To get there in a hurry, just move the focus control until ∞ is aligned with the *f*-stop you are using, on the side of the depth-of-field scale indicating Far Limit.

RULES ABOUT DEPTH OF FIELD

• As normally used, short-focal-length lenses give more depth of field than long lenses.

• Any lens has more depth of field when focused at greater distance from the camera.

• Any lens has more depth of field when stopped down to smaller aperture.

• At any aperture, you get maximum depth of field by focusing at the Hyperfocal Distance. Smaller apertures give more depth of field when set that way than large apertures do.

FOCUSING AT FRACTIONS OF THE HYPERFOCAL DISTANCE		
IF YOU FOCUS ON	DEPTH OF FIELD FROM	TO
H	H/2	∞
H/2	H/3	H
H/3	H/4	H/2
H/4	H/5	H/3
H/5	H/6	H/4
H/6	H/7	H/5

An interesting and rarely useful rule is shown by this table. The pattern of numbers should be obvious. This rule is not affected by the standard of sharpness used to establish H.

- When shooting nearby subjects, the plane of best focus is about 1/3 of the way into the depth of field. As you change focus to more distant subjects, the plane of best focus becomes closer to the near limit of depth of field.
- When depth of field is not enough, use smaller aperture, or move back, or switch to a shorter-focal-length lens.
- When depth of field is too much, use larger aperture, or move closer, or switch to a longer-focal-length lens.

HOW TO PHOTOGRAPH BUILDINGS

When you stand close to a tall building to take its picture, you have to point the camera upward to get it all in. This makes the side walls appear closer together at the top and, in the photo, it looks like the building is falling over backwards.

Solutions:
- Don't point the camera upwards. Hold it so the sides of a building—or corners of a room—are parallel to the sides of your viewfinder and the building won't lean over backwards in your photo. When you do this, you may not be able to get the top of a building in your picture.
- Move back until you get all of the building in the viewfinder. Sometimes this gives too much foreground in the picture—a lot of lawn or parking lot, for example.
- Don't shoot from ground level. Get the camera higher if possible. Shoot from a window or the top of a building across the street.
- Use a shift lens.

USING A SHIFT LENS

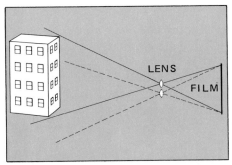

View cameras and some special lenses for 35mm SLR's allow shifting the lens parallel to the film. This changes the part of the scene which falls within the film frame.

This SMC Pentax 28mm ƒ-3.5 Shift Lens moves on its mount, as you can see, and does not have automatic diaphragm. It also rotates on its mount so it can be shifted in any direction. It has built-in filters selected by a knurled ring (arrow) and is a *preset* lens type. This allows you to view wide open, then stop down to the preset ƒ-number without removing your eye from the camera viewfinder.

Point the camera upward so you get all of the building, but it seems to lean over backwards.

Move the camera downward so the sides of the building are parallel to the sides of the viewfinder.

Then *shift* the lens vertically until the entire building comes back into view. This time it's not leaning.

USING A LENS THAT TILTS AND SHIFTS

THE SCHEIMPFLUG PRINCIPLE

Line parallel to back of camera—extension of film plane

Tilted Lens

Subject in focus

Subject out of focus

Subject in focus

Line through lens, parallel to front face of lens

Line through plane where best focus is desired

All three lines pass through common intersection

View cameras and some special lenses for 35mm SLR's allow tilting or rotating the lens in respect to the film plane. This controls the plane of best focus, angling it in the same direction that you tilt the lens. This drawing shows how to figure which way to tilt the lens.

This Canon Tilt and Shift lens is 35mm, *f*-2.8. As manufactured, it tilts one direction and shifts the other but can be adjusted to tilt and shift in the same direction. It rotates on its mount for complete versatility.

You're making an artistic low-angle shot through a water fountain. With camera angled up, building leans over backwards.

Move camera so film plane is parallel to face of building. Side of building will be parallel to side of viewfinder as you can see up the upper right corner of the frame. But now you're photographing mainly water fountain.

Shift the lens upward to bring the building back into the frame. The part of the water fountain that is nearest camera is out of focus. There isn't enough depth of field to make it sharp and keep the building in focus also.

Use the tilt feature of the lens, swinging it to the left. This brings foreground into sharp focus with sparkly water reflections off that brass urn. It makes another part have worse focus, but I still like this effect. Also, it makes the right-side corner of the building a little soft.

48

SUBJECTS IN MOTION

To stop action with your camera, use a shutter speed short enough so the subject doesn't move perceptibly while the shutter is open. For many purposes, you can figure the stop-action shutter speed with this formula:

$$T = \frac{D}{1000 \, S}$$

T is shutter-open time in *seconds.*

D is distance between camera and subject in *feet.*

S is subject speed in *miles per hour.*

This formula applies to a subject crossing at 90 degrees to the direction you are pointing the camera.

OTHER WAYS TO REDUCE BLURRING DUE TO SUBJECT MOTION

• Switch to film with a higher ASA speed so you can use shorter exposure times.

• Move camera so subject is moving more nearly toward or away from line-of-sight.

• Move back and accept smaller image of subject. If you subsequently enlarge to get the same image size, moving back won't do any good.

• Shoot at the peak of action. Many activities have a dramatic point at which motion ceases or is greatly reduced: A jumper at the top of his jump; a golfer at the top of his backswing, the instant before throwing a ball; a diver at the apex.

In photo literature, you'll see a wide range of recommended shutter speeds to stop action. The reason everybody doesn't agree is, it depends on how much image blurring

TYPICAL SPEED OF SUBJECTS IN MOTION (MPH)	
Person strolling	2
Brisk walk	3
Person running	8
Bicycle rider	15
Bicycle racing	30
Horse walking	4
Horse running	10
Cars racing on dirt track	40
Motocross racing	40
Indy racers on straight	200
Indy racers in turn	100

SHUTTER-SPEED CORRECTION FOR SUBJECT CROSSING ANGLE	
If subject is crossing at 90°	Use table or formula
If subject is crossing at 45°	Use one step slower shutter speed
If subject is moving directly toward or away from camera	Use two steps slower shutter speed

STOP-ACTION SHUTTER SPEED FOR SUBJECTS CROSSING AT 90 DEGREES					
SPEED (MPH)	DISTANCE TO SUBJECT (FEET)				
	5	10	25	50	100
1	1/250	1/100	1/60	1/30	1/15
2	1/500	1/250	1/125	1/60	1/30
4	1/1000	1/500	1/250	1/125	1/60
8	1/2000	1/1000	1/500	1/250	1/125
15		1/2000	1/1000	1/500	1/250
30			1/2000	1/1000	1/500
60				1/2000	1/1000
125					1/2000

This table and the formula given on this page apply to a 50mm lens. If you double lens focal length, use 1/2 the recommended exposure time.

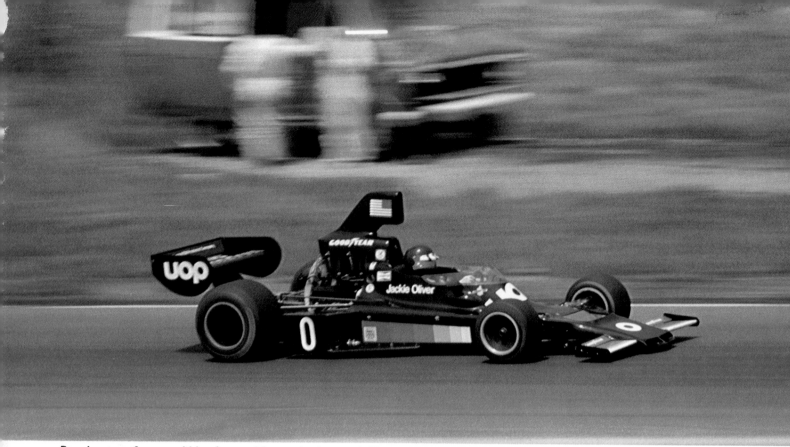

Panning transfers speed-blur from subject to background. This is sometimes a very effective way to retain feeling of high speed yet preserve detail in subject of interest. Photo by Tom Monroe.

is tolerable. You may be able to use 2 or 3 steps slower shutter speed than these recommendations and still get acceptable results.

PAN WITH THE SUBJECT

With a horizontally moving subject traveling at a fairly uniform speed, swing or *pan* the camera horizontally. Move the camera *smoothly* so you keep the subject centered in the viewfinder. *Smoothly* click the shutter and keep the camera *smoothly* panning with the subject until after the exposure is made.

Panning transfers blur from subject to background. When you are moving the camera with the subject, the subject appears stationary but background seems to move in the opposite direction.

SOMETIMES A SPEED-BLUR IS EFFECTIVE

You don't always want to stop action completely. Subjects in mo-

tion look static when frozen by high shutter speed. A little blurring, or sometimes a lot, makes a picture with more interest and excitement.

To blur a moving subject deliberately hold the camera still during exposure, while the subject moves in the viewfinder.

HOW TO ESTIMATE THE AMOUNT OF BLUR

The amount of blur is important. Too much softens the image and makes details hard to recognize. Too little doesn't get the desired effect.

Decide how much blur you want. A good way is to pick a fraction of the length of the moving subject. For example, a long blur is half the length of the subject. If a car is 20 feet long, you may want 10 feet of blur. For a runner, you may want about 1/2 foot of blur. A more restrained effect for a speeding car is about half the diameter of a wheel—about one foot.

Use this formula:

$$T = \frac{B}{1.5\,S}$$

T is time of exposure in *seconds*.
B is desired length of the blur in *feet*.
S is speed of the subject in *miles per hour*.

Example: A car is moving at 80 MPH and you want 1 foot of blur.

$$T = \frac{1}{1.5 \times 80}$$

$$= \frac{1}{120} \quad \text{second}$$

$$\text{Use } \frac{1}{125} \quad \text{second.}$$

This formula is for a subject crossing the field of view at an angle of 90°. If the subject is crossing at 45°, use one step slower shutter speed.

If the subject is moving directly toward or away from the camera, the result may not look like a speed-blur. Consider changing camera position to get the subject crossing in front of the lens.

In modern SLR's, the light which will expose the film is measured after it comes through the lens and through any lens accessories in use, such as filters. The light is measured by a small sensor, sometimes more than one, which produces an electrical signal proportional to the amount of light.

Several locations are used for the light sensor but all perform the same basic function—measuring the light. Three types of sensors are used:

- Cadmium Sulfide—CdS
- Silicon, called *Silicon Blue*
- Gallium-Arsenic-Phosphide—GAP

CdS has two disadvantages. It reacts slowly when the light level is low, so you should wait until the reading stabilizes. In dim light this may take 30 seconds or more. Also, CdS requires time to "adjust" between greatly different light levels because it has a "memory." If used in very bright light and then immediately used in very dim light, the dim-light reading will not be accurate until a minute or two has passed. Both of these conditions are unusual and do not affect ordinary use of a camera with a CdS sensor.

Silicon cells produce a much lower electrical output which requires amplification in the camera by a sophisticated electronic circuit. They don't require adjustment time in dim light and have no memory. Both silicon and CdS respond to infra-red light, which people can't see, and require an infra-red filter over the cell inside the camera, so it will read correctly.

Understanding how your camera measures light and calculates exposure is important—particularly for scenes with unusual lighting.

Silicon cells are used in some automatic cameras because of their fast response. So fast that, in some automatic cameras light measurement takes place instantaneously, *while you are depressing the shutter button!*

GAP light sensors have performance characteristics very similar to silicon and can be regarded as an alternate method. Their main advantage is that they don't respond to infra-red light.

EXPOSURE CALCULATOR

Modern SLR's have a built-in exposure calculator which takes the light measurement from the sensor, combines it with other information and figures a pair of control settings for correct exposure.

The camera exposure calculator works with four bits of information:
• Film speed
• Light measured behind the lens
• Shutter speed
• Lens aperture

You set film speed into the camera. The other three factors are "coupled" to the exposure calculator by mechanical or electronic devices in the camera itself.

If you are using a non-automatic SLR, the exposure calculator "recommends" a pair of exposure-control settings. As you adjust shutter speed and lens aperture manually, the exposure display in the viewfinder monitors the operation and shows when you have made correct settings.

Exposure is the effect of light on film, made visible by development. Exposure is determined by 3 things:
• Film speed or sensitivity to light— stated by a film-speed number.
• Brightness of the light that falls on the film—determined by scene brightness and lens aperture setting.
• Length of time light is allowed to fall on the film—determined by shutter-speed setting.

The Basic Exposure Formula— Called the *Law of Reciprocity,* or more often the *Reciprocity Law,* exposure in most photographic situations is expressed by this formula:

E = I x T

E is exposure of the film.

I is intensity of light on the film.

T is the time duration of exposure.

Assume the camera is set for a certain amount of exposure at a certain scene brightness and exposure time. To make it simple, let's use easy numbers:

24 = 4 x 6

Now assume that 6 is too long for shutter-open time and we wish to use only 3—a reduction by half. The same exposure will result if we double the other factor:

24 = 8 x 3

As you can see, a large number of *pairs* of values can be found which have the same product when multiplied together, and therefore cause the same exposure on film. All of these *pairs* of exposure settings are *equivalent.* An exception is called *Reciprocity Failure,* discussed on page 69.

THE ADVANTAGE OF EQUIVALENT EXPOSURE SETTINGS

The *two* exposure controls on your camera do three things.
• Together, aperture and shutter speed determine exposure.

Exposure of the subject in these two shots is equivalent. In this photo, I used small aperture and slow shutter speed. Small aperture gave enough depth of field to put the background in focus. As you can see, my dog doesn't think much of my technique.

• Aperture alone controls depth of field.
• Shutter speed alone controls image blur and determines whether or not you can hand-hold the camera or stop motion of a moving subject.

For nearly every photo you make, you should consider not only getting the right exposure but also the individual effects of the two exposure controls. Usually you will have a good photographic reason to choose some particular aperture or else you will decide to use some particular shutter speed.

HOW TO MAKE EQUIVALENT EXPOSURE SETTINGS

The camera exposure controls are aperture size and shutter speed. Because the standard series of steps for each of these controls changes by a factor of two—either doubles or cuts in half—one step of aperture change is equal to one step of shutter-speed change: Provided you make them in the correct directions.

Changing to smaller *f*-numbers increases aperture size and therefore increases the amount of light reaching the film.

Changing to shorter shutter-open times, called *faster shutter speeds,* reduces the length of time light falls on the film.

One step larger aperture can be balanced by one step faster shutter

So I changed to large aperture and fast shutter speed, throwing the background out of focus to make a very nice portrait. Goodo likes it just fine.

Some accessories used between lens and camera, such as a bellows, do not complete the mechanical linkage between the lens and the camera body. Also, some lenses are not equipped with levers to allow open-aperture metering. In either case, lens aperture actually closes down as you adjust it and the amount of light entering the camera is reduced.

Lenses which allow open-aperture metering have a lever on the back which moves when you change lens aperture size. The aperture itself doesn't change because the lever is telling the camera what size is being selected. The aperture won't close down until the instant before the shutter opens.

speed so exposure remains the same. The reverse is also true.

The exception is reciprocity failure, discussed on page 69.

Counting Steps—If you start with correct exposure and then decide to change one of the two control settings, count the number of clicks and you can make an equivalent setting without depending on your exposure meter. Shutter-speed dials usually have one click-stop or detent for each shutter speed. Lens aperture controls usually have detents in between full f-stops, so 2 clicks make one full stop.

Example: Your settings for race cars on the starting line are 1/250 at f-11. When the race starts, you change shutter speed to 1/1000 to catch cars in motion. What f-stop should you use, assuming the light hasn't changed?

Count clicks on the shutter-speed dial:

1/250 → 1/500 → 1/1000 = 2 clicks toward faster shutter speed.

Make the compensating change in aperture:

f-11 → f-8 → f-5.6 = 2 full steps larger aperture.

Use 1/1000 at f-5.6.

METERING WIDE OPEN OR STOPPED DOWN

Sometime before exposing film, a light measurement is taken. There are three ways:

• *Open-aperture* or *full-aperture* metering is done while viewing the scene with the lens wide open. This gives maximum scene brightness in the viewfinder and requires no special step to take the exposure reading. Because the light meter does not see the amount of light that will be used to make the exposure after the lens is stopped down, it must *anticipate* the effect of stopping down the lens.

Lenses which allow open-aperture metering are equipped with a signal lever which "tells" the camera what aperture has been selected at the lens even though the lens has not yet stopped down to that aperture. This allows the camera exposure calculator to figure in the effect of stopping down the lens.

• *Stopped-down* metering is done with the lens at shooting aperture—normally a smaller aperture than wide open. First, compose the picture and focus, using maximum aperture. Then stop down the lens to shooting aperture and take the exposure reading. The light meter in the camera measures the same light that will be used to expose the film. No special linkage between camera and lens is required.

• Instantaneous metering is a feature of recently developed cameras using Silicon or GAP light sensors. Typically, the light sensor is turned on by depressing the shutter button about halfway. Usually a slight resistance is felt at the point where the light sensor is turned on. These sensors work so fast that the camera exposure calculator can figure exposure during the time it takes to depress the shutter all the way. If the camera is automatic, it will also make its control setting during that short time interval.

Because the photographer does not have to stop down the lens to make an exposure reading, instantaneous metering is another form of open-aperture metering.

Virtually all currently made cameras offer open-aperture metering but can also meter stopped down when necessary.

Some cameras operate the viewfinder exposure display in exactly the same way whether metering wide open or stopped down. Others meter differently when stopped down. Operating the same way is slightly more convenient.

SHUTTER PRIORITY AND APERTURE PRIORITY

If you choose shutter speed first, then use whatever aperture is needed for correct exposure, you are operating with *shutter priority*. You do this, for example, when you want to stop motion of a racing car. You decide to use 1/500 or 1/1000 and you won't use any slower shutter speed because you don't want image blur.

If depth of field is the most important consideration, you set aperture first and use whatever shutter speed is needed for correct exposure. This may require use of a tripod on account of slow shutter speed. Choosing aperture first is *aperture priority*.

With a non-automatic camera, you can operate either way and the methods are usually equally convenient.

PRIORITY OF AUTOMATIC CAMERAS

Automatic SLR's set one of the two exposure controls for you, *after* you have set the other one manually. Priority is built-in and normally cannot be changed.

Automatic SLR's will eventually be designed to give the user choice of shutter priority or aperture priority.

To operate with shutter priority, an automatic camera requires a special lens, designed so the camera mechanism can change aperture size

If you are using stopped-down metering, or if you have stopped-down the lens to see depth of field, the viewfinder image becomes darker as you select smaller aperture. At times this makes viewing difficult.

With full-aperture metering, the viewfinder image stays bright even though you are setting the lens aperture control to make the picture with a very small aperture.

OPERATION OF NON-AUTOMATIC SLR CAMERAS	
SHUTTER PRIORITY	**APERTURE PRIORITY**
1. Focus on scene	1. Focus on scene
2. Set shutter speed	2. Set aperture
3. Set aperture	3. Set shutter speed

OPERATION OF AUTOMATIC SLR CAMERAS
SHUTTER PRIORITY
1. Focus
2. You set shutter speed
3. Camera sets aperture
APERTURE PRIORITY
1. Focus
2. You set aperture
3. Camera sets shutter speed

MATCH-NEEDLE: One needle moves when you change shutter speed, the other when you change aperture. When the two needles are aligned, exposure is correct according to the camera's built-in meter.

STOPPED-DOWN: Some cameras have a special index mark for stopped-down metering. When the moving needle is aligned with the index mark, exposure is correct. Some cameras use a match-needle display whether metering wide open or stopped down.

NEEDLE CENTERING: This is a very simple and easy-to-read display. When the needle is centered in the slot, exposure is OK. If the needle is above center, you are overexposing. Below center means underexposure.

AUTOMATIC CAMERA WITH SHUTTER PRIORITY: Scale along bottom indicates shutter speed you have selected manually. Moving needle along scale at right shows the aperture being selected automatically by the camera.

AUTOMATIC CAMERA WITH APERTURE PRIORITY AND LED'S: You set lens aperture manually. Row of red LED indicator lights along left side of screen indicates shutter speed being selected automatically by the camera. A light goes on beside selected shutter speed.

MANUAL CAMERA WITH LED DISPLAY: This camera is completely manual, but shows you both shutter speed and aperture as you select them. Row of LED indicators along right side of screen is exposure indicator. Green dot in center means exposure OK. Orange dot means a half-step over or under. Red dot means a step or more over or under.

according to a signal from the exposure calculator in the camera. Naturally, makers of auto cameras with aperture priority supply suitable lenses.

Aperture priority is done by controlling shutter speed in the camera, after lens aperture is selected manually. It requires nothing special in the lens but the camera body must be designed so the exposure calculator controls shutter-open time.

One system has no clear superiority over the other. If you worry most about stopping motion, a shutter-priority camera will be more convenient. If you worry about depth of field, an aperture-priority automatic will be easier to use.

Neither system is completely inflexible. You can check camera settings on the controls or in the viewfinder display so you know what the automatic camera is doing.

With a shutter-priority camera, suppose you select a shutter speed of 1/500 and then notice the camera selecting f-4. If you want more depth of field, start again. Try a shutter-speed setting of 1/60 which is 3 steps slower. The camera will automatically select f-11 which is 3 steps smaller aperture. Depth of field will be improved.

With an aperture-priority camera, suppose you select f-11 and the camera chooses 1/60. This shutter

These are typical viewfinder displays. Nearly every brand and model has a different display, but most are variations of those shown here.

A very high percentage of scenes we photograph are average scenes with 18% reflectance overall. People—but not portraits—grass and foliage, sunlight and shade make an average scene. Photo by Don Burton.

speed is too slow because the subject is moving. Change aperture to *f*-4 and the camera will change shutter speed to 1/500.

Of course it takes a little more time to change one control setting so you force the camera to change the other. Nevertheless you are not completely dominated by either type of automatic camera.

FILM SPEED AS AN EXPOSURE CONTROL

Because your SLR will ordinarily give the amount of exposure requested by the film-speed setting, changing the setting is a way of changing the amount of exposure.

If, by testing or experience, you determine that a particular scene should have one step more exposure than your camera would normally give, you can cause that to happen by reducing the film-speed setting to half.

The film-speed dial should always be set *exactly* on a marked number or dot. Refer to the table on page 17 for the film-speed numbers represented by dots on the camera control.

Examples: You are using ASA 125 film and want to set the camera so it gives one step more exposure than normal. 125 divided by 2 is 62.5 but that setting is not available. Set to ASA 64.

You are using ASA 25 film and want to set the camera so it gives one step less exposure than normal. Multiply film speed by 2 and set the dial to 50.

EXPOSURE INDEX (EI)

ASA film speed has a particular meaning. It is the official speed rating published by the manufacturer of the film. If you use some other speed rating, you are not using the ASA number. When you use some other speed setting, the setting is called an *Exposure Index* (EI).

AN AVERAGE SCENE

The brightness of an illuminated object depends on how much light falls on the object *and* how much light the object reflects. Black cloth reflects about 3% of the light which falls on it. White paper reflects about 90%. These percentages are called *reflectance* or *reflectivity*.

An average outdoor scene reflects about 18% of the light illuminating the scene. Some parts reflect more, some less, but on the average the entire scene reflects 18% of the light.

Within its field of view, an exposure meter doesn't "see" individual objects and doesn't recognize bright spots or dark spots. It's as though it takes light from the entire scene, mixes it together thoroughly and then takes the reading. This "mixing" idea is called *integrating* the light.

The meter responds to the average or integrated amount of light.

A gray card that reflects 18% of the light looks like an average scene to an exposure meter. The inside covers of this book are approximately 18% gray.

When average outdoor scenes are photographed in color, all of the colors average out to gray *and* the scene reflects 18% of the light. Therefore an 18% gray card simulates an average scene whether photographed in color or b&w.

NON-AVERAGE SCENES

Most outdoor scenes with some dirt, rocks, foliage, sky and people at medium or far distances are average.

If there is a lot of sky in the scene, it isn't average because the sky is brighter than 18% gray. If the terrain is white beach sand or snow and a lot of it is visible to the meter, the scene isn't average. If you are taking a close-up portrait of a person with light skin, it isn't average because light skin typically reflects about 36% of the light. Man-made surroundings such as buildings and interiors are average only if they happen to reflect 18% of the light.

Because film speeds and exposure meters are based on shooting average scenes, you can't believe your exposure meter when it is measuring non-average scenes.

EXPOSURE-METER SENSITIVITY PATTERN

You will use your camera more intelligently if you know the sensitivity pattern of the exposure meter. There are several different patterns.

Full-Frame Averaging—This is the "Plain Jane" of exposure meters. The meter responds equally to everything in the frame, or nearly so. A bright spot in the corner will have about as much effect as a bright spot in the middle of the scene being measured.

Center-Weighted Metering—Because the subject of interest is usually placed near the center of the frame, center-weighted meters pay more attention to the center than the edges and therefore give more "weight" to brightness in the center of the scene. A bright spot near the edge *will not* affect the meter as much as a bright spot in the center.

Center-weighting solves two common shooting problems. It tends to ignore bright sky above and behind your subject so you are less likely to get a false reading. It also tends to ignore bright foregrounds such as sand or snow.

Bottom-Weighted Metering—Bottom-weighted exposure meters are more sensitive to the center and below center of the frame. They are based on the idea that the most common exposure problem is bright sky and therefore tend to ignore the sides and top of the scene.

Bottom-weighted metering is only bottom-weighted when you are holding the camera normally for a horizontal frame. Turn the camera to shoot a vertical frame and it becomes side-weighting—either left-side or right-side, depending on which way you turn the camera.

It's very important to remember that when using a camera with bottom-weighted metering.

Semi-Spot Metering—Light for exposure measurement is taken from a small circular or rectangular spot in the center of the viewing screen. The definite measuring area is marked on the viewing screen. No other part of the frame affects the meter so you know *exactly* what part of the scene is being measured.

You have more control of exposure with semi-spot metering but you have to understand it and realize the reading will be determined by light coming from the small area being measured.

Dual-Metering—Some SLR's offer two kinds of metering, selectable by a switch. This is usually semi-spot in one position of the switch and center- or bottom-weighted in the other.

Some cameras change the metering pattern depending on which lens you have installed. These measure a larger part of the scene with wide-angle lenses than with telephoto lenses. The camera instruction manual should show the meter-sensitivity patterns for different lenses.

Some cameras have exposure-measuring systems which compensate electronically for backgrounds which are unusually bright or dark.

Full-frame metering responds uniformly to light anywhere in the frame.

Center-weighted metering has 100% sensitivity only in the center of the screen. Light farther away from center has proportionately less effect on the reading.

Bottom-weighted, or lower-center metering responds to the middle and lower portion of the frame. This is done to reduce sensitivity to sky backgrounds.

Semi-spot metering responds to light only in a defined small area at the center of the screen. Light outside this area has no effect on the reading.

SUBSTITUTE METERING

With any kind of exposure-meter-sensitivity pattern, the best trick in your bag is *substitute metering.* If there is any doubt about what the meter is seeing, or if there is any doubt about whether or not the area being metered has average reflectance, meter on a substitute surface with known reflectance. Be sure the substitute metering surface is in the *same light* as the scene you intend to photograph.

The ASA film-speed rating system, and the exposure calculator in your camera are both based on measurement of average scenes with 18% reflectance. Therefore a very good substitute measuring surface is a gray card with 18% reflectance —known to its fans as an *18% gray card,* or just a gray card.

Kodak publishes gray cards in several forms, all carefully controlled to have 18% reflectance. These are available at your friendly local camera shop. The inside covers of this book are printed approximately 18% gray and should be close enough for most photography.

How to Use a Gray Card—Put the card in the same light as the scene or subject to be photographed. You can do it at the subject location, or nearer the camera if the light is the same. In sunlight, for example, you can hold the card in front of the camera if the scene is also sunlit.

Angle the card so you don't see any glare from its surface. Surface glare will not be 18% reflectance.

Have the card close enough to the camera, or vice-versa, so the card fills the viewfinder, or nearly so. This eliminates any problem due to the meter-sensitivity pattern. If the meter sees *only* the gray card, that's all it meters—no matter what kind of weighting it has.

Meter on the card and set the camera exposure controls. Remove the card, or point the camera at any scene in the same light and make the exposure without changing the camera exposure controls. Often the viewfinder display will show incorrect exposure when you do this. If so, that *proves* the scene is not average because an average scene will meter the same as a gray card. It also proves how canny you are to use the gray card. Don't change the camera controls.

Metering on Skin—Light skin typically reflects about 36% of the light, one step more than 18% gray. Most palms are fairly light. You can check yours by metering on it, then metering on a gray card and comparing the readings.

You can do substitute metering on your palm by holding it in front of the lens, in the same light as the subject to be photographed. Meter and then increase

If a scene does reflect the average amount of light—18%—then it doesn't matter if you meter on the scene or on an 18% gray card in the same light.

Light skin reflects about one step more light than 18% gray. Take the reading, then open up one step.

This sky background will "fool" any of the metering patterns shown earlier. Even center-weighted and semi-spot will read sky background. You can meter on sky, then open up 1-1/2 or 2 steps. You can move close, meter on light skin, and open up 1 step. For this shot, I metered on the grass nearby, in an area illuminated by sunlight. Metering on a gray card would have given about the same result. With b&w film, exposure corrections can be made during printing but I think it is best to get a good exposure on the negative.

exposure by one step more than the display recommends. Here's why: If you set the controls as the camera exposure calculator suggests, whatever the exposure meter sees will record as 18% gray. A palm with 36% reflectance *should* record one step brighter than 18% gray. Therefore take the reading and then increase exposure one step either by opening aperture or increasing shutter-open time.

To Make a Portrait Against the Sky —If you meter on a light-skinned face against the sky, nothing in the scene has average brightness. Light skin is brighter than 18% gray and sky is brighter than skin. If the sky occupies a lot of the metering area, it will dominate the meter reading. If you follow the exposure meter's suggested settings, sky comes out gray and skin comes out very dark.

Move close so your subject's skin fills all or most of the frame. Meter, open up one stop, back up if you need to for good picture composition, make the exposure.

Metering against White—Product

photography for advertising and technical manuals is often done against a white background. Sometimes you can't avoid metering on a lot of white area. For example, you are photographing a paper clip on white paper.

White paper or cloth typically reflects about 90% of the light. Because the exposure meter assumes everything out there is 18% gray, it will recommend an exposure setting that is 5 times too little. 90%/18% = 5.

When metering with a lot of white background in view, divide the recommended shutter-speed setting by 5 and then use the closest setting on the control. Or open aperture a little more than 2 stops— 2-1/2 will do.

Metering against Black—This is the reverse of metering on white. If black dominates the metering area, take the reading and then close down by about 2 stops.

Metering on Terrain—An old-fashioned photographic trick when shooting people against sky is to point the camera downward to take

the reading—so the meter sees less sky and more terrain. Set the controls and then move the camera up again to take the picture. This works just as well now as it did in the old days. It's another form of substitute metering.

Many common surfaces have approximately 18% reflectance. Get acquainted with them and you always have something nearby to use for metering when an unexpected event occurs—even if it's a flying saucer glowing against purple sky.

Use a gray card for comparison and take readings in sunlight on brown dirt, grass whether it's green or not, weeds, foliage, gray-colored concrete, weathered asphalt, clothing a little darker than caucasian skin, paint on a medium-toned building or car, brick walls, stone walls, your dog, and whatever else you see. You'll find most of these have very nearly 18% reflectance. You can meter on any of them and make good pictures in difficult situations. Learn to do substitute metering and it will become your standard method.

Metering on Dark Skin—Dark skin comes in many shades. Some is very close to 18% reflectance. With a little practice, you can judge with your eye and make exposures accordingly.

Here's your friendly neighborhood substitute metering surface. Grass, brown dirt, old paving, foliage and rocks, alone or in combination usually have a reflectance surprisingly close to 18%.

Metering on a White Card—The back side of Kodak gray cards is 90% white. So is any other piece of white paper or cloth. Sometimes, when metering in dim light, you don't get enough light reflected from an 18% surface to measure accurately. Use a white surface and get 5 times as much light. Take the reading, then increase exposure by a factor of 5. Multiply shutter-open time by 5 and use the nearest setting, or open up by 2 stops or a little more.

RULES FOR SUBSTITUTE METERING	
Meter on an 18% reflectance surface	Follow exposure meter recommendation
Meter on a *brighter* surface	Use *more* exposure.
Meter on a *darker* surface	Use *less* exposure
Meter on white	Use 5 times as much exposure
Meter on black	Divide recommended exposure by 5
Meter on light skin	One step more exposure

OVERRIDING AN AUTOMATIC CAMERA

When you do substitute metering with an automatic camera, there's a problem. As soon as you move the camera so it no longer sees the substitute metering surface, the reading changes and the camera automatically changes the exposure setting obtained from the substitute metering surface. You need some way to force the camera to hold that setting while you point to the scene and make the exposure. There are several ways.

Some cameras have a special *memory-hold* button. While metering on the substitute surface, depress the button to lock the exposure setting. Then point at the scene you intend to shoot and make the picture without releasing the memory-hold button.

With some automatic cameras, the exposure setting is locked in when you depress the shutter button halfway. If so, depress it halfway while metering the substitute surface. Hold it that way while you point at the scene you intend to shoot and complete the shutter-button stroke.

Some cameras memorize the exposure setting when you start the self-timer. If so, meter on the substitute surface and start the self-timer. While the timer is counting down, move the camera to the scene you intend to shoot and wait until the timer clicks the shutter. Hope the subject will be doing what you want when the shutter clicks.

Meter the substitute surface with the camera set for automatic operation. Notice the camera exposure setting. Take the camera off automatic and set the controls for the same exposure. Then point at the scene and shoot the picture.

METERING THE SCENE DIRECTLY

Most of us took our first photography lessons from simple pocket cameras with few controls. These cameras taught us to meter the scene we intend to shoot, composed just as we intend to shoot it. Substitute metering is never considered and can't be done anyway with a simple camera.

SLR manufacturers preserve this grand tradition in camera instruction booklets. They explain, more or less, how to use the type of metering in the camera. Substitute metering is rarely mentioned, even for cameras with a memory-lock control intended for substitute metering.

Of course you will get a good exposure if you meter an average scene directly. Most scenes are average—so most pictures are successful. Ambitious photographers seek out non-average scenes. If these are metered directly, you must make some compensation by changing exposure according to the scene, or you will get a bad exposure. This depends on what kind of metering you have.

EXPOSURE-FACTOR CONTROLS

Some automatic cameras have a control intended to correct exposure for non-average scenes while you are metering directly on the

This is an average scene. With people in view, but not close-ups, it would still be average. With most camera metering systems, you can meter it directly and shoot at the meter recommendation. With a semi-spot meter, avoid metering on the bright reflection in water. Meter on the grass in the foreground, or on the tree reflection in the water.

This scene will meter satisfactorily with any system. It was shot with a semi-spot meter held exactly as shown. The meter took the reading from foliage illuminated by sunlight but with shadows under the leaves and below the tree. Part of the reading was from the distant wall. Exposure is satisfactory.

These numbers are *factors*, meaning normal exposure is multiplied by the indicated number. If you choose 1/4X, you will get 1/4 as much exposure, or 2 steps less. 1/2X is one step less. 1X does not change exposure. 2X is one step more and 4X is two steps more.

If you set this control to change exposure for a shot, you must remember to set it back to 1X or 0. If you don't, the rest of the film roll may be incorrectly exposed.

OTHER WAYS TO TAKE CHARGE OF AN AUTOMATIC CAMERA

You can fool an automatic camera by dialing in a different film speed. If you want one step more exposure than the camera would normally give, change the film-speed to half its former setting. To get one step less exposure, double the film-speed setting.

After making the shot, be sure to return film speed to the correct

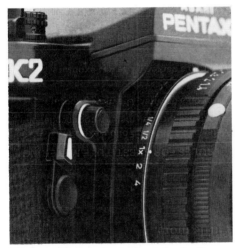

scene, with the picture composition you intend to shoot. These are called *exposure-factor controls.* They command the camera to use more or less exposure than it would if allowed to set exposure without any help from you.

An exposure-factor control requires photographic judgment on your part. If the background is bright and a lot of it is in the metering area, set the control to give more exposure. If background is dark and there is a lot of it in the metering area, set the control to give less exposure.

Typical exposure-factor controls can be set to give 1 or 2 steps of exposure change, either increase or decrease.

One way of labeling this control is:

−2, −1, 0, +1, +2

These numbers are exposure steps. At the 0 setting, exposure is not changed.

Another way of labeling the control is:

1/4X, 1/2X, 1X, 2X, 4X

Bottom-weighted meter, with camera turned for a vertical frame format, becomes side-weighted. Sky background causes underexposure.

Exposure-factor controls are basically another way of adjusting the film speed setting, persuading an automatic camera to give more or less exposure because it "thinks" the film is faster or slower than it really is. These controls are located with the film-speed dial—on lens mount or camera top, depending on brand and model.

number or you will change exposure for all the remaining frames on the roll.

Another way is to take the camera off automatic and use it under manual control to set exposure any way you want it.

Depending on brand and model, automatic cameras behave differently when switched to manual operation.

FIND OUT WHAT YOUR AUTOMATIC CAMERA DOES ON MANUAL

When set for manual control of exposure, some automatic cameras continue to operate the display as though the camera were still on automatic. Changing the camera exposure controls has no effect on the exposure display in the viewfinder. If your camera is like this, consider the exposure display as a separate exposure meter telling you what it thinks should be correct exposure. Set the controls any way you want. You have to take the camera away from your eye and look at the controls to see where they are set, although one of the exposure controls may be properly displayed in the viewfinder.

Other automatic cameras switch the display so it shows the effect of manual changes of the controls. If you compensate an exposure by giving one more step than the meter recommends, the display will show one step of overexposure but you see the effect of control changes. If the display indicates control settings, they will be the ones you have set, not the ones the meter recommends.

To see what your camera does when switched to manual, first observe the display when it is operating on automatic. Then change to non-automatic and adjust shutter speed and aperture manually while observing the display to see what it does.

BACKLIGHTING

Interesting photos result when the subject is illuminated from behind. In portraiture it creates a halo around the hair and gives a

Outdoor portraits in sunlight are a problem unless the subject is completely backlit. Sunlight from the front causes squinting. From the side it causes dark shadows. Here, shadows were reduced by a white reflector on the right side, just out of camera view. You can see reflections of the reflector in subject's eyes.

When face is completely backlit, you can get an acceptable portrait by exposing for the face. This overexposes sky and causes a color change in color slides. The sky will be light or "washed out."

lovely soft light on facial features. In sports and action photography, high drama is created by shots like a pole vaulter against the sun or a racing car coming out of a luminous cloud of dust.

Usually it is best not to let the sun appear directly in the image. It will cause reflections and sometimes multiple images of the lens aperture—a technical accident that people excuse as an art form. Try to put the sun directly behind the subject.

NEVER LOOK THROUGH OPTICS OF ANY KIND DIRECTLY AT THE SUN. THIS INCLUDES THE CAMERA VIEWFINDER. PERMANENT DAMAGE TO YOUR EYE MAY RESULT.

Other forms of backlighting include a person inside a room but in front of a window, a person against the sky, and backlighting deliberately arranged with floodlights or flash.

There is one sure way of getting a good exposure. Move in close to the subject and take a reading

excluding the backlighting. For a portrait, move in and take a reading on the subject's face.

If you must take the exposure reading with the backlight entering the meter, the rule is to give 1 or 2 steps more exposure than the meter suggests.

BRIGHTNESS RANGE OF SCENES

Between the brightest and darkest parts of a scene are a certain number of exposure steps.

If a scene is uniformly illuminated, such as by the sun, the amount of light coming toward the camera from each part of the scene is determined only by the reflectance of that part.

Sometimes it helps to measure the brightness range of a scene you intend to photograph. If so, disregard areas where you don't intend to record details. For example, if you pose a subject at the mouth of a cave, the interior of the cave will be so dark that no details show. It's OK to let that go completely

Not wishing to wait around for the setting sun, crafty Josh Young manufactured a golden sunset by using a yellow #85B filter over the camera lens. Exposure reading was made on the ocean surface, so backlit subject is recorded in silhouette.

black in the picture. Measure the darkest area with details you want to see in the picture.

Reflections from polished surfaces, such as chrome in sunshine, are usually so bright they obscure all details of that surface. It's OK to let such areas go completely white in the picture. Measure the brightest area with details you want to see in the picture.

Scenes with Uniform Illumination—Suppose a scene has objects in it with every reflectance from 3% to 90%. If the scene is uniformly illuminated, the brightness of each object is proportional to its reflectance.

It's easy to figure how many exposure steps there are in the scene because each time the reflectance doubles, the light doubles, and that's one step:
3%, 6%, 12%, 24%, 48%, 96%

There are about 5 exposure steps to be recorded on film. Because the range from 3% to 90% is very nearly the largest possible range of reflectances, 5 exposure steps is the largest brightness range you will ever see in any scene under uniform illumination. Unless, of course, there are light *sources* in the scene.

Scenes with Non-uniform Illumination—If a scene is not uniformly illuminated, such as partly in sunlight and partly in shadow, the brightness range is increased by the difference in illumination.

Suppose the highly-reflective part of the scene is in sunlight and reflects 90% but the part of the scene with 3% reflectance is in shadow. If the shadow is 2 steps less bright than sunshine, the 3% reflectance will reflect 2 steps less light than it would if it were in sunshine. Therefore a shadow on part of the scene causes the brightness range to become 7 exposure steps rather than 5.

Dark shadows can be 4 steps less bright than direct lighting. This raises the scene brightness range to 9 steps. Most films won't record more than 7 steps without special processing.

Please notice: For a scene to have the range of brightnesses just mentioned, the scene itself must have the maximum range of reflectances. This is uncommon, but possible.

HOW TO MEASURE THE BRIGHTNESS RANGE OF SCENES

Put your camera close to the brightest part, so the exposure meter sees only that part. Balance the exposure display and notice the settings. Don't cast a shadow where you are measuring.

Then do the same thing at the darkest part of the scene where you want to record details. The scene-brightness range is the number of exposure steps difference between the two readings.

If you have an accessory meter, it may be easier to use for these measurements than the one in your camera.

Example: The darkest reading is f-2.8 at 1/60; brightest is f-11 at 1/60. Brightness range is 4 steps.

With color-slide film you get what you shoot. These are two exposures of the same scene—the inside lobby of a Hyatt hotel. Camera was hand-held, pressed against wall at right.

Nothing in this scene has unusually high or low reflectance. Color-slide film recorded details in sunlight and in open shade where courtyard is open to the sky. Film cannot cope with dense shade under the overhanging roofs.

FILM EXPOSURE RANGE

Depending on film type, there is a certain number of exposure steps the film can record and still show some detail. If the brightness range of the scene exceeds the film's *exposure range,* you lose detail in the shadows—or highlights—or both.

All general-purpose films have enough exposure range to record any scene under uniform illumination. This assumes there are no light sources in the scene, but we normally don't try to record detail in a light source anyway.

The exposure-range problem always results from non-uniform illumination of the scene. However non-uniform illumination is very desirable because it casts some shadows and give surface modeling and apparent depth to a photo. Good photography often requires *controlling* the light variation across the scene.

Here is the *approximate* number of exposure steps you can record on different types of film:

APPROXIMATE EXPOSURE RANGE OF FILM

Black & White	7 steps
Color-Slide Film	6 steps
Color-Print Film	5 steps

This assumes normal processing of film, as done in commercial labs.

FILM LATITUDE

Some films are advertised as having "wide latitude" which really means "wide exposure range." Latitude exists only when the exposure range of the film exceeds the brightness range of the scene. If the film can record 7 steps, but the scene has only 3 steps of brightness, there is a latitude of 4 steps.

Film latitude is not a property of film alone. It results from a combination of film capability and scene-brightness range.

PRACTICAL SHOOTING SUGGESTIONS

You can't always control the light, but sometimes you can. Use a reflector, a flash, or a flood lamp to put light in the shadows if you need to.

Variations of reflectance among parts of the scene and variations in lighting across the scene oppose each other. If everything in the scene reflects about the same amount of light, then lighting across the scene can vary a lot. If there is a wide variation of reflectances in the scene, then lighting should be fairly uniform.

If the low-reflectance parts of a scene are in bright light and the highly reflecting parts are in shadow, the overall scene may have a low brightness range and use only a few exposure steps on the film. If the highly reflecting parts are in bright light and the low-reflectance parts are in shadow, the exposure range needed may exceed the film capability.

For average scenes, follow these rules:

With color-print film, the illumination should be nearly uniform across the scene.

With b&w or color-slide film, part of the scene can be in shadow that isn't very dark, such as the shade of a tree.

With all color films, reproduction of vivid colors takes away some of the film's capability to record a wide brightness range. If there are vivid colors in the scene, lighting should be more uniform.

By measuring scene-brightness range, and then carefully examining the pictures you make, you can learn how to cope with all these variables.

CENTERING THE EXPOSURE

Film with an exposure range of 7 steps can record a scene with a brightness range of 7 steps, *provided* the exposure from the scene is *centered* on the exposure range of the film. That means it doesn't hang over either end of the film's range.

The basic rule of exposure is to set the camera controls so the middle tone of the scene becomes the middle tone of the film's exposure range.

All of the metering methods discussed so far will do that. The clearest example is placing a gray card in the scene and metering on the card. Because 18% reflectance is the middle tone of both scene and film, metering on the gray card will place that card exactly where it belongs on the film's exposure range. All of the other tones in the scene, both light and dark, will fit on the film's exposure range.

Naturally the same thing happens if you meter on a medium tone in the scene; if you meter on an average scene; if you do substitute metering correctly; or if you meter a non-average scene and make proper exposure compensation.

The only assumption is that the brightness range of the scene does not exceed the exposure range of the film.

Tan dog on beige carpet is a scene with narrow brightness range. On any kind of film it can be moved up or down on the tonal range of the film, within limits, without losing detail into white or black. Here the scene is exposed at each of two steps above and below normal exposure.

EXPOSURE FOR SCENES WITH NARROW BRIGHTNESS RANGE

If you are shooting a scene with a narrow range, such as a gray cat on a medium-toned pillow; a blonde model against a light-colored drape; or a weathered gray building against a cloudy sky, you can place the brightnesses of the scene anywhere within the exposure range of the film. You can have all shades in the picture turn out very light, medium, or very dark—the choice is based on the artistic effect you want to create.

For true-to-life tones, meter on an 18% surface in or out of the scene, but in the same light. After doing that, you can control tone placement on the film in your camera by changing exposure. To make all tones darker than true-to-life, decrease exposure 1 or 2 steps. To make them lighter, increase exposure 1 or 2 steps.

If you have color-slide film in your camera, you get only one chance to expose the scene properly. Color-slide film is converted into a positive image by subsequent processing in a photo lab but this processing does not allow any way to correct or change tone placement in the image. What you see is what you shot.

With negative film in the camera—either color or b&w—there is a second opportunity to change tone placement. It can be done when printing the positive image. While printing, exposure can be changed either to correct a bad exposure of the negative or to shift tone values up or down the scale for artistic reasons. This is easier to do with b&w film.

Shifting tone placement during printing of b&w film and expanding or compressing the tone range by controlling development of the negative has become popular among serious b&w photographers. These techniques are usually called *zone system,* of which there are several versions.

EXPOSURE FOR SCENES WITH A WIDE BRIGHTNESS RANGE

If the scene-brightness range exceeds what the film can accommodate, you can't get everything on film.

If you center exposure so the middle tone of the scene becomes the middle tone on the film, the scene will "hang off" each end of the film's exposure range. You will lose some picture detail in bright areas because these areas become solid white. You will also lose some detail in the shadows because the shadows become solid black. You may not want it that way.

To favor shadow detail, meter on a middle tone in the shadow. This "saves" detail in the shadows, but loses a lot more at the other end.

If highlight detail is important, meter on a middle tone in the brighter light. You will save the highlights but lose more detail in the shadows.

The basic rule of metering still applies:

Meter on the brightness you want to appear as a middle tone on the film in your camera.

With color-slide film, you get from the lab the same exposure you originally made in the camera, so you must do any tone-placement when you shoot the picture.

With negative film, there is an opportunity to shift tones up or down the scale during development and printing. However when the scene-brightness range is equal to or greater than the film's exposure range, original exposure is critical because it determines the range of details that are recorded on the negative, between black and white.

When part of the scene is in bright sunlight and part in deep shadow, normal developing and "straight" printing cannot cope with the brightness range, even on b&w film. This negative was printed three ways: For shadow detail, for highlight detail, and halfway between. Except for the dark surface in the upper-right corner, detail is everywhere on the negative. A darkroom person could print this negative by holding back light where there is too much, thereby getting most of the detail in the shadow *and* in the highlight. Printing control techniques are described in H.P.Books' volume, *Do It In The Dark* by Tom Burk.

EXPOSE FOR THE SHADOWS

An old-time rule among photographers shooting black-and-white film is:

Expose for the shadows and let the highlights fall where they may.

This means expose for visible detail in shadows where the viewer *expects* to see detail and don't worry about highlight exposure. There's no handy rule for doing that because it depends on how dark the shadows are and what's in there. As a beginning, try metering on a medium tone in the shadows.

With black-and-white film, this is a good rule because viewers of b&w photos are usually more disturbed by loss of shadow detail than loss of highlight detail.

A better procedure is to control lighting so you don't have to sacrifice detail at either end.

When your subject is in shadow, and you can't change the situation, expose for the shadowed area and let the background fall where it may. If you are shooting negative film, some correction can be made in printing. If you are shooting slides, this is what you get.

EXPOSE FOR THE HIGHLIGHTS

Color-slide and motion-picture photographers using color film have a different rule, sometimes referred to as *key-tone metering.*

In the movies, it just doesn't look right for the female star's face tone to change from scene to scene. This may happen if the entire scene is metered because of reflectance changes from scene to scene. Movie makers use special *incident* light meters to solve this problem.

In a color-slide show, it also doesn't look right for skin tones to vary from slide to slide, or for your car to have a different shade at every stop on your vacation.

You can solve this problem by putting your favorite person in every photo and metering on a skin tone. Or you can put your car in every shot and meter on it. Or you can put that super-useful gray card in every scene and meter on it. Then your favorite wife or car can get some rest once in a while. And the lowly gray card becomes a *key-tone-metering device.*

INCIDENT LIGHT MEASURING

Accessory light meters are made in two types. Reflection-type light meters are pointed at the scene and measure light *reflected* by the scene. Incident light meters are placed at the scene, pointed toward the camera. They measure light falling on the scene—*incident light.* Some meters can be used both ways.

Here's why the movie maker uses an incident meter. As the star moves from scene to scene, with a different lighting setup for each scene, *one thing* that never changes is her skin reflectance. If the skin looks brighter or less bright to the camera, it's because there is more or less light. Straight thinking suggests measuring the amount of light falling on the scene and adjusting the camera accordingly. Then skin looks the same every time.

Your SLR camera has a built-in meter which you point at the scene. Therefore it is a reflection-type meter. Here's how to convert it into a professional incident meter:

Put a gray card in the scene. Meter on it. A gray card always reflects 18% of the light. If you get a brighter reading from the card, it's because the incident light is brighter. When you adjust exposure while metering on the gray card, you are really setting up for the amount of incident light.

EXPOSURE BY AVERAGING READINGS

This method is often recommended by photo writers. I think it is just to make the whole deal difficult.

Meter on the brightest and darkest parts of the scene and note the two readings. Average them by using the exposure step that is halfway in between.

Example: At a shutter speed of 1/125, the brightest part of the scene calls for f-11 and the darkest part calls for f-2. The difference is 5 steps. A setting midway in between will be 2.5 steps from either end. Set aperture halfway between f-4 and f-5.6.

This automatically puts the middle tone of the scene in the center of the film's exposure range. It's the same as metering on the middle tone. It works on scenes which don't have a middle tone because you don't actually meter on it.

However some exposures may not be realistic. If you shoot a scene with only middle and dark tones, a realistic print should show only middle and dark tones. Exposing that scene by averaging the highest and lowest meter readings will make all tones brighter than real life.

For Math Enthusiasts—You can't average two f-numbers by adding them together and dividing by two. That procedure gets the *arithmetic* average, which is incorrect.

Wrong Example: Take the arithmetic average of f-2 and f-8:

$$\frac{f\text{-}2 + f\text{-}8}{2} = f\text{-}5 \text{ which is } \textbf{wrong}$$

The f-number series is a *geometric* series so you have to take the *geometric* average:

$$f \text{ average} = \sqrt{f_a \times f_b}$$

Right Example:

$$f \text{ average} = \sqrt{f\text{-}2 \times f\text{-}8}$$
$$= \sqrt{f\text{-}16}$$
$$= f\text{-}4 \text{ which is } \textbf{correct.}$$

I've never found any good reason to shoot by averaging readings and consider it a photographic curiosity. Try it if you wish.

INCREASING COLOR SATURATION IN SLIDES

Color slides are normally viewed by projection in a darkened room. Use key-tone metering to prevent visible absurdities from slide to slide—such as instant sun tan.

Be very precise in metering and exposing color slides because serious under- or overexposure causes color changes which don't look right. Usually if you get exposure correct within a half-step your slide looks fine when projected and the colors look OK.

Color Saturation—If you take vivid-red poster paint and mix in some white, you get a lighter shade which we say is *less saturated.* Mix in still more white to get a pastel pink and you have even less saturation.

If you could start with pink and take out white until the color is a strong red, you would be increasing color saturation.

Color slides become more saturated with less exposure. Many photographers like the effect and customarily give a small amount of underexposure to color slides. A handy way is to set the film-speed dial to the next higher setting.

Intervals on the film-speed dial are 1/3 steps, so the next higher speed setting gives an underexposure of 1/3 step. Or you can get a half step by changing the aperture control one click. Using more than a half step is risky.

When shooting for publication in magazines or books, increasing color saturation by mild underexposure of slides is common. Picture brightness can be restored in the printing process and the saturated colors look nice.

WHAT THE FILM LAB DOES

If you send *negative* film—color or b&w—to a typical volume commercial film processor, it will receive standard development. The prints will be made on automatic printing machines. People at the lab *may* look at the prints afterwards, but nobody examines the negatives and adjusts the printing machine for each individual shot.

Automatic printers are designed to work well on average scenes. They believe every scene reflects 18% of the light and all colors in a scene average out to gray. Therefore they can spoil your shot of a non-average scene even though you did a perfect job of getting it on the negative.

For example, you make a good exposure of a subject against a white background. The machine does not believe all that white background so it converts it into middle gray when making the print and your subject gets lost in gloomy darkness. If you shoot against a dark background, the automatic printer will make the background gray and everything else will be too light.

The machines are limited in the amount of color change they can make to get all colors to average out to gray. Nevertheless if you shoot a scene that is mainly blue, or mainly any color except gray, you are likely to get back incorrect colors.

An improvement offered by some commercial labs is called *video processing* or *video-analyzed* prints. An operator sits at a machine which uses a TV picture tube to display a picture derived electronically from your negative. The operator adjusts controls until the picture looks OK. Then he pushes a button and a print is made to look about the same. If the operator's judgment is good, as it usually is, you get a good print. If he recognizes that you photographed your wife against a snow bank, you will get back white snow.

None of this applies to color slides. Slides are developed and changed to a positive image automatically by a process called *reversal.* The process is standardized and there is no opportunity to change colors or brightness. What you get is what you shot. For this reason, color slides are best for making tests of your equipment and technique.

SUBJECT FAILURE

The photo-processing industry uses an interesting term to describe negatives of non-average scenes that can't be printed on unsupervised automatic equipment.

They say it's a case of "subject failure," meaning the subject fails to meet the requirements of the printing machine because it doesn't average out to 18% gray!

If you go around shooting subject failures, don't send your negative film to a volume processor. Of course you can send your slides.

WHERE TO GET NON-AVERAGE NEGATIVES PRINTED

Send your negs of non-average scenes to a custom processor, or develop and print them yourself.

There are two kinds of custom labs. Some offer video-analyzed color prints. These can be excellent if the video operator makes the picture the way you intended.

The other kind advertises "hand-made" prints which means the lab person holds your negative in his hand, uses his best judgment in setting the printer for exposure and color balance and makes the print. If it doesn't look right, he makes another with different settings. If his idea of a good print agrees with yours, you will like the result. If not, they may remake the print for you if you send it back and explain what you want.

RECIPROCITY FAILURE

Films are designed to work properly over a certain range of light intensity during the exposure. If there is more or less light on the film than its normal range, film sensitivity is *reduced.*

This is a violation of the reciprocity law, therefore we call it *reciprocity-law failure,* or just *reciprocity failure.*

Even though reciprocity failure is caused by too much or too little light, the best clue to warn us of it is exposure *time.* If the exposure time is unusually short, the light must be unusually bright. If a very long time is indicated, the light must be very dim.

For most general-purpose films, exposure sensitivity is normal if shutter speed is between 1 second and 1/1000 second, inclusive. *There are exceptions.*

If you operate in the range of reciprocity failure all films will be underexposed unless you make a correction. Color films will be underexposed and may also exhibit a color change unless you make a correction.

CORRECTIONS FOR RECIPROCITY FAILURE

The basic correction is always *more exposure* than the exposure meter suggests. With color films, a color filter may also be specified to prevent a color change.

Some film manufacturers show reciprocity-failure corrections on the data sheet packed with the film. Others send you the information on request. The film manufacturer's information is the best guide. No rule or formula applies to *all* films. For some films, a change in development procedure is also specified. See pages 133 - 134.

When shooting, always consider the possibility of reciprocity failure. Otherwise you can work hard at getting an unusual or artistic shot and end up with underexposed film and bad colors. Reciprocity failure due to bright light is unusual. In dim light it is very common.

These two photos were made in a slide copier from the same original. A half-step less exposure gives more saturated colors.

BRACKETING EXPOSURES

Bracketing means making several different exposures of the same scene, hoping to get one that is just right.

It's a form of exposure insurance. If the picture is not easy to repeat, or you are not going to be back there again, bracketing is a cheap way to ensure you will have a picture. It is often said, "Film is the cheapest thing in your gadget bag."

HOW TO BRACKET

Form a definite sequence for bracketing. Otherwise it's easy to become confused halfway through the operation, particularly if there is some distraction.

One good way is to plan it all mentally, deciding how many exposures you will make and at what intervals. Then start at the least exposure you plan to give and work up from there in steps.

Example: The meter reading is f-8 at 1/250 and you decide to bracket 3 half-steps above and below that exposure. You decide to do it by changing aperture. Set the camera at the metered exposure, then close

aperture by 3 half-steps. Make the first shot, open up a half-step and shoot again. Continue until you have made 7 exposures. Notice the frame-counter reading before you start and you should never lose track of the number of frames exposed.

Naturally you can bracket with shutter-speed changes, or with combinations of aperture and shutter-speed changes. And, you may want to bracket an even wider range, just to make sure you get that important photo.

WHEN TO BRACKET

It's worth exposing additional frames to assure getting a good shot if:
• The shot is important.
• You traveled a long way or did a lot of work to set it up.
• You have only one opportunity to make the shot.
• There is uncertainty about proper exposure, due to reciprocity failure or anything else.
• You want to see the artistic effect of different exposures.

DOUBLE AND MULTIPLE EXPOSURES

If a subject against a *dark* background is photographed with normal exposure, the film frame can be considered as two distinct areas. The area of the subject is normally exposed. The dark background caused little or no exposure on the film.

A second subject against the dark background can be photographed on the same frame, also with normal exposure *provided* the areas on the film occupied by the two subjects do not overlap.

Now the film frame can be considered as three areas. One for each subject and some still unexposed or underexposed background. Obviously a third subject could be placed in the unused dark background area and normal exposure could be given to the third subject.

The rule for multiple exposures against a *dark* background where

This double exposure is an advertising photo made by Josh Young. Flowers were arranged on black velvet for first exposure, leaving room in the center for the model. Second exposure was model against dark rock. Normal amount of exposure was given each time because there is very little image overlap.

the subjects *do not overlap* is to give normal exposure to each shot.

When subjects do overlap, the situation is different. Normal overexposure of two subjects occupying the *same* area on film amounts to twice as much exposure as that area needs—one step too much. Three overlapping exposures give three times as much total exposure as the film needs, and so forth.

With overlapping subjects, the rule is to give the correct *total* amount of exposure to the film, allowing each individual shot to contribute only a part of the total. If there are two overlapping images, each should receive one-half the normal exposure. Three overlapping images should each receive one-third the normal exposure, and so forth.

This is done by dividing the normal amount of exposure for each shot by the total number of exposures to be made. Please notice: This *does not* require each exposure to be the same. Measure for each exposure, divide by the number of exposures to be made, and give the resulting amount—whether or not it is the same as some other subject requires.

This procedure tends to give normal exposure to the *combined* image on the film, but each individual image is less bright according to how many shots there are. If you make more than three exposures, each individual image becomes pretty dim, but the effect is sometimes pleasing anyway. Also, even though the background is dark, it will get lighter and lighter with successive exposures.

RULES FOR MULTIPLE EXPOSURES
• Dark uncluttered backgrounds are preferable.
• The background gets lighter with each exposure.
• If there is no image overlap, give normal exposure to each shot.
• If there is image overlap, divide the normal exposure for each shot by the total number of shots to be made.

Multiple exposures can be very effective. If you are careful, you can get it just right in the camera. You have more control doing it during printing. Confession: This one was done in the lab. Bill Keller did it using Josh Young's negatives of an *Up With People* cast.

• A handy way to adjust exposure is, multiply film speed by the planned number of shots and set the nearest available speed on the camera dial. Then use the camera normally for each shot.
• Don't forget to reset film speed afterwards.
• You can also adjust exposure by changing shutter speed or aperture.

OPERATING THE CAMERA FOR MULTIPLE EXPOSURES
Cameras prevent accidental double exposures by a mechanical interlock which requires advancing the film before each shutter operation.

The procedure for deliberately making multiple exposures varies among cameras. Check your instruction booklet.

If you are shopping for a camera, some methods are a lot more convenient than others.

Some SLR's have a control which allows multiple exposures—usually a pushbutton. This is very handy. Operate the control each time and shoot as many times as you want on the same frame. The control allows you to operate the film-advance lever to "wind up" the camera for the next shot *without advancing the film.*

Some SLR's require a rather complicated procedure: Hold the film-rewind button depressed, rewind the film partially into the cartridge, then bring it back into position using the film-advance lever. If your camera uses this method, follow the instruction-book procedure exactly.

A short-cut method can be used on most cameras, including those with no "official" method for making multiple exposures:

Tension the film by turning the rewind knob clockwise until *very*

HOW TO ESTIMATE EXPOSURE WHEN YOU CAN'T MEASURE IT

Most SLR's work at one or more shutter speeds even if the camera battery is dead or absent. But the camera exposure meter doesn't work. To estimate exposure settings, follow this step-by-step procedure to get an EV number. Then convert EV to camera settings using the EV table on page 75. When shooting, bracket above and below the estimated exposure.

1. BASIC EXPOSURE FOR FRONT-LIT SUBJECT IN DIRECT SUNLIGHT

ASA	12	25	32	50	64	80	100	125	160	200	320	400	500
EV #	12	13	13	14	14	15	15	15	16	16	17	17	17

For the film speed you are using, start with the indicated EV. Then correct as follows:

2. IF SHADOWS ARE VISIBLE, CORRECT FOR DIRECTION OF LIGHT

Light from side	SUBTRACT 1 EV
Light from Back	SUBTRACT 2 EV

If no shadows are visible, make no correction. Do not apply corrections from both step 2 and step 5 of this procedure.

3. CORRECT FOR ANGLE OF SUN

If Sun Angle is Less Than 45° Above Horizon SUBTRACT 1 EV

4. CORRECT FOR CLOUDS AND HAZE

Clear sky	NO CORRECTION
Sun obscured but shape of sun can be seen and there are light shadows.	SUBTRACT 1 EV
Sun obscured but sky is distinctly brighter in vicinity of sun. No shadows.	SUBTRACT 2 EV
Sky is heavily overcast. Position of sun is not apparent. No shadows.	SUBTRACT 3 EV

5. CORRECT FOR SHADE ON SUBJECT

	Subject in Open Shade (Much of Sky Visible)	Subject in Deep Shade (Little Sky Visible)
Clear sky	SUBTRACT 3 EV	SUBTRACT 4 EV
Clouds or haze but shape of sun can be seen and there are light shadows	SUBTRACT 2 EV	SUBTRACT 3 EV
Heavily overcast	NO CORRECTION	SUBTRACT 1 EV

Do not use correction from Step 5 if you used Step 2.

6. CORRECT FOR REFLECTIVITY OF SUBJECT

If subject reflects more light than average.	ADD 1 EV
If subject reflects less light than average.	SUBTRACT 1 EV

7. FIND CAMERA SETTINGS

Apply all corrections to the basic EV number obtained in Step 1. Then refer to the EV table on page 75 to convert the corrected EV number to camera control settings. This procedure gives an exposure *estimate*. For important shots, bracket one and two steps both ways from the estimated exposure.

slight resistance is felt. Grip the camera so you have a finger free to hold the rewind knob in this position. Don't let it move until you have completed this procedure.

Operate the film-rewind control with another finger and hold it in the rewind position. Operate the film-advance lever as though you were advancing the next frame. Because the film-rewind is held, the film does not actually move in the camera—at least not very much. Your next shot will be on the same frame. Practice this a couple of times without film in the camera because you may run short of fingers.

How To Check Film Registration— With the three-finger method just described, the film may or may not move a bit. You can check your technique: Remove the lens. Set shutter-speed dial on B. Depress the shutter button and hold it to keep the shutter open. Use a pencil to mark a rectangle on the film. Close the shutter. Do the double-exposure trick with your fingers. Open the shutter again. Look for the rectangle you marked with pencil. If it moved, you can see it.

Blank-Frame Insurance — Because the film may move during multiple exposures made by the three-finger method, multiple exposures may overlap the preceding frame or the one following. If you plan the multiple exposure in advance, shoot a blank frame before and after. If you do it on impulse, at least shoot a blank frame after.

Some models surprise you by not advancing the film when you operate the film-advance lever after completing the multiple exposure. The rewind button remains depressed until *after* you operate the film-advance lever, forcing you to make one more exposure even though you don't want to. Make it with the lens cap on and no harm is done.

Cameras with a special multiple-exposure control normally make multiple exposures without film slippage, so blank frames after are not necessary.

WHAT THE FRAME COUNTER DOES DURING MULTIPLE EXPOSURES

If your camera is equipped with a special multiple-exposure control, it may be built so the frame counter does not advance when making multiple exposures. You can make several shots on frame 7 and the counter will not change to 8 until you actually advance the film.

Cameras using multiple-exposure procedures involving the rewind button usually count strokes of the film-advance lever rather than actual movement of the film. If you

With daylight film and no filter, this is the green tint you get when photographing a color-TV screen. A CC40R filter over the lens will give better color. Theoretically you can photograph a TV screen at 1/30 second because it takes the TV set that long to make one complete image. If your camera shutter-speed timer is not exact, you may get a dark band in the picture, such as you can see near the bottom of this one. Shooting at 1/15 is safer because the TV tube should have made two images during that time.

make 3 shots on frame 7, the frame counter will count 7, 8, 9, and then move to frame 10 when frame 8 is ready to be exposed. This is not a major inconvenience when you know about it. Watch your frame counter while making a double exposure and you will see what it does.

At the end of the roll—If the camera disengages the frame counter during multiple exposures, it maintains the correct frame count all the way to the end of the roll.

If it counts film-advance-lever strokes, the frame count will be wrong after the first multiple exposure on the roll. If you make several multiple exposures, it may take 40 or more strokes of the film-advance lever to expose a 36-exposure roll of film.

The frame counter usually has a slip clutch. It will count to 36 or a little higher and then stop counting. You can still advance film until you reach the end of the roll and feel resistance at the film-advance lever. Then rewind.

EXPOSURE VALUE (EV)

A scale of numbers called Exposure Values (EV) identifies definite exposure settings, no matter what combination of aperture and shutter speed is used.

The practical EV range is from −5 to +20. If the exposure controls are set for EV −5, the light is very dim. At +20, the light is very bright. A change of one EV step, such as from EV 5 to EV 6, represents one standard exposure step.

Some camera manufacturers use EV numbers to specify the measuring range of the built-in exposure meter.

Later in this book, I will use EV numbers as a way of stating an exposure setting to photograph a particular scene or subject, such as a lunar eclipse. When you know the EV number you can choose from several pairs of control settings—aperture and shutter speed—according to other considerations involved in making the photo, such as depth of field.

Find possible pairs of control settings in the accompanying EV table.

HOW TO READ THE EV TABLE

EV numbers run along the left, shutter speeds along the top, and f-stops are in the body.

Example: Find EV −6 at the left. Read across the table and note the shutter speeds at the top. This EV can be set three ways: f-2 at 4 minutes, f-1.4 at 2 minutes, f-1 at 1 minute.

Example: Find EV 18 on the left. It can be set six ways including f-64 at 1/60 and f-11 at 1/2000.

The Basis of EV Numbers—The number assigned to each exposure step is arbitrary. EV 0 is f-1 at 1 second, which is easy to remember.

For Math Fans:

$$EV = 3.3 \, \text{Log}_{10} \left(\frac{f^2}{T} \right)$$

f is f-stop

T is exposure time

Don't Be Defeated by the Specs—Some camera instruction booklets

EV NUMBERS & EQUIVALENT EXPOSURE SETTINGS

SHUTTER SPEED

$$EV = 3.3 \, \text{Log}_{10} \left(\frac{f^2}{T} \right)$$

EV	4 min.	2 min.	1 min.	30 sec.	15	8	4	2	1	1/2	1/4	1/8	1/15	1/30	1/60	1/125	1/250	1/500	1/1000	1/2000
−8	f-1																			
−7	1.4	f-1																		
−6	2	1.4	f-1																	
−5	2.8	2	1.4	f-1																
−4	4	2.8	2	1.4	f-1															
−3	5.6	4	2.8	2	1.4	f-1														
−2	8	5.6	4	2.8	2	1.4	f-1													
−1	11	8	5.6	4	2.8	2	1.4	f-1												
0	16	11	8	5.6	4	2.8	2	1.4	f-1											
1	22	16	11	8	5.6	4	2.8	2	1.4	f-1										
2	32	22	16	11	8	5.6	4	2.8	2	1.4	f-1									
3	45	32	22	16	11	8	5.6	4	2.8	2	1.4	f-1								
4	64	45	32	22	16	11	8	5.6	4	2.8	2	1.4	f-1							
5		64	45	32	22	16	11	8	5.6	4	2.8	2	1.4	f-1						
6			64	45	32	22	16	11	8	5.6	4	2.8	2	1.4	f-1					
7				64	45	32	22	16	11	8	5.6	4	2.8	2	1.4	f-1				
8					64	45	32	22	16	11	8	5.6	4	2.8	2	1.4	f-1			
9						64	45	32	22	16	11	8	5.6	4	2.8	2	1.4	f-1		
10							64	45	32	22	16	11	8	5.6	4	2.8	2	1.4	f-1	
11								64	45	32	22	16	11	8	5.6	4	2.8	2	1.4	f-1
12									64	45	32	22	16	11	8	5.6	4	2.8	2	1.4
13										64	45	32	22	16	11	8	5.6	4	2.8	2
14											64	45	32	22	16	11	8	5.6	4	2.8
15												64	45	32	22	16	11	8	5.6	4
16													64	45	32	22	16	11	8	5.6
17														64	45	32	22	16	11	8
18															64	45	32	22	16	11
19																64	45	32	22	16
20																	64	45	32	22

APPROXIMATE EXPOSURE FOR NIGHT SCENES (BRACKETING RECOMMENDED)						
SUBJECT	**ASA FILM SPEED**					
	25-32	50-64	100-125	160-200	320-500	800-1200
Interiors with enough light to read by	EV 5	EV 6	EV 7	EV 8	EV 9	EV 10
Faces in candlelight	EV 2	EV 3	EV 4	EV 5	EV 6	EV 7
Group around campfire	EV 5	EV 6	EV 7	EV 8	EV 9	EV 10
Night sports events	EV 6	EV 7	EV 8	EV 9	EV 10	EV 11
Subject in arc-type spotlight	EV 8	EV 9	EV 10	EV 11	EV 12	EV 13
Stage shows	EV 7	EV 8	EV 9	EV 10	EV 11	EV 12
Brightly lit streets	EV 6	EV 7	EV 8	EV 9	EV 10	EV 11
Floodlit buildings	EV 3	EV 4	EV 5	EV 6	EV 7	EV 8
Electric signs	EV 8	EV 9	EV 10	EV 11	EV 12	EV 13
Christmas lights	EV 3	EV 4	EV 5	EV 6	EV 7	EV 8
Full moon, clear sky	EV 13	EV 14	EV 15	EV 16	EV 17	EV 18
3/4 moon, clear sky	EV 12	EV 13	EV 14	EV 15	EV 16	EV 17
1/4 moon, clear sky	EV 11	EV 12	EV 13	EV 14	EV 15	EV 16
Crescent moon, clear sky	EV 10	EV 11	EV 12	EV 13	EV 14	EV 15
Moon in total eclipse	EV 0	EV 1	EV 2	EV 3	EV 4	EV 5
Subject illuminated by full moon high in clear sky	EV -6	EV -5	EV -4	EV -3	EV -2	EV -1
Sky at sunset	EV 11	EV 12	EV 13	EV 14	EV 15	EV 16
Sky immediately after sunset	EV 8	EV 9	EV 10	EV 11	EV 12	EV 13
Aurora Borealis	EV -7	EV -6	EV -5	EV -4	EV -3	EV -2

specify exposure meter range by EV numbers or a table of allowable settings for the exposure controls. This seems to say you can't use exposure-control settings beyond that range, *which is not true.*

The camera booklet may say dim-light limit of accuracy for the exposure meter is EV 2. You can still set the exposure controls to get a lower EV number, such as −3. But you have to find some other way to decide on the amount of exposure to use.

NIGHT PHOTOGRAPHY

When light measurement is possible using the camera meter or an accessory meter, that's the best way. There are cases where photography is possible but light measurement may not be. This table will serve as a guide. Bracket exposures if you have to be sure of getting good exposure.

Whenever exposure time is one second or longer, check the film data sheet to see if reciprocity failure will occur. If so, compensate according to the data sheet. See pages 133-134. For exposures longer than 1/30 second, use a tripod and cable release.

Color films are designated for daylight or tungsten (incandescent) illumination and should be used accordingly. See the color-temperature discussion, page 80.

Moonlight calls for daylight film to get correct color rendition. Spotlights (arc lamps) used in circuses and theaters resemble daylight illumination and give best color rendition with daylight film. Incandescent lights such as stage footlights and general stage illumination give best color with tungsten film. Fluorescent and gas-discharge lamps such as mercury-vapor and sodium-vapor lamps are special cases usually requiring color filters over the camera lens to get good color.

Convert EV numbers to camera settings using the EV table on page 75.

HOW TO HANDLE SPECIAL PHOTOGRAPHIC SITUATIONS

Rainbows—Take exposure reading from sky near rainbow.

Sunsets — Take exposure reading from sky near sunset.

To Get a Large Moon—Use a long-focal-length lens —200mm minimum.

When the Sun Is In the Picture—

CAUTION! NEVER LOOK AT THE SUN THROUGH ANY KIND OF OPTICAL INSTRUMENT INCLUDING THE VIEWFINDER ON YOUR CAMERA. PERMANENT EYE DAMAGE MAY RESULT!

For ordinary scenes where the sun is incidental to the photo, take exposure from the scene or subject of interest. Direct sunlight into a lens may cause flare and ghost images.

Photographing the Sun Itself—Not recommended without special precautions. See Kodak Publication AC-20 for information.

Star Tracks—Camera on tripod, lens wide open with medium or fast film. Shoot during dark of moon. Expose as long as desired. Make test exposures to see effect of general sky brightness. Stars in northern hemisphere rotate around the North Star at 15° per hour.

Meteors, Comets and Man-Made Satellites—Camera on tripod, lens wide open with medium or fast film. Shoot during dark of moon. Expose until subject of interest passes through field of view.

Lightning at Night—Camera on tripod with medium or fast film, lens aperture at f-8 or f-11. Use 50mm lens or shorter focal length. Open shutter, wait for lightning, close shutter. Skylight from lightning outside of field of view, or city lights reflected in clouds, or moonglow may limit exposure time to about 2 minutes for each frame. You may put several exposures on the same frame if it is a very dark area.

Fireworks in Sky—Camera on tripod with medium or fast film, lens aperture at f-11 or f-16. Hold shutter open for several bursts of fireworks.

Photographing Silhouettes: Arrange subject against bright background such as the sky. Take exposure reading from bright background.

Photographing a TV Screen—Use tripod or other steady support. Use daylight color film for color TV. Use shutter speed of 1/15 second. Choose lens and camera position so TV screen fills viewfinder. Adjust TV picture for details in both shadows and highlights, turning down contrast if necessary. Use meter in camera as with any other scene, taking care not to meter on shadows or highlights in TV image. Because of *required* slow shutter speed, shoot at peak of action or in periods of no subject movement. Color photos will have overall green cast which can be reduced or eliminated by using a light-red filter such as CC40R or equivalent over the camera lens.

USE OF EV NUMBERS TO SPECIFY CAMERA EXPOSURE-METER RANGE

When camera makers specify the range of the built-in exposure meter in EV numbers, they also state a film speed and a lens aperture—usually ASA 100 and f-1.4. Here's why:

Basically an EV number identifies a pair of camera-control settings and other pairs which give the same exposure. The EV number says *how the camera is set,* and has nothing at all to do with the amount of light on the scene.

If we say some EV setting gives correct exposure *on ASA 100 film,* then we have used the EV number to specify the amount of light on the scene, based on ASA 100 film in the camera.

If the film is changed to ASA 400, correct exposure will result from a different EV setting which is 2 EV numbers *higher* because ASA 400 film requires 2 steps *less* exposure.

When using EV numbers to specify the measuring range of an exposure meter, it is the scene-brightness range that matters. Scene-brightness range can be specified by a range of EV numbers if an ASA film speed is also stated.

A built-in exposure meter can measure only light that comes through the lens and a larger aperture admits more light. An exposure meter with a certain working range with a lens set at f-4, will gain 3 more steps just by changing the aperture to f-1.4.

To remove this ambiguity, when exposure meter range is specified by EV numbers, *both* ASA film speed and the lens aperture must be stated—usually ASA 100 and f-1.4.

OTHER WAYS TO SHOW CAMERA EXPOSURE-METER RANGE

Stating exposure-meter range by EV numbers is neat, simple and compact and camera specs often do that.

However the camera maker usually doesn't know that you personally own an EV table and are very handy at translating the numbers into camera-control settings. Therefore camera booklets typically show a table of allowable control settings within the meter's accuracy range, called *meter-coupling range,* or something similar.

They are published with the hope that camera users will faithfully consult them to discover if camera settings are within limits so the meter is accurate.

Some camera makers have discovered our infidelity and build the camera so it flashes a red warning signal when we set the controls beyond the meter-coupling range.

HOW TO CONTROL LIGHTING

RULES FOR POSITIONING LIGHT SOURCES	
To Decrease Illumination By:	Multiply Light-Source Distance By:
1 exposure step	1.4
2 exposure steps	2
3 exposure steps	2.8
4 exposure steps	4
5 exposure steps	5.6
To Increase Illumination By:	Divide Light-Source Distance By:
1 exposure step	1.4
2 exposure steps	2
3 exposure steps	2.8
4 exposure steps	4
5 exposure steps	5.6

Notice the mathematical coincidence: The distance factors in the right column of these tables are the same as the *f*-number series on your lens.

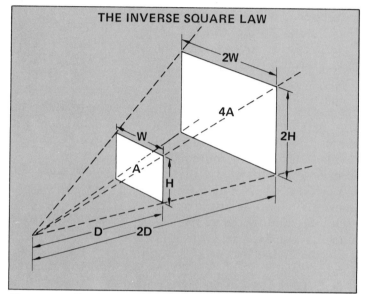

THE INVERSE SQUARE LAW

If an expanding beam of light travels twice as far, it illuminates a surface that is twice as wide and twice as tall—in other words, 4 times as much area. When the same amount of light is spread over 4 times as much area, brightness of the illuminated surface is only 1/4 as much. That's the famous inverse square law about light.

Shadows or uneven illumination have both artistic and technical impact. Portraits and scenes benefit artistically from shadows because they give depth or dimension to an otherwise flat and lifeless picture.

However, when part of the subject is in shadow and part in bright light, the brightness range is increased and may exceed the capability of the film. A common failure in photography is to ignore the brightness range. See page 65.

INVERSE SQUARE LAW

When the distance is increased between most light sources and the subject being illuminated, the brightness of illumination on the subject decreases. This is true of all light sources which produce *expanding* beams of light.

These sources behave according to the *inverse square law* which says: If you double the distance, light becomes only 1/4 as much. If you triple the distance, light becomes only 1/9 as much. In other words, square the distance-increase factor to find the light-decrease factor. Multiply distance by 5 and the light becomes 1/25 as much.

Mathematically,

$$B_2 = B_1 \left(\frac{D_1}{D_2}\right)^2$$

B_2 is subject brightness after you have moved the light.

B_1 is brightness before you move the light.

D_1 is the distance associated with B_1.

D_2 is the distance after moving the light.

RULES FOR POSITIONING LIGHT SOURCES

When working with a light source you can move—such as a

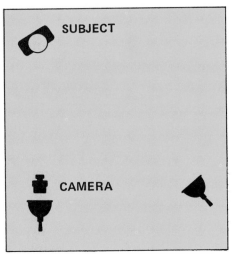

Basic two-light setup for portraits. Adjust positions and distances of the two lights for the desired effect. Lighting drawings used courtesy of Smith-Victor Corporation.

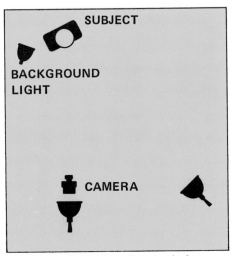

Illuminate the back wall or back drop with a third light, out of view of the camera of course, for better visual separation between subject and background.

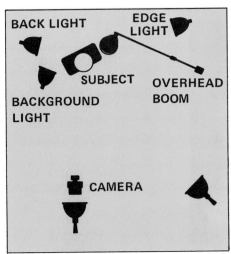

In a portrait studio, you'll find a whole array of lights—used as needed for subject and desired effect.

flood lamp—put it anywhere and turn it on. Then measure the amount of light on the subject using the exposure meter in your camera. This tells you if it is too much or too little by showing you the exposure setting needed for that amount of light.

Decide how much you want to change subject brightness by deciding how many exposure steps you would like it to change. For example, if the meter says *f*-2 and you prefer to use *f*-8, you need 4 steps more light. Or, you may need to reduce the amount of light.

MAIN LIGHT AND FILL LIGHT

To make portraits of people or to photograph an object, it is customary to use at least two lights. One, called the *main light*, is placed so it casts shadows to give modeling of the subject features. These shadows will nearly always be too dark, so a second light is used at a different position to lighten the shadowed areas. This is called the *fill light* because it "fills" the shadows. Usually the main light is on one side of the subject and the fill light is on the other.

The main light is positioned to establish the basic lighting pattern. Its location determines the angle that shadows make and its brightness has the most effect on film exposure.

When a main-light position has been decided, locate the fill light for the desired lighting ratio and artistic effect.

Depending on the situation, other lights are used. In portraiture, a *back light* or *hair light* is placed behind the subject so the light itself is not visible to the camera but the subject is outlined by a soft glow—particularly noticeable around the hair.

Another light is sometimes directed toward a background of uniform color so the picture doesn't recede into darkness.

LIGHTING RATIO AND BRIGHTNESS RATIO

When a subject is illuminated by two light sources from different angles, there are three values of light on the subject. Suppose one source is twice as bright as the other, as measured at the subject. Let's say the first source puts 2 units of light on the subject and the second source only puts 1 unit on the subject.

The *lighting ratio* is simply the ratio of the two amounts of light falling on the subject. In this case it is 2 to 1, or 2:1.

Where the main light falls on the subject, the brightness is 2. Where the main light casts shadows, it does not illuminate. The fill light casts light into the shadows, where the brightness is 1 in this example. Some surfaces will be illuminated by *both* light sources. On these surfaces, the brightness is 3 units.

Brightness ratio is the ratio of subject brightnesses seen by the camera. In this example, the brightness ratio is 3:1, or just 3.

There is some confusion in photo literature about these two ratios. Lighting ratio is the *cause* of uneven illumination. Brightness ratio is the result, and it is what must be recorded on film.

HOW TO CONTROL THE RATIO WHEN USING FLOOD LAMPS

Because brightness ratio affects what you get onto the film, it is what you want to control. It is difficult to measure with your camera meter because the shadows are usually small. You would have to move the camera up very close and maybe take it off the tripod. Or,

you could use an accessory hand-held spot meter.

Brightness ratio is always "one more" than the lighting ratio. For example, a lighting ratio of 2:1 gives a brightness ratio of 3:1; a lighting ratio of 3:1 gives a brightness ratio of 4:1, and so forth.

Lighting ratio can be measured with your camera just by turning on one light at a time and using a gray card to reflect some of it back toward the camera. However it's usually just as easy to figure lighting ratio based on placement of the lights. It is convenient to use identical lamps with the same light output. If you do, consult the accompanying lighting and brightness-ratio table.

LIGHTING RATIO AND BRIGHTNESS RATIO

For a Lighting Ratio of:	Use Fill-Light Distance Equal to Main-Light Distance Times:	Brightness Ratio is:
1:1	1	2:1
2:1	1.4	3:1
3:1	1.7	4:1
4:1	2	5:1
5:1	2.2	6:1

Brightness ratio is what the camera sees.

BRIGHTNESS-RATIO LIMITS

With Black-and-White Film	5:1
With Color Slide Film	4:1
With Color Negative Film	3:1

There are no firm rules about brightness-ratio limits because it depends on the subject and the effect you want to create. As a rule of thumb, you will preserve detail in the shadows by limiting brightness ratio to the values in this table.

EXPOSURE

Exposure is determined primarily by the main light because it puts the most light on the subject. If the lighting ratio is low, the fill light puts nearly as much light on the subject. Meter with both lights turned on. Other lighting, such as back lights and lighting on the background can be ignored and measurement made with them either on or off.

If the lighting ratio is greater than about 3:1, the light contribution by the fill light has only a small effect on exposure and you can meter with only the main light turned on.

Metering on an 18% gray card at the subject location is virtually foolproof. Angle the card, facing it between camera and main light so the camera does not see glare from the surface.

USING REFLECTORS

The crafty photographer's secret weapon is a reflector. These are panels such as white poster board or crinkled aluminum foil glued to a piece of cardboard. You can often improvise one on the spot.

Reflectors are used to throw some light into a shadow. With only one light source such as the sun, you may control the lighting ratio very adequately with just a reflector. Even with a complete studio-lighting setup, reflectors are used to "fine-tune" the lighting.

When using color film, colored reflectors such as a nearby wall or a table cloth or a piece of clothing may surprise you by reflecting colored light into the scene, especially into skin areas.

COLOR TEMPERATURE

Incandescent light sources give off light due to being heated. A piece of iron, when heated, first glows a dull red color. At higher temperatures, the color gradually changes to cherry red, then yellow, then white when it has become "white hot."

A handy and accurate way to describe the color of a heated object is to state its temperature in degrees Kelvin (K). The Kelvin temperature scale measures absolute temperatures—that is, zero Kelvin is as cold as it is possible to get. The Kelvin scale uses the same degree size as the more common Centigrade or Celsius (°C) scales of the metric system. To convert °C to °K, add 273 to °C. Therefore freezing is 0°C and 273°K. When using the Kelvin scale, the degree symbol is usually omitted. 273°K is written 273K.

When Kelvin temperatures are used to indicate the color of light being radiated by a heated object, the temperature is called color temperature, implying that the real purpose is to say what color the object is.

Bodies don't begin to emit light until around 1000K, which is a very dull red. A candle flame has a temperature of about 1800K. The filaments of household incandescent lamps operate at a color temperature of around 3000K, depending on the wattage rating of the lamp.

Direct sunlight has a color temperature of about 5500 K and there is much less red and yellow color in sunlight than in the light from an incandescent lamp.

As color temperature increases, the light becomes less red-colored and more blue-colored. Light from the sky is blue and has a color temperature of about 12,000K. Of course the sky is not hot but the idea of color temperature applies anyway. If an object were at a temperature of 12,000K it would radiate light with a color very similar to blue sky.

Color temperatures are part of the language of photography. As a rough calibration, remember that light at about 1500K is red, 3000K is yellowish, 5500K is white sunlight, and 12,000K is blue skylight.

FLOOD-LAMP TYPES

Incandescent lamps have filaments made of tungsten, therefore

	TUNGSTEN PHOTO LAMPS WITH SCREW-TYPE BASES (PARTIAL LIST)				
	ANSI CODE	WATTS at 118V	AVERAGE LIFE (Hours)	COLOR TEMPERA-TURE (K)	BASE
Reflector Type	DAN	200	4	3400	Medium
	BEP	300	4	3400	Medium
	EBR	375	4	3400	Medium
	DHX	375	15	3200	Medium
	BFA	375	4	3400	Medium
	FAE	550	—	3400	Medium
No Reflector	BBA	250	4	3400	Medium
	EBV	500	8	3400	Medium
	BXR	1000	10	3400	Mogul
	ECT	500	60	3200	Medium
Blue No Reflector	BCA	250	4	4800	Medium
	EBW	500	8	4800	Medium
	DXT	1000	10	4800	Mogul

American National Standards Institute (ANSI) code numbers are used to identify the same type of lamp made by more than one manufacturer. This data courtesy GTE Sylvania.

incandescent light is referred to as *tungsten light.* Tungsten lamps, including photo lamps, are rated in Watts, an indication of the amount of electrical power they use. The amount of light produced is roughly proportional to the wattage rating.

Photo lamps typically have higher wattage ratings than most household bulbs. Photo-lamp ratings range from 200 to 1000 Watts.

With b&w film, color temperature is not very important but with color film a visible color change in the photo will result from using light with the wrong color temperature for the film.

For this reason, special color films are made for use with tungsten lamps. There are two types of *tungsten film.* Type A is designed to give good color rendition when the subject is illuminated with tungsten lamps having a 3400K color temperature. Type B works

with a color temperature of 3200K. When it is not possible to match film and light source color temperature, color filters can solve the problem. See the discussion on page 107.

Tungsten photo lamps are available to produce either 3200K or 3400K light. Some have a built-in reflector, others look like household light bulbs and require mounting in a reflector. Another photo-lamp type has a blue coating to give the light output a color temperature similar to daylight. These can be used with films designed for use outdoors in daylight, called *daylight color films.* A list of commonly available films is on page 132.

Photo lamps have standard ANSI nomenclature which can be used to order lamps or to check catalog cross references to find the manufacturers' identifications for the same lamp.

LIFE EXPECTANCY AND LIGHT OUTPUT OF TUNGSTEN PHOTO LAMPS

Ordinary tungsten lamps fail because tungsten evaporates from the heated filament until the filament becomes so thin it breaks. Lamp life is very sensitive to operating voltage. If the voltage is increased only a few percent, operating time to failure may be decreased to half the rating. Operating at a few volts lower than normal may double life expectancy. Of course the amount of light and its color temperature changes with line-voltage fluctuations.

Because lamps which produce light at 3200K operate at lower filament temperature, their life expectancy is considerably longer than similar lamps operating at 3400K.

As tungsten evaporates from the filament, it forms a gray coating on the inside of the lamp. This reduces light output continuously during the life of the lamp. At failure, a typical tungsten lamp is producing only about 65% as much light as when new.

Deposition of tungsten on the inside of the lamp also causes a gradual reduction in color temperature—typically about 100K over the life of the lamp.

TUNGSTEN-HALIDE LAMPS

A major improvement in photo lamps is the *tungsten-halide* type, also called *tungsten-halogen.* By special construction and use of a halogen gas inside the bulb, tungsten which evaporates from the filament is continuously removed from the glass envelope and replaced on the filament.

Advantages include: More light for the same electrical power, much longer lamp life, relatively constant light output during the life of the lamp, and relatively constant color temperature.

Tungsten-halogen lamps are available in various wattage ratings in both 3200K and 3400K color temperatures. The lamp must be

matched to its socket and the socket is usually built into a reflector. Therefore shop for a reflector-lamp combination to suit your needs.

Replace the lamp with the same type when one burns out. Do not handle these lamps with your fingers when replacing the lamp. Use a piece of facial tissue to take the lamp out of its box and to insert it in the fixture.

LIGHT STANDS

There are so many different types of light stands that the best advice is to shop slowly. Look at a lot before you choose one. Check ads and write for data and catalogs. Pay particular attention to how the lamp holder attaches to the stand and what you do to adjust the angle. I do not recommend lights that attach with a spring clamp.

HOW TO FIGURE ELECTRICAL LOAD

Buildings are normally wired with several electrical wall outlets on a single circuit fed from a fuse or circuit breaker in an electrical panel. If the electrical current exceeds the fuse or circuit-breaker capacity, it will open the circuit. Fuses and breakers are marked with their current capacity in Amperes. A typical 115-Volt circuit is rated at 15 Amps.

In planning to use photo lamps where there is existing wiring, first locate and identify the electrical circuits that serve the area you'll use for picture taking. There may be more than one. This can be done by plugging a small lamp into a wall receptacle and then switching off circuits at the electrical panel until there is no power to operate the lamp—it goes off. If you own a voltmeter or electrical test lamp, use it instead. Then test other wall receptacles the same way until you know how many circuits you have and which breaker or fuse turns them off. Follow the circuits into adjacent rooms because you don't want to plug photo lamps into a circuit already heavily loaded by other electrical equipment such as refrigerator, freezer or stove.

Notice the current rating on the breaker switches controlling each circuit you plan to use. If you exceed that amount, the breaker will open or the fuse will blow.

Add the wattage ratings of all electrical equipment you intend to use on a single circuit. Include any equipment already connected. Then find the current required as follows:

$$\text{Amperes} = \frac{\text{Watts}}{\text{Volts}}$$

Volts is the line voltage. To be conservative, assume the line voltage is 100 Volts. If you want to push circuit capacity to the limit, assume it is 120 Volts.

Example: You intend to use two 250-Watt lamps and one 500-Watt lamp. The total wattage is 1000 Watts.

$$\text{Amperes} = \frac{\text{Watts}}{\text{Volts}}$$

$$= \frac{1000}{100}$$

$$= 10 \text{ Amps, conservatively}$$

$$\text{or, Amperes} = \frac{1000}{120}$$

$$= 8 \text{ Amps, living dangerously}$$

If this is the only load on a 15-Amp circuit, you are OK with either calculation. Conservatively, you can still draw another 5 Amps for other things. Maybe you can still draw another 7 Amps, but you may trip the circuit breaker.

CAUTION: Never replace a fuse or circuit breaker with another having a higher Ampere rating. The fuse or breaker is matched to the wire size in the circuit. Changing to a higher capacity may heat up the wires and start a fire. If your equipment overloads the circuit, spread the load by plugging some of the lights into another circuit.

Flash is useful in more than one way. The obvious use is to put more light on the subject when the existing light is too dim. Flash is also used when there is plenty of other light to make the picture—less obvious but probably more important to successful photographers. Flash modifies existing light, changing the overall lighting effect to make an artistic or technical improvement.

There are flash bulbs and electronic flash in several forms. Initial cost of equipment using flash bulbs is less, but cost-per-flash is much higher. Simple low-power non-automatic electronic flash units have become so cheap that they make more sense to me than using flash bulbs. Even so, small flashbulbs and an associated flash holder weigh less, take up less space and put more light on the subject than a medium-size electronic flash.

FLASH BULBS

There are two main types. Blue-coated bulbs make light similar to daylight. Clear bulbs make light similar to tungsten lamps. Both come in a large variety of types, sizes, mounting bases and light output. They are used in flash-bulb holders.

FLASH BULB CLASS	TYPICAL TIME TO PEAK OUTPUT (milliseconds)
F — Fast	8
MF — Medium Fast	13
M — Medium	17
S — Slow	30

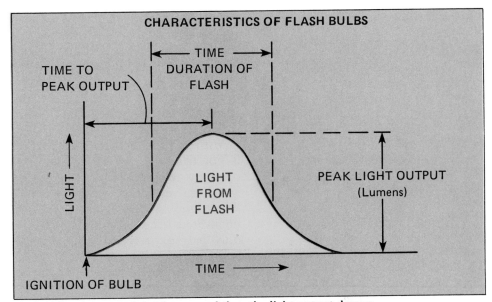

CHARACTERISTICS OF FLASH BULBS

Flash bulbs rise to peak brightness and then the light output decays.

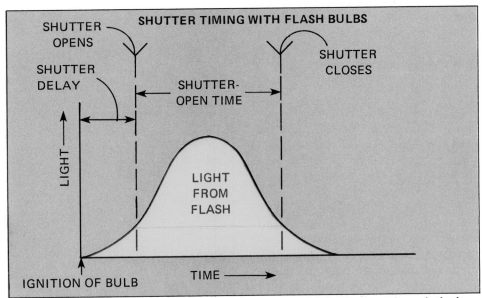

SHUTTER TIMING WITH FLASH BULBS

With bulb flash, shutter-open time affects the amount of light that gets through the lens.

Flash bulbs are assigned letter symbols to indicate the time delay between the instant of firing and the development of peak brightness.

FLASH-BULB CHARACTERISTICS

Some important characteristics are shown in the accompanying drawing.

Time To Peak Output—Because flash bulbs make light by combustion inside the glass envelope, it takes time for the light to reach full brightness, measured in thousandths of a second (milliseconds).

The time interval between the instant of firing and peak brightness varies among different types.

Time Duration—Normally measured between the instant the light increases to half brightness and the later instant when it falls off to half brightness.

Peak Light Output—The unit of light, *lumens,* is used to specify peak output. Total light produced is determined both by the brightness in lumens and flash duration, therefore total light is measured in *lumen-seconds.*

SHUTTER TIMING WITH FLASH BULBS

A timing mechanism in the camera delays shutter opening until a flash bulb has had time to reach useful brightness. This avoids unnecessarily long exposure times and reduces the effect of the surrounding ambient light on the film when your intention is to expose with light from the flash.

AMOUNT OF LIGHT REACHING THE FILM

When the burst of light from a flash bulb reflects off the subject and returns to the camera, the amount that gets through to the film depends on several things:

• Light output of the flash bulb.

• Size and type of reflector used behind the flash bulb.

• Reflectance of the subject.

• Timing of the shutter in relation to the flash.

• Camera control settings.

As you can see in the shutter-timing drawing, the shutter opens sometime along the rise of the flash, depending on the amount of *shutter delay.* Then the shutter admits light for the length of time it is open. After the shutter closes, if shutter speed is fast, the flash bulb may still be making light.

An Important Difference in Shutter Types—A few SLR cameras use *leaf shutters* in the lens. These open and close in a way similar to the aperture in the lens. When a leaf shutter opens, it starts with a tiny hole which becomes larger as the shutter becomes more fully open. Closing is the reverse.

Even when a leaf shutter has just started to open and is a very tiny hole, the light that gets through expands and falls on all parts of the film frame. A leaf shutter, as it opens, gradually increases *the amount* of light reaching the film but has no effect on *where* light falls on the film.

With a focal-plane shutter, that is not true. These shutters start to open by releasing the first curtain, which moves across the film frame. When the window has not yet uncovered the complete frame, only part of it receives light. Closing is the reverse, with a moving second curtain which blocks light to an increasing width across the frame as it closes. See page 13. The significance of this will become clear in a minute.

ELECTRONIC-FLASH TIMING

Electronic flash rises to full brightness almost instantly, remains bright for a very short time, and extinguishes almost instantly.

To sync electronic flash with a focal-plane shutter, the flash is triggered by the camera at the instant the first curtain *completes* its travel across the frame. The entire frame must be open to receive light from the flash at that instant, so the second curtain must not have begun its trip across the frame. Therefore only certain shutter speeds can be used, as discussed in the next section.

If you happen to have a lens with a built-in leaf shutter, it also triggers an electronic flash at the instant the shutter is completely open. This is simply to capture maximum light from the flash. An electronic flash will turn on and then off again before the leaf shutter can begin to close, so you can use electronic flash at any shutter speed.

X SYNC

The special synchronization for electronic flash is called *X sync.* With a focal-plane shutter, X-sync can not be used at all shutter speeds.

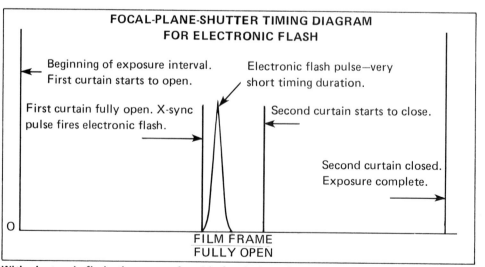

FOCAL-PLANE-SHUTTER TIMING DIAGRAM FOR ELECTRONIC FLASH

Beginning of exposure interval. First curtain starts to open.

First curtain fully open. X-sync pulse fires electronic flash.

Electronic flash pulse—very short timing duration.

Second curtain starts to close.

Second curtain closed. Exposure complete.

FILM FRAME FULLY OPEN

With electronic flash, the range of usable focal-plane shutter speeds is limited. Exposure time must be long enough so the second curtain does not start to close until after the first curtain is fully open and the electronic flash has occurred. Longer exposure times merely cause the second curtain to wait longer before starting to close. Shorter exposure times cause the second curtain to start closing too soon. When flash occurs, part of frame will be covered by second curtain.

1/60

1/125

1/250

1/500

1/1000

Shutter-open time for a focal-plane shutter begins at the instant the first curtain is *released* to begin its travel across the frame and ends at the instant the second curtain is *released*. When an electronic flash is fired by end-of-travel of the first curtain, the second curtain must not yet be released. Otherwise it will cover up part of the frame. Therefore the shutter-open time used must be *slightly longer* than the travel time of the first curtain across the frame.

In 35mm SLR's, focal-plane shutters which travel horizontally typically take about 1/100 second to make the trip. Because you must select a slower shutter speed, use 1/60 second. The shutter-speed dial is usually marked in some special way to remind you to use that setting for electronic flash. You can use a slower speed, but you should have a good reason to do it.

Because the height of the film frame is less than the width, vertically moving focal-plane shutters make the trip faster. Therefore 35mm SLR's with vertical shutters usually offer X sync at 1/125 second or slower. The shutter-speed dial is usually marked at 1/125 to remind you to use that setting for electronic flash. A few cameras have other X-sync speeds such as 1/100 or 1/80.

What if you use electronic flash at a shutter speed that's too fast? If you use electronic flash at a focal-plane-shutter speed which is too fast, you take a picture of the second curtain, partway across the frame. Part of the frame will show the scene, the other part will be black.

Some cameras give you an all-black frame instead. These cameras offer X sync only at the cor-

This photo made with flash at a shutter speed of 1/60 which is the normal X-sync shutter speed for the camera used.

Same camera and flash used at 1/125. Second curtain of focal-plane shutter has already started to travel and blocked off part of frame.

rect shutter speed or slower. At faster shutter speeds they expect you to use flash bulbs. They delay shutter opening to allow the flash bulb to develop useful brightness. The electronic flash happens during the delay so there is no exposure at all.

What if you use electronic flash at a shutter speed that's too slow? The recommended X-sync shutter speed is the slowest speed that allows a brief moment when the film frame is completely open to light. That is, the first curtain has the frame open and the second curtain has not yet started to close.

The electronic-flash duration is a very short period of time, perhaps

Here's what the focal-plane shutter does at X-sync speed and higher. These photos taken with flash triggered by the camera in the picture. These shutter curtains travel from right to left. When first curtain reaches left side of frame, X-sync contacts trigger flash so you can see what the second curtain is doing at that instant. At 1/60 second, second curtain has not yet started to close, so frame is completely open. At 1/125 and faster, second curtain has already started to close when first curtain reaches fully open. At 1/1000 second, second curtain follows first so closely that exposure of entire frame is made by that narrow traveling slit of light.

only 1/1000 second. The flash happens at the instant the first curtain is fully open. For the rest of the exposure time the flash is off but the film is receiving exposure due to whatever amount of ambient light there is on the scene. Thus there are *two* exposures on the film. One due to the short-duration flash and another due to the general light from the scene which reaches the film during the entire period the shutter is open.

If the subject is moving, there may be a sharp image due to flash exposure and a blurred image due to the longer exposure with ambient light. Sometimes this is desired for artistic or other reasons.

Normally you can use electronic flash with a focal-plane shutter at the recommended shutter speed for X-sync, or any slower speed. Using a slower speed just means the shutter stays open longer after the flash happens, so there is more exposure due to ambient light. If this is desired, there's no reason not to do it.

For a special effect, Josh Young used electronic flash and a shutter speed of 1/4 second. Two exposures result: a sharp image due to the flash and a blurred image due to exposure under room light.

FP FLASH BULBS FOR FOCAL-PLANE SHUTTERS

Special FP flash bulbs have a rise-time about the same as M-class. bulbs. Instead of rising to a peak and then rapidly falling off, light output rises to a plateau and remains nearly constant for a relatively long time—25 to 40 milliseconds, depending on bulb type.

Because of their long duration, FP flashbulbs avoid sync problems with focal-plane shutters. In effect, they turn on before you operate the shutter and remain on throughout the exposure. Therefore the focal-plane shutter cannot distinguish an FP bulb from a continuous light source.

When using FP bulbs, SLR cameras delay shutter opening until the bulb reaches full brightness. Then the focal-plane shutter sequence begins. Typical FP flash bulbs are types 6, FP-26, 6B and FP26B. B signifies blue. All have a 27-millisecond light-duration at nearly uniform brightness. At shutter speeds

of 1/60 or faster, the entire exposure takes place under uniform illumination from the flash. Longer exposures are possible, but the light will decay before the shutter closes.

As mentioned earlier, some cameras offer only X sync at certain shutter speeds such as 1/60. If your camera instruction booklet says FP bulbs can be used at 1/125 and faster, or 1/30 and slower, but not at 1/60, it's because the camera offers only X sync at 1/60.

HOW TO CONNECT THE FLASH TO THE CAMERA

Most modern SLR's have a *hot shoe* on top of the pentaprism or an accessory hot shoe that can be attached to the camera. These are mounting brackets that accept the mounting "foot" of the flash unit. In the center of a hot shoe is an electrical contact which connects to the flash unit and fires the flash at the proper instant. When a flash unit designed for use with a hot shoe is installed on the camera, no other electrical connection is needed.

Some flash units are not designed to work with a hot shoe. These use electrical cords, called *PC cords,*

to make a connection with a flash socket on the camera body, called a *PC socket.*

There are two types of flash sockets. With some, the PC connector just pushes into the socket and is held there only by friction. The cord can unplug accidentally. Screw-type flash sockets have a threaded collar which mates with a threaded fitting on the end of a

Small flash units mount on camera hot shoe and are fired by electrical contact in hot shoe. No separate cord connection is required between camera and flash.

special flash cord. When the connection is made by threading the connector into the socket, there is little chance of accidental disconnection. Threaded flash sockets usually also accept a push-in type of cord but without the additional security of the threaded mechanical connection.

You can ensure against the PC cord pulling out of its socket by taping the cord to the camera and to the flash unit with duct tape. This is sold in hardware stores. Some photo stores carry it, too.

Protection Against Electrical Shock —When using electronic flash, the firing voltage is high enough to be felt. If an electronic flash is connected to a socket on the camera body, the firing voltage may also appear on the hot-shoe contact. If your finger or eyebrow happens to be there at the time, you can get a shock. Some cameras prevent this by using a *hot/cold shoe* which is electrically disconnected unless a flash unit is installed. These shoes have a small switch to turn on the circuit, operated by installing the flash.

Other camera models come with a plastic hot-shoe cover which you should keep in place except when a flash unit is installed in the shoe.

If you have an electronic flash installed in the hot shoe, it is possible to get a shock from a flash socket on the camera body if you touch it. Camera makers do several things to prevent this. Some sockets have the center part deeply recessed so touching it is unlikely. Some come with plastic covers which should be kept in place except when the socket is being used. Some have a pivoted cover which must be pushed aside before a PC cord can be plugged in.

OPERATING TWO FLASH UNITS SIMULTANEOUSLY

On some cameras you can install a flash in the hot shoe, connect another to a flash socket on the camera body, and both will fire. This is not recommended because the electrical load is doubled with two units and the resulting high current may damage the delicate flash-firing contacts in the camera.

Some cameras with a pivoting flash-socket cover on the camera body also use the pivoting cover to operate a switch. This switch disables the hot shoe when a flash is cord-connected to the camera, therefore you are prevented from firing two flashes simultaneously. The same switch also protects you from accidental shock at the hot shoe when using a cord-connected electronic flash.

You can defeat the camera maker's good intentions by using special flash cords or a "Y" connector so you only connect one end to the camera but there are two ends to connect flash units. This may get you a repair bill.

A better way is to use special flash *slave units.* These are small light sensors that plug into the second flash. The slave unit detects the flash from the unit you have connected to the camera and instantly fires the second unit. There is no cord connection from the second unit. You can fire as many other flashes as you want, using slave units.

FLASH SYNCHRONIZATION BY THE CAMERA

SLR cameras offer X, M and FP sync although not all cameras offer all three. The hot shoe and flash sockets are labeled to show what kind of sync is there.

Larger handle-mount flash units attach to camera with bracket or can be hand-held separate from camera. Either way, electrical connection between camera and flash is made by connecting cord.

X sync is for electronic flash.

M sync is for M-class flashbulbs but is fairly close to the time delay needed for MF and FP bulbs.

FP is for FP bulbs.

Some cameras show only M sync on the connector but the instruction booklet allows you to use MF or FP bulbs with M sync. Because the time delay is not exact, this affects the amount of light you get on the film. The instruction booklet will also tell you the allowable shutter speeds for each of these options.

GUIDE NUMBERS

With most camera brands and models, you can't measure the effect of flash with the exposure meter in your camera, therefore you need a way to *predict* the amount of light on the subject and decide what exposure settings to use. This is done by using a guide number (GN) as follows:

$$f\text{-stop} = \frac{GN}{\text{Distance to Subject}}$$

Measure the distance from flash to subject, or estimate it, or read it off the focusing scale on the lens if the flash is mounted on the camera. Divide that distance into the guide number and the answer is the *f*-stop you should use.

Example: Suppose your flash has a guide number of 28 feet and you are using it to photograph a subject 10 feet from the flash.

$$f = \frac{GN}{\text{Distance}} = \frac{28 \text{ feet}}{10 \text{ feet}} = 2.8$$

Set the aperture at *f*-2.8 and you should get a good exposure of the subject. Objects nearer will receive too much light, objects more distant will not get enough light.

Guide numbers are often stated with a distance unit, such as 27 feet or 9 meters. You must use the same unit for distance to subject or you get the wrong *f*-number. If no unit is stated, you can usually assume it is feet, but sometimes it is meters. If there is doubt, settle it by testing. Make one shot each way and see which works.

SYLVANIA BLUE DOT™ FLASH-BULB GUIDE-NUMBER DATA									
SYLVANIA BLUE FLASHBULBS									
Lamp Type	Shutter Speed	**ASA Film Speeds**							
		10 to 12	16 to 20	25 to 32	40 to 64	80 to 125	160 to 200	320 to 500	
Hi-Power Flashcube	X or F Up to 1/30	45	60	80	110	140	180	280	
	Up to 1/60	31	40	50	70	100	125	180	
	1/125	25	34	42	60	80	100	150	
	M Sync. Only 1/250	21	27	34	48	70	80	130	
	1/500	17	22	27	40	55	70	100	
Magicube	X or F Up to 1/60	32	42	55	75	100	130	200	
Flashcube	X Sync. Up to 1/30	32	42	55	75	100	130	200	
	Up to 1/60	22	28	36	50	70	90	130	
	1/125	18	24	30	42	60	75	110	
	M Sync. Only 1/250	15	19	24	34	48	60	90	
	1/500	12	16	19	28	38	48	70	
AG-1B Zirconium-Filled Class MF R5	X Sync. Up to 1/30	46	60	75	100	150	190	280	
	Up to 1/60	30	38	48	65	95	120	170	
	1/125	26	32	42	60	80	100	150	
	M Sync. Only 1/250	22	28	34	48	70	85	130	
	1/500	18	22	28	40	55	70	110	
M-2B Class MF R4	X Sync. Up to 1/30	42	55	70	95	140	170	250	
M-3B Zirconium-Filled Class M	X or M Up to 1/30	65	80	100	140	200	260	400	
	1/60	55	70	85	120	170	220	320	
	M Sync. Only 1/125	46	60	75	100	140	180	280	
	1/250	36	46	60	80	120	150	220	
	1/500	30	38	48	65	95	120	180	
R4 Focal Plane	X Sync. Up to 1/30	65	85	110	150	220	280	400	
	1/125	42	50	65	95	130	170	240	
	FP Sync. Only 1/250	30	38	48	65	95	120	170	
	1/500	20	26	34	46	65	85	120	
	1/1000	15	19	24	34	46	60	90	
Press 25B Class M R1	X or M Up to 1/30	65	80	100	150	200	260	380	
	1/60	60	75	95	130	190	240	360	
	M Sync. Only 1/125	50	65	85	120	160	200	300	
	1/250	40	50	65	90	130	160	240	
	1/500	30	40	50	70	100	120	180	
FP-26B Class FP R1	Up to 1/30	65	85	110	150	220	260	400	
	1/125	32	40	50	75	100	130	190	
	FP Sync. Only 1/250	22	28	36	50	70	90	140	
	1/500	16	20	26	36	50	65	100	
	1/1000	11	14	18	26	36	46	70	
Type 2B Class M R2	Up to 1/30	100	130	160	220	320	400	600	
	1/60	85	110	140	200	280	360	520	
	M Sync. 1/125	75	95	120	170	240	300	440	
	1/250	60	75	95	130	190	240	340	
	1/500	44	55	75	100	140	180	260	
Type 3B Class S R3	S Sync. Up to 1/30	130	170	220	300	420	550	800	

SYLVANIA BLUE DOT™ FLASH-BULB GUIDE-NUMBER DATA								
SYLVANIA CLEAR FLASHBULBS								
			ASA Film Speeds (Tungsten)					
Lamp Type	Shutter Speed		10 to 16	20 to 32	40 to 64	80 to 125	160 to 250	320 to 500
AG-1 Zirconium- Filled Class MF R5	X Sync. Up to	1/30	65	90	130	180	260	360
	Up to	1/60	40	60	85	120	170	240
		1/125	34	50	70	100	140	200
	M Sync. Only	1/250	28	42	60	85	120	170
		1/500	24	34	48	70	95	140
M-2 Class MF R4	X Sync. Up to	1/30	60	90	120	180	240	360
M-3 Zirconium- Filled Class M	X or M Up to	1/30	90	130	180	260	360	500
		1/60	75	110	150	220	300	440
	M Sync. Only	1/125	65	90	130	180	260	360
		1/250	50	75	100	150	200	300
		1/500	40	60	85	120	170	240
R4 Focal Plane	X Sync. Up to	1/30	95	130	190	260	380	550
		1/125	55	80	120	170	240	340
	FP Sync. Only	1/250	40	60	85	120	170	240
		1/500	28	42	60	85	120	170
		1/1000	20	30	42	60	85	120
Press 25 Class M R1	X or M Up to	1/30	95	140	200	280	400	550
		1/60	90	130	180	260	360	500
		1/125	75	110	160	220	320	440
	M Sync. Only	1/250	60	85	120	180	240	360
		1/500	46	65	95	130	190	260
		1/750	34	50	70	100	140	200
Press 40 Class M R2		Up to 1/30	100	150	200	300	420	600
		1/60	90	130	180	260	360	500
	M Sync.	1/125	75	110	160	220	320	440
		1/250	60	85	120	170	240	340
		1/500	46	65	95	130	190	260
FP-26 Class FP R1		Up to 1/30	100	140	200	280	400	550
		1/125	48	70	95	140	190	280
	FP Sync. Only	1/250	34	48	70	95	140	190
		1/500	24	34	48	70	95	140
		1/1000	17	24	34	48	70	95
Type 2 Class M R2		Up to 1/30	150	220	300	420	600	850
		1/60	130	190	260	380	550	750
	M Sync.	1/125	110	160	220	320	460	650
		1/250	85	130	180	260	360	500
		1/500	70	100	140	200	280	400
Type 3 Class S R3	S Sync. Up to	1/30	200	280	400	550	800	1150

Reflectors: These Guide Numbers are based on use of specific reflectors indicated by the reflector numbers: R1—4-5-inch polished reflector, R2—6-1/2 to 7-1/2-inch polished reflector, R3—Studio reflector, R4—3-inch polished reflector, R5—2-inch polished reflector. When using satin-finished reflectors of same size open lens one-half f-stop, for fan-type reflectors, open 1 f-stop.

Guide numbers are only a guide to proper exposure with flash and are based on shooting indoors, in average-sized rooms with light walls and ceilings. The walls and ceilings reflect some of the light onto the subject. When used outdoors, you don't get the additional light from reflections and the guide number formula gives too little exposure. Try opening up one step. If you shoot indoors in a large room with dark walls and a high dark ceiling, additional exposure of a half step or more is required. Bracket exposures if you have to take home a picture and there's no time to test.

GUIDE NUMBERS FOR FLASH BULBS

The guide-number equation gives you an f-stop very simply. That's because all of the complexity is in the guide number itself. For flash bulbs, it depends on the type of bulb, film speed, shutter speed, and the type of sync used in the camera.

This is all sorted out in look-up tables published by flash-bulb manufacturers and film manufacturers. Sometimes they don't agree. Solve the problem by making test shots to see what works best.

GUIDE NUMBERS FOR ELECTRONIC FLASH

Guide numbers for electronic flash are considerably simplified. Shutter speed doesn't matter because the flash is on and off again before the shutter can get closed even at its fastest speed—besides you usually use the camera flash-sync speed anyway. There is no choice in type of sync—you must use X—so guide numbers are based on X sync. All that's left is the light output of the flash unit and the film speed you are using.

Obtain the guide number for an electronic flash from the manufacturer's data or the instruction booklet. It will be specified for a certain film speed. It may be in feet or meters.

If you are using an electronic-flash unit for the first time, do not

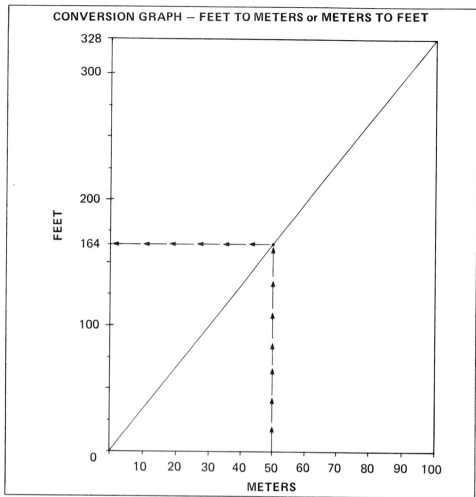

CONVERSION GRAPH — FEET TO METERS or METERS TO FEET

This thing converts meters into feet and vice-versa. In the example shown by the dotted lines, 50 meters converts to 164 feet—or, 164 feet converts to 50 meters.

Now you know the guide number is 20 feet at ASA 25. Then you convert the ASA basis from 25 to 400.

$$\text{New GN} = 20 \times \sqrt{\frac{400}{25}}$$
$$= 20 \times \sqrt{16}$$
$$= 20 \times 4$$
$$= 80 \text{ feet}$$

CONVERTING GUIDE NUMBERS TO A DIFFERENT FILM SPEED

This table gives guide-number conversion factors which you use to multiply the published guide number for the published film speed to get a new guide number for a new film speed.

Example: Your flash has a published guide number of 33 feet at a published ASA film speed of ASA 100. You are using it with ASA 160 film. What guide number should you use? As shown by the shaded square in the table, the conversion factor is 1.3. Multiply the published guide number by the conversion factor.

33 feet x 1.3 = 43 feet

The guide number to use with ASA 160 film is 43 feet.

FLASH METERS

Another way to get good exposure with flash is a special flash meter placed at the scene. Pop the flash once without exposing film. Then read the flash meter for recommended camera settings. With those settings, use a second flash to make the exposure.

With bulb-type flash, you waste one bulb to do this. Most electronic flash units have a trigger button so you can fire the flash without operating the camera. With electronic flash, you only waste a small amount of electrical power.

BARE-BULB FLASH

Using a flash holder with a removable reflector or a special holder with no reflector at all, some photographers make indoor pictures *bare bulb*—without a reflector. This gives good modeling of facial features by the direct

believe the guide number until you've shot test exposures to make sure the GN fits the kind of pictures you take. If you have to get a picture with an untested (by you!) electronic flash, bracket exposures.

CONVERTING GUIDE NUMBERS

If the guide number is given in one unit and you prefer to use the other, here's how to convert; To get GN in feet, multiply GN in meters by 3.3. To get GN in meters, divide GN in feet by 3.3.

If guide number is published for one film speed, you may need to know it for a different film speed. To convert published GN at published film speed to a new GN for new film speed:

$$\text{New GN} = \text{Published GN} \times \sqrt{\frac{\text{New Film Speed}}{\text{Published Film Speed}}}$$

Example: Your flash has a published GN of 6 meters at ASA 25. You want to use ASA 400 film and measure distance in feet.

First, convert meters to feet.

$$\text{feet} = \text{meters} \times 3.3$$
$$= 6 \times 3.3$$
$$= 20 \text{ feet}$$

GUIDE NUMBER CONVERSION FACTORS TO CHANGE ASA BASIS OF GUIDE NUMBER

NEW ASA FILM SPEED

PUBLISHED ASA FILM SPEED	25	32	40	50	64	80	100	125	160	200	250	320	400
25	1.0	1.1	1.3	1.4	1.6	1.8	2.0	2.3	2.5	2.8	3.2	3.6	4.0
32	0.88	1.0	1.1	1.3	1.4	1.6	1.8	2.0	2.3	2.5	2.8	3.2	3.6
40	0.8	0.88	1.0	1.1	1.3	1.4	1.6	1.8	2.0	2.3	2.5	2.8	3.2
50	0.71	0.8	0.88	1.0	1.1	1.3	1.4	1.6	1.8	2.0	2.3	2.5	2.8
64	0.63	0.71	0.8	0.88	1.0	1.1	1.3	1.4	1.6	1.8	2.0	2.3	2.5
80	0.56	0.63	0.71	0.8	0.88	1.0	1.1	1.3	1.4	1.6	1.8	2.0	2.3
100	0.5	0.56	0.63	0.71	0.8	0.88	1.0	1.1	1.3	1.4	1.6	1.8	2.0
125	0.44	0.5	0.56	0.63	0.71	0.8	0.88	1.0	1.1	1.3	1.4	1.6	1.8
160	0.4	0.44	0.5	0.56	0.63	0.71	0.8	0.88	1.0	1.1	1.3	1.4	1.6
200	0.35	0.4	0.44	0.5	0.56	0.63	0.71	0.8	0.88	1.0	1.1	1.3	1.4
250	0.31	0.35	0.4	0.44	0.5	0.56	0.63	0.71	0.8	0.88	1.0	1.1	1.3
320	0.28	0.31	0.35	0.4	0.44	0.5	0.56	0.63	0.71	0.8	0.88	1.0	1.1
400	0.25	0.28	0.31	0.35	0.4	0.44	0.5	0.56	0.63	0.71	0.8	0.88	1.0
500	0.22	0.25	0.28	0.31	0.35	0.4	0.44	0.5	0.56	0.63	0.71	0.8	0.88
640	0.2	0.22	0.25	0.28	0.31	0.35	0.4	0.44	0.5	0.56	0.63	0.71	0.8
800	0.18	0.2	0.22	0.25	0.28	0.31	0.35	0.4	0.44	0.5	0.56	0.63	0.71
1000	0.16	0.18	0.2	0.22	0.25	0.28	0.31	0.35	0.4	0.44	0.5	0.56	0.63
1250	0.14	0.16	0.18	0.2	0.22	0.25	0.28	0.31	0.35	0.4	0.44	0.5	0.56
1600	0.13	0.14	0.16	0.18	0.2	0.22	0.25	0.28	0.31	0.35	0.4	0.44	0.5
2000	0.11	0.13	0.14	0.16	0.18	0.2	0.22	0.25	0.28	0.31	0.35	0.4	0.44
2500	0.1	0.11	0.13	0.14	0.16	0.18	0.2	0.22	0.25	0.28	0.31	0.35	0.4
3200	0.09	0.1	0.11	0.13	0.14	0.16	0.18	0.2	0.22	0.25	0.28	0.31	0.35
4000	0.08	0.09	0.1	0.11	0.13	0.14	0.16	0.18	0.2	0.22	0.25	0.28	0.31
5000	0.07	0.08	0.09	0.1	0.11	0.13	0.14	0.16	0.18	0.2	0.22	0.25	0.28
6400	0.06	0.07	0.08	0.09	0.1	0.11	0.13	0.14	0.16	0.18	0.2	0.22	0.25

NEW ASA FILM SPEED

PUBLISHED ASA FILM SPEED	500	640	800	1000	1250	1600	2000	2500	3200	4000	5000	6400
25	4.5	5.0	5.6	6.3	7.1	8.0	8.9	10.0	11.3	12.7	14.1	16.0
32	4.0	4.5	5.0	5.6	6.3	7.1	8.0	8.9	10.0	11.3	12.7	14.1
40	3.6	4.0	4.5	5.0	5.6	6.3	7.1	8.0	8.9	10.0	11.3	12.7
50	3.2	3.6	4.0	4.5	5.0	5.6	6.3	7.1	8.0	8.9	10.0	11.3
64	2.8	3.2	3.6	4.0	4.5	5.0	5.6	6.3	7.1	8.0	8.9	10.0
80	2.5	2.8	3.2	3.6	4.0	4.5	5.0	5.6	6.3	7.1	8.0	8.9
100	2.3	2.5	2.8	3.2	3.6	4.0	4.5	5.0	5.6	6.3	7.1	8.0
125	2.0	2.3	2.5	2.8	3.2	3.6	4.0	4.5	5.0	5.6	6.3	7.1
160	1.8	2.0	2.3	2.5	2.8	3.2	3.6	4.0	4.5	5.0	5.6	6.3
200	1.6	1.8	2.0	2.3	2.5	2.8	3.2	3.6	4.0	4.5	5.0	5.6
250	1.4	1.6	1.8	2.0	2.3	2.5	2.8	3.2	3.6	4.0	4.5	5.0
320	1.3	1.4	1.6	1.8	2.0	2.3	2.5	2.8	3.2	3.6	4.0	4.5
400	1.1	1.3	1.4	1.6	1.8	2.0	2.3	2.5	2.8	3.2	3.6	4.0
500	1.0	1.1	1.3	1.4	1.6	1.8	2.0	2.3	2.5	2.8	3.2	3.6
640	0.88	1.0	1.1	1.3	1.4	1.6	1.8	2.0	2.3	2.5	2.8	3.2
800	0.8	0.88	1.0	1.1	1.3	1.4	1.6	1.8	2.0	2.3	2.5	2.8
1000	0.71	0.8	0.88	1.0	1.1	1.3	1.4	1.6	1.8	2.0	2.3	2.5
1250	0.63	0.71	0.8	0.88	1.0	1.1	1.3	1.4	1.6	1.8	2.0	2.3
1600	0.56	0.63	0.71	0.8	0.88	1.0	1.1	1.3	1.4	1.6	1.8	2.0
2000	0.5	0.56	0.63	0.71	0.8	0.88	1.0	1.1	1.3	1.4	1.6	1.8
2500	0.44	0.5	0.56	0.63	0.71	0.8	0.88	1.0	1.1	1.3	1.4	1.6
3200	0.4	0.44	0.5	0.56	0.63	0.71	0.8	0.88	1.0	1.1	1.3	1.4
4000	0.35	0.4	0.44	0.5	0.56	0.63	0.71	0.8	0.88	1.0	1.1	1.3
5000	0.31	0.35	0.4	0.44	0.5	0.56	0.63	0.71	0.8	0.88	1.0	1.1
6400	0.28	0.31	0.35	0.4	0.44	0.5	0.56	0.63	0.71	0.8	0.88	1.0

light from the flash but prevents the shadows from being too dark because of light reflected from the walls and ceiling. The reflected light is diffused and gives a pleasing softness to the general illumination.

A flash-holder reflector reflects better than walls, so there is some loss of light with a bare bulb. Try one and two steps more exposure.

OPEN FLASH

Still another way to use flash with your camera is to open the shutter on B, lock it open, and keep it open while firing one or more flashes, either bulb-type or electronic.

This lets you do some tricks. If you are shooting a large dark interior, you can pop several flashes from the same location, just to get enough exposure. This can happen, for example, at night when you are using a telephoto lens because for some reason you can't get close to the subject. If the subject isn't moving, you can use several flashes in sequence with the shutter held open.

Here's a way to figure how many flashes you need. Decide what f-stop you will use. Figure the distance that will be properly illuminated with that f-stop and one flash, using the flash guide number:

$$D_1 = \frac{GN}{f}$$

D_1 is the distance properly illuminated by one flash.

Then determine the distance to the subject, D_s. The number of flashes to use, N, is found by:

$$N = \left(\frac{D_s}{D_1}\right)^2$$

Example: Your flash has a guide number of 48 feet with the film you plan to use. You choose f-8 to get reasonable depth of field. The distance you can cover with a single flash is

$$D_1 = \frac{48}{8}$$

$$= 6 \text{ feet}$$

The subject distance, D_s, is 24 feet. Figure the number of flashes.

$$N = \left(\frac{24}{6}\right)^2$$

$$= (4)^2$$

$$= 16 \text{ flashes}$$

This is simply an application of the inverse square law about light.

CAUTION: When you make a large number of flashes, their cumulative effect may not be as much as you expect. The total exposure is less than the sum of its parts. Therefore add some more flashes. The only way to find out how many is to test. Doing this will show how much more economical electronic flashes are, compared to bulb flashes.

Another way is to get a lot of flash units and fire them all simultaneously. The method of calculation is the same. Instead of firing 16 flashes individually, fire them all simultaneously. This is more likely to give correct film exposure without adjustment because it is only one exposure, at the correct amount of light.

PAINTING WITH LIGHT

You may need to photograph a building, a large statue, or a large room at night. A single flash won't do the job because it doesn't illuminate enough area.

With an open shutter, you or an assistant can move around with a flash unit, popping flashes at various locations to illuminate the entire scene.

Consider using a type FF flash bulb instead. These are similar to FP bulbs except they make light for 2.5 seconds! They have a medium screw base, so require a special holder of the type used for most of the powerful flash bulbs.

While the flash is making light, move the beam around over the surface in S-shaped patterns, being careful not to overlap very much.

In a 7-inch-diameter polished reflector, with ASA 100 film, the FF-33 bulb has a guide number of 470.

Another way is to use continuous light sources such as movie lights. Whatever you use, exposure depends on how evenly the light is moved around to illuminate the entire scene and how often the light traces over the same point. Camera settings should be determined by testing. Be sure the person holding the light source doesn't stand between the camera and an illuminated part of the scene—if he does, you will photograph him in silhouette.

HOW TO USE FLASH FOR MAIN AND FILL LIGHTS

To use flash as the main light, use the guide number to figure f-stop for the distance between *flash* and subject.

For a two-flash setup, position the main light so it will cast shadows. Position the fill light to fill the shadows—usually near the camera but on the opposite side from the main light.

Use the f-number calculation to predict the amount of light from each flash. If the two flash units are identical, positioning them at the same distance from the subject will give the same f-number calculation for each flash. That tells you the amount of light on the subject will be the same for each flash. This is a 1:1 lighting ratio, sometimes called *full fill*.

Normally you will use 1, 2 or 3 steps less light for the fill. Using 4 or more steps doesn't give enough fill light to be worth the trouble.

Position the fill flash at greater distance according to this table:

FOR FILL FLASH	MULTIPLY MAIN FLASH DISTANCE BY
1 step less	1.4
2 steps less	2
3 steps less	2.8

With electronic flash, you can reduce light output approximately 1 step by putting one layer of white pocket handkerchief or white facial tissue in front of the flash. This is risky with bulb flash because the bulbs get very hot and could start a flame.

With electronic flash you can reduce light output about 1 step by covering half of the flash window with your fingers or some other way. To reduce 2 steps, cover 3/4 of the window. Don't try to cover bulb flashes with your fingers—you'll get burned.

BOUNCE LIGHTING

Any light of small size such as a flood lamp or a flash tends to make sharp shadows and give a harsh lighting effect. This can be reduced by bouncing the light off a reflecting surface so the reflected light illuminates the subject. This makes a very pleasing portrait.

Suitable reflectors are specially made umbrellas, flat panels, walls and ceilings. In every case, some light is lost in reflection.

With Continuous Light Sources—Arrange the lighting for the desired effect, measure with a meter and expose accordingly.

With Flash—Exposure can be predicted, using the flash guide number, and then increasing exposure to compensate for the bounce. It is common to bounce light off the ceiling because it arrives at the subject from above which we accept as natural-looking light.

To use the guide-number calculation, measure flash-to-subject distance along the light path—from flash to the reflecting surface and then from the surface to the subject. With practice, you can estimate this closely. Then increase exposure 1 or 2 steps to compensate for light loss.

With Umbrella—Point the flash or continuous light source into the umbrella and the umbrella at the subject. Light-loss compensation is in the umbrella instructions—typically it is 1/4 to 3 steps.

Color of Light—Light reflected from a colored surface—wall, ceiling, umbrella or an item of clothing—will be colored and the effect is visible in a color photo.

Some small hot-shoe-mounted flash units have swivel flash heads so you can point them upward to bounce the light off the ceiling. With detachable handle-mount flash, you can point the light in any direction you choose.

Light-diffusing umbrellas are available in various colors and styles. This Reflectasol® Soff Shoulder® unit is portable and gives an elevated, diffused light source which is very good for portraits, just as you see in this photo.

USING FLASH WITH SUNLIGHT

Use slow-speed film or a neutral-density filter over the lens—page 123. Fast film at flash-sync speed may require apertures smaller than the lens has.

Super-Simple Flash Fill—Pose the subject so the sunlight makes facial shadows. Using a shutter speed suitable for flash, meter the subject and set the camera for full normal exposure by sunlight.

Using the f-stop set into the lens in the preceding step and the guide number of the flash, calculate subject distance for full exposure with flash:

$$\text{Distance} = \frac{\text{Guide Number}}{f\text{-stop}}$$

Place both camera and flash at the distance calculated for full exposure with flash. Outdoors, flash is one-half to one step less bright because there are no room reflections, so this setup gives a lighting ratio between 1:1 and 2:1.

If this Places Camera Too Far from the Subject—Change to a longer lens. Or, move the camera closer to the subject but leave the flash at the calculated distance. This requires an extension flash cord and an assistant or tripod to hold the flash. Or, move both camera and flash closer and reduce the amount of light from the flash by covering it with a handkerchief or white facial tissue.

If You Want Less Fill Light— Leave camera in position but move the flash back. Multiplying flash-to-subject distance by 1.4 reduces the light by 1 step. Or use camera and flash at the same location but reduce light from the flash by covering the window, as described earlier.

If This Positions the Camera Too Close—Move camera back but leave the flash in the calculated location.

Outdoor photo in direct sunlight causes strong shadows across Sandy's face and under her chin.

Camera and flash set up by super-simple method described in text. Shadows are opened up—notice necklace chain is now visible in shadowed area. This is a brightness ratio of about 3 to 1.

Same set-up, except half of electronic-flash window is covered, changing brightness ratio to about 5 to 1. Using less fill than this is usually not worthwhile.

I have opened the lens until the background is visibly overexposed and Berta's face is still in shadow.

Flash is very useful for backlit subjects. Notice outdoor exposure is better, face exposure is better. Flash unit was pointed upward so light bounced off ceiling. This gives diffused, natural-looking light with some modeling of facial features.

FLASH WITH BACKLIGHTING

When the background is very bright, such as sky or a window behind your subject, and the background gets normal exposure, your subject's face will be dark. Using the guide-number calculation, set the camera for full normal exposure of the subject, with flash. Shoot that way.

ELECTRONIC-FLASH MOUNTING METHODS

The mounting method is important in your choice of an electronic flash. Some mount in your camera

hot shoe. A few of these can also be cord-connected to the camera when you don't want to mount them in the hot shoe. Another type, usually called *handle-mount,* is intended for use separate from the camera, connected by a flash cord. Handle-mount units can be attached to the camera by a *flash bracket* which attaches to the tripod socket on the bottom of the camera.

The flash bracket holds the handle-mount flash unit with a quick-release clamp so you can easily separate flash from camera when you want to.

Hot-shoe types usually have less light output but there is some overlap between the two types.

The hot-shoe type is convenient because no flash cord is used and the flash becomes part of the camera. The hot-shoe location is poor because it points the flash directly into the face of your subject, giving flat lighting. If the flash is too close to the lens, some light entering the subject's eyes can reflect directly back into the lens. Blood vessels at the back of the eye color the reflected light and your subject exhibits *red-eye.* This is unusual with shoe-mounted flash on 35mm

Strong side lighting usually makes a bad portrait.

With a powerful flash up close, the lens opening required for normal exposure with flash becomes very small. This can reduce exposure from daylight so much that no shadows are left. This is not flash fill, this is a photo made with flash. Flash unit was on camera, giving flat, harsh lighting on face.

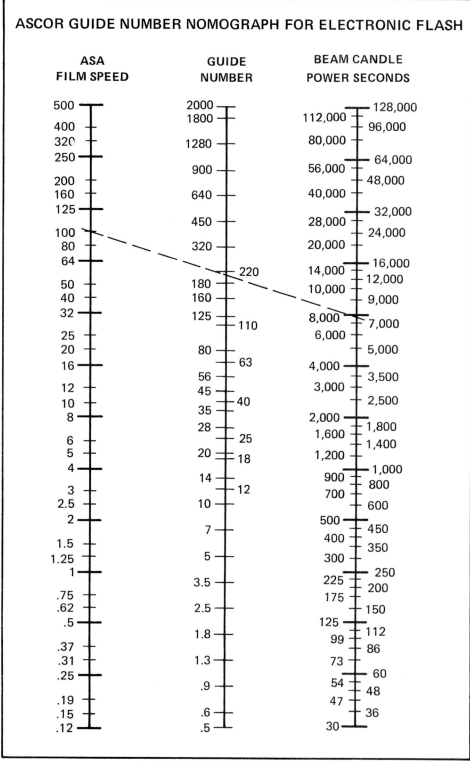

ASCOR GUIDE NUMBER NOMOGRAPH FOR ELECTRONIC FLASH

ASA FILM SPEED	GUIDE NUMBER	BEAM CANDLE POWER SECONDS

Some flash units use Beam Candle Power Seconds (BCPS) to specify light output, instead of a guide number. Usually you need the guide number. This handy nomograph furnished by Berkey Marketing Companies, Inc., solves the problem. It shows ASA film speeds, guide numbers and BCPS numbers. Draw a straight line between any two of these three and the line will pass through the third.

SLR's because the distance between flash and lens is normally large enough to prevent it.

Camera hot shoes are intended to support only small lightweight flash units. Some shoe-mount flashes are relatively large and may bend the pentaprism housing on the camera.

Some shoe-mount units have a pivoting lamp housing so the flash can be directed upward to bounce off the ceiling. This gives much-improved people pictures. These units are usually heavier than the type without bounce capability, so there is more risk of bending the camera body.

Handle-mount flash units, cord-connected to the camera, are cumbersome and usually leave only one hand free to operate the camera. However, with a long cord, they can be held high and away from the camera. You can aim this type to bounce light off the ceiling or a nearby wall for better lighting for people pictures. When bracket-mounted to the camera they are easy to handle and operate but the whole apparatus then becomes rather large and heavy. Handle-mount flash units usually have more light output and operating features than the shoe-mount types. You may have to put your camera on a tripod or have an assistant hold the flash when using handle-mount flash units.

NON-AUTOMATIC ELECTRONIC FLASH

These can be thought of as "reusable" flash bulbs. They make a certain amount of light each time they operate and are used with guide numbers to figure f-stop. Most have a built-in GN calculator to solve the guide-number equation for you. First, set film speed into the calculator. The calculator displays pairs of numbers—distance and f-stop. Look at the distance between flash and subject, read the adjacent f-stop and set it on the lens.

Calculator on this non-automatic electronic flash unit does the guide-number arithmetic for you. Set movable dial to ASA film speed being used—in this case, ASA 25. Calculator says use f-2.8 when distance to subject is 3 meters or 10 feet.

Amount of Light—Portable electronic flash units are battery-powered. Between the battery and the flash tube is a special circuit which increases the voltage to a higher value such as 400 Volts. This higher voltage is stored in a capacitor which is an electrical-charge reservoir. When the flash tube is turned on by the camera, it makes light until there is not enough charge left in the capacitor to supply the tube. The tube turns itself off when the capacitor charge runs out.

Brightness is determined by the flash tube used and other design factors. Duration of light from a non-automatic flash is determined by the size of the storage capacitor. Duration is virtually constant from flash to flash.

AUTOMATIC LIGHT-SENSING FLASH

These eliminate guide-number calculations and allow you to use the same f-stop setting over a wide range of flash-to-subject distances. This is done by a light sensor which measures light reflected from the scene and turns off the flash when it "thinks" enough light has returned for proper exposure *in the camera*. The light sensor is independent of the camera, mounted either in the body of the flash or on an extension cord so it can be mounted on the camera.

Either way, the flash sensor must view the same scene the camera lens does. The angle of view of the flash sensor doesn't change when you change lenses on the camera. Typically the sensor sees an angle between 10° and 30°. With wide-angle lenses, the sensor examines the central part of the scene, assuming it is pointed correctly. With telephoto lenses, the sensor may see more than the lens.

The sensor works fine when viewing an average scene or a middle tone. It can be fooled the same way as the exposure meter in your camera—by non-average scenes or by metering on very light or dark backgrounds. You can compensate the same way, by using larger or smaller aperture.

Automatic flash works with the same camera setting over a range of distances because the sensor changes flash time duration. At maximum range, the flash shuts off just like a non-auto flash—because it runs out of power in the capacitor. At shorter distances, the flash is turned off by the sensor. Therefore the flash tube makes light for a shorter time. At the minimum working distance, the flash tube is turned on and off in the shortest possible time. This can be a very short interval such as 1/50,000 second.

For the flash sensor to measure light for the camera, it must "know" the exposure settings. You should have the camera set at

Automatic electronic flash units have a light-measuring sensor that receives light reflected from the scene. This flash mounts in the camera hot shoe, but the flash head swivels upward for bounce flash. Sensor is in the body (arrow) and continues to look straight ahead even when the light is bounced.

This automatic flash calculator dial offers three distance ranges and three f-stops, depending on where you have set the sensor control on the front of the flash unit. At f-4, you can shoot automatically up to 15 feet. At f-2.8, you can shoot up to 20 feet. At f-2, you can shoot up to 30 feet. Minimum distances are not shown but are usually about 10 percent of the maximum distance. Rotating selector dial to higher film speeds allows use of three different apertures.

electronic-flash-sync speed. The remaining exposure control is *f*-stop.

With a large lens aperture, the same amount of light from the flash will give proper exposure at a greater distance. Therefore maximum working distance of the flash is determined by the aperture setting. Most automatic electronic flash units allow 2 or more aperture settings so you have some control over depth of field. A built-in calculator tells you the maximum range for each aperture setting.

When the camera lens is set at the smaller of two allowable aperture sizes, less light passes through the lens. The light sensor must also receive less light if it is to measure exposure accurately on behalf of the camera. When multiple *f*-stops are allowed, there is some way to change the amount of light received by the flash sensor. This may be a sliding panel with a set of holes varying in size. By moving the panel, you select a hole that lets in the correct amount of light to agree with the lens setting. Another way is a sliding panel with a set of filters which are darker in steps. By selecting the correct filter, flash-sensor sensitivity is changed to agree with the lens *f*-stop. Still another way is to control flash-sensor sensitivity by an electrical control on the flash unit. They all give the same results.

Minimum operating range of the automatic flash is sometimes displayed on the flash calculator, sometimes not mentioned, and sometimes given in the flash instruction booklet. Typically it is about 10% of the maximum range.

How to Set Up—On the flash calculator dial, set in the film speed. This positions a set of distance ranges opposite a set of *f*-numbers. There will be as many distance ranges as there are choices of *f*-numbers. Decide which *f*-stop you want to use and observe the maximum distance indicated for that *f*-stop. Also observe the color or letter identification of that distance scale. For example, if there are two allowable

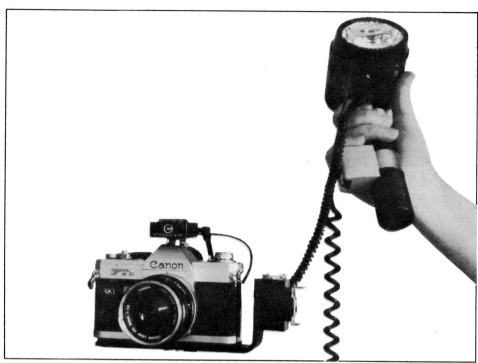

Detachable flash units have separate sensors which you mount on camera hot-shoe or on flash bracket. Sensor "looks" where the camera does while you point the flash unit up or to the side for bounce flash.

f-stops and two distance ranges, the distance scales may be red and green, or A and B. This coding helps you set the sensor so it receives the same amount of light as the camera lens. On the front of the flash is a control marked red and green, or A and B, or something equivalent. Set the control to agree with the distance range you intend to use and the corresponding *f*-stop. Then set that *f*-stop at the lens. Now you are ready to shoot.

At all distances between minimum and maximum of the range you are using, you can shoot without changing anything except focus. The light sensor measures the amount of light reflected from the subject and turns off the flash when there is enough exposure.

Switching to Non-Automatic—Most light-sensing automatic flash units have one sensor-control setting which puts the flash on non-automatic. This setting merely blocks all light from the sensor so it can never turn off the flash. The flash

makes light for as long as it can each time you fire it. It is used with a guide number just like any other non-automatic flash. A few auto-flashes don't have the non-auto setting, but you can make it work that way by putting a piece of black tape over the sensor.

How to Find the Guide Number of an Automatic Flash—If the instructions don't give the guide number, or if you have forgotten it, the calculator will tell you what it is. On any of the distance scales, notice the maximum range and the associated *f*-stop. Multiply range by *f*-stop to get guide number. This number is only for the film speed you have set into the calculator and only for non-automatic operation of the flash.

Example: One of the distance scales shows a maximum range of 20 feet when lens aperture is *f*-4. Guide number is 80 feet for that film speed.

Bounce Flash with Automatic Units—Some shoe-mount automatics have a pivoting flash head so you can

bounce light off the ceiling. The sensor is in the flash body so it continues to look straight ahead. Bounce flash is automatic because the sensor continues to measure light from the scene.

Handle-mount flash units are easy to point anywhere, including the ceiling. To use these for bounce, the flash head must swivel or the sensor must be a separate unit designed to mount in the hot shoe or on a flash bracket adjacent to the camera, pointed at the scene.

Confidence Lights—Most electronic flash units have a pushbutton you can use to fire the flash independent of the camera. Some have a *confidence light* on the flash unit to tell you if you are going to get a good exposure. Fire the flash independently of the camera. If the confidence light goes on, you know enough light came back from the scene to get a good exposure. This is particularly useful for bounce flash because the *direct* distance-to-subject is less than the bounce path of the light. Therefore the range of operation is reduced when bouncing the light. If you get the confidence light, you know the light loss due to bouncing is not too much.

Ready Light—Electronic flash units have a small ready light on the flash body that glows when the capacitor has charged enough to operate the flash. Don't fire until you

INTERCHANGEABLE BATTERIES

Duracell®	Voltage	Type	Eveready®	Ray-O-Vac®	Japanese
MN1300	D1.5	Alkaline	E95	813	AM1
MN1400	C1.5	Alkaline	E93	814	AM2
MN1500	AA1.5	Alkaline	E91	815	AM3
MN1604	9.0	Alkaline	—	—	—
MN2400	AAA1.5	Alkaline	E92	824	AM4
MN9100	N1.5	Alkaline	E90	810	AM5
MS76	1.5	Silver	S76	RS76	GM13
PX1	1.35	Mercury	EPX1	RPX1	HS-P
PX13	1.35	Mercury	EPX13	RPX13	HS-D/H-D
PX14	2.7	Mercury	EPX14	RPX14	HS-2D/H-2D
PX19	4.5	Alkaline	531	RPX19	—
PX21	4.5	Alkaline	523	RPX21	—
PX23	5.6	Mercury	EPX23	RPX23	—
PX24	3.0	Alkaline	532	RPX24	—
PX25	4.05	Mercury	EPX25	RPX25	—
PX27	5.6	Mercury	—	RPX27	—
PX28	6.0	Silver	544	RPX28	4G13
PX30	3.0	Alkaline	EPX30	RPX30	—
PX32	5.6	Mercury	—	—	HM-4N
PX625	1.35	Mercury	EPX625	RPX625	H-D
PX640	1.35	Mercury	EPX640	—	H-N
PX675	1.35	Mercury	EPX675	RPX675	HS-C/H-C
PX825	1.5	Alkaline	EPX825	RPX825	AMF
RM400R	1.35	Mercury	E400	T400	—
RM640	1.4	Mercury	E640	T640	—
SA13D	D1.5	Rechargeable Alkaline	—	—	—
SA14C	C1.5	Rechargeable Alkaline	—	—	—
SA15AA	AA1.5	Rechargeable Alkaline	—	—	—
TR112R	2.7	Mercury	—	—	KM-2D
TR164	5.6	Mercury	E164	T164	KM-4N
7R31	K4.0	Mercury	538	RPX31	—
7K67	FLAT-PAK® 6.0	Alkaline	539BP	—	—
M215	22-1/2	Zinc	412	215	O15
M504	15	Zinc	504	220	W10
M505	22-1/2	Zinc	505	221	W15
PF489	225	Zinc	489	N150	—
PF491	240	Zinc	491	1010	O160
PF497	510	Zinc	497	1012	O320

If you don't find the exact battery called for in the instructions for your camera or flash, this table will help you find an equivalent. Data courtesy of Duracell Products Company, division of P. R. Mallory & Co., Inc.

General Electric Company manufactures rechargeable NiCad batteries in several commonly used sizes, a plug-in recharger, and several battery holders to connect batteries to the charger. NiCad batteries have slightly less voltage per cell than alkaline batteries. In my flash units, using NiCad cells instead of alkaline causes no perceptible change in exposure.

see the light. The capacitor continues to charge slowly after the light goes on, so you'll get more light if you wait a while. Notice the length of time required for the ready light to turn on. Wait for the same amount of time before operating the flash and you will usually get up to twice as much light output—one exposure step more.

Battery-Charge Indicator — The ready light tells you battery condition if you notice how long it takes to turn on. When batteries are fresh, the light comes on quickly. As batteries get weak, it takes longer and longer to charge the capacitor and therefore you have to wait longer between shots.

Recycle Time—The time interval you must wait between shots until the ready light comes on is called *recycle time.* It is shortest with fresh batteries. When it reaches 30 seconds or so, it's time to replace or recharge the batteries.

Specifications for electronic-flash usually give recyle time with fresh batteries. It gets longer as the batteries discharge. The time is important to some uses, such as weddings and sports. If you make one shot of the bride coming down the aisle and can't make the next until she makes the return trip, recycle time did it to you.

Battery Types—Most small electronic flashes use size AA flashlight batteries. Ordinary batteries cost less and give fewer flashes. Alkaline batteries cost more, but give more flashes and actually cost less for each flash. Rechargeable NiCad batteries are also available. These can be recharged up to 1000 times and are worth the initial cost of batteries and charger if you've been using a lot of throwaway batteries.

Medium and high-power flashes use either high-voltage battery packs or rechargeable NiCad batteries. NiCads are either inside the flash or in a separate battery pack. These require an accessory battery charger. Specifications usually say how long it takes to put enough charge back into the NiCad battery

to shoot another roll of film. If you're in that much of a hurry, get two battery packs and keep one charged all the time. Don't store them discharged.

If you happen to discharge Ni-Cad batteries fully, perhaps by leaving the flash switch turned on for a week or else by leaving the flash on your shelf for a few months without use or attention, the batteries will require special treatment to bring them up to charge again. Check the instructions that came with your flash or with the NiCad batteries. Usually the recommended treatment is a lengthy charging period, such as 24 hours. If the batteries do not assume a full charge, the usual recommendation is to discharge them and then try another lengthy recharge. Discharge is done by installing or connecting the batteries to a flash unit and leaving the flash unit switched on until the batteries will no longer fire the flash.

Forming the Capacitor—When new or when a flash unit has not been used for a long time, the capacitor must be "formed." This is done electrically by charging the capacitor and then discharging it by firing the flash. Each time the capacitor is discharged and then recharged it improves its ability to store electricity up to about 5 times. After that, the capacitor should be as good as it's going to get.

Some flash units should not be flashed as rapidly as possible—check the instruction booklet.

The capacitor should not be stored for a long time without a charge. When you put the flash away, have it all charged up with the ready light on. Turn it off *without* firing the flash. If you don't use it regularly, recharge the capacitor about once a month by switching on the flash until the ready light comes on again. Turn it off without firing the flash.

If you forget to do this for a few months, reform the capacitor

again when you resume using the flash.

Beam Angle—If the angle of view of your lens is greater than the beam angle of the flash, the picture will be dark around the edges. Flash specs give the beam angle which you can compare to lens angles of view given on page 31. Some electronic flash beams are shaped to agree closely with a horizontal 35mm frame—that is, the beam is wider horizontally than it is vertically. The information on page 31 helps you cope with that, too.

If the beam fits closely around a horizontal frame you should rotate the flash when you rotate the camera for a vertical frame. This is automatic with shoe-mount units, or a flash bracketed to the camera.

Color Quality of the Light—Manufacturers usually say the light from an electronic flash matches daylight closely enough for use with daylight film. Most users agree. Sometimes the photo will have a blue cast.

If you notice this with your flash, correct it with a faint yellow filter over the camera lens or over the flash window. A Wratten 81A filter is sometimes recommended for this, but correction is best done for each individual flash and by testing. For filter info, see page 107.

If you see a yellow color when looking into the window of the flash unit, the manufacturer has included a yellow filter and the flash is more likely to be satisfactory.

Other Electronic-Flash Accessories—There is much competition to produce new things. Handy accessories you can buy today include:

Filters that fit over the flash window to change the color or the amount of light. These include filters to make the light similar to tungsten, for use with tungsten color film. Gray-colored filters to reduce the amount of light so you

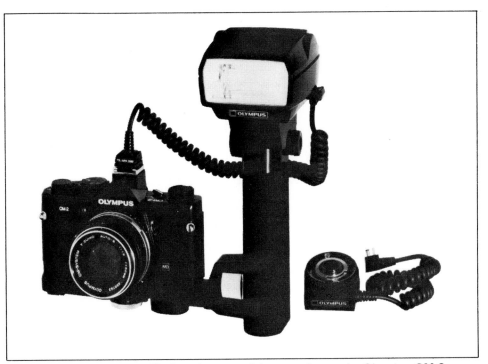

The Olympus Quick Auto Flash makes a special connection to the Olympus OM-2 camera so the camera's built-in light sensor controls flash duration. A separate light sensor for hot-shoe mounting on cameras other than the OM-2 is shown at right.

can shoot at smaller aperture, or closer.

Plastic diffusers to fit over the window, giving a softer light.

Plastic domes to fit over the window, diffusing the light and *also* directing some of it to the ceiling for bounce light.

Clear lenses to snap over the flash window for a wider beam angle when using wide-angle lenses on the camera.

AUTOMATIC FLASH USING THE CAMERA'S BUILT-IN METER

The Olympus OM-2 camera has an unusual light-metering system in the camera body which has some advantages when used with the special Olympus Quick Auto Flash unit.

There are light sensors in the camera body which measure light reaching the film and control the focal-plane shutter when the camera is set for automatic opera-

tion. The first curtain of the shutter is opened by the camera's shutter-release button. The light sensors start measuring exposure. When the correct amount of light has come through the lens the sensors send an electronic signal to the second curtain, causing it to close and shut off light to the film.

Exposure time is not pre-set at the beginning of the exposure. It is determined *during the exposure interval* by the light sensors in the camera body. If the amount of light changes during exposure, the sensors will leave the shutter open longer or close it sooner, depending on which way the light changed.

The special Quick Auto Flash connects to the OM-2 camera and uses the camera's built-in light-sensor system to turn off the flash when enough exposure has been measured by the sensor system.

This has several advantages. There is no doubt that the light sensor "sees" the same image

made by the lens. When you change lens focal length, the sensor continues to examine the image made by the lens so you never have to worry about the sensor seeing a wider or narrower angle than the lens does.

To use this flash unit, the camera must be on automatic. You must select an aperture that causes the camera to automatically select a shutter speed of 1/60 second or slower. This assures that the film frame will be completely open to light when the first curtain reaches the end of its travel—the second curtain will not yet have started to close.

X-sync from the camera fires the flash at the instant the first curtain is fully open. The light-sensor system turns off the flash when there is enough exposure. It also signals the second curtain to close, therefore the shutter will not remain open for a full 1/60 second even though the camera "had that intention" when you operated the shutter button.

Travel time for each curtain of a horizontal-run focal-plane shutter is typically about 1/100 second. Remember that shutter-open time is from the *start* of the first curtain's travel to the *start* of the second curtain's travel. Therefore the shortest exposure time you can get is still a little more than 1/100 second even though the flash itself may operate for a much shorter interval, such as 1/30,000 second.

AMBIENT-LIGHT PROBLEM

With electronic flash and a focal-plane shutter, you must use a relatively slow shutter speed. If you are shooting in relatively bright light, there will be two exposures on the film: One from the short-duration flash, the other from the ambient light affecting the film for the entire shutter-open time such as 1/60 or 1/125 second.

If these two images coincide on the film, there is no problem. If anything moves, it may cause a blur or two definite images. There isn't much we can do about this except

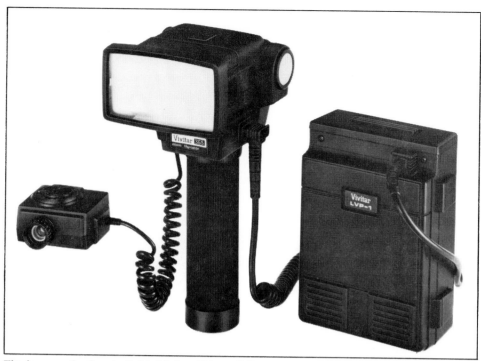

The lens on the front of this Vivitar "Zoom" flash is adjustable in and out to change the flash beam angle to match the angle of view of lenses from 35mm to 105mm. The separate camera-mounted light sensor also has an angle-of-view adjustment covering the same range. The flash head pivots upward for convenient bounce flash when the unit is bracket-mounted to the camera.

to use flash when ambient light is low. But this prevents flash fill with sunlight, for example. When using flash on a moving subject, try panning with the subject. This keeps the second image closer to the first.

RECIPROCITY FAILURE WITH AUTOMATIC FLASH

Most electronic flash is short enough to cause reciprocity failure with most films. However it is rarely observed. With automatic electronic flash and a very close, highly reflective subject, the flash may cut off in an extremely short time such as 1/30,000 second which theory says must cause reciprocity failure. Even in those conditions it is rarely observed.

A likely explanation is ambient light because it adds to exposure. The basic correction for reciprocity failure is more exposure in proportion to the severity of the reciprocity failure.

When an automatic flash runs for its maximum time, as with a distant subject, there is some additional exposure due to ambient light acting for the full shutter open time. This is a small percentage of the total amount of light reaching the film.

When an automatic flash runs for its minimum time, as with a close subject, the additional exposure due to ambient light remains the same but is a higher percentage of the total light. This acts as a sort of automatic correction.

LIGHT AND COLOR

To use filters effectively in photography, it helps to understand a few simple things about light, what happens to it in the atmosphere, how it causes the sensation of color, and how it becomes polarized.

Sunlight is considered white and is composed of all visible colors. Light rays travel in straight lines unless affected by a lens, diffraction or reflection. Along the ray path, light travels as a wave motion and has a wavelength. Different *wavelengths* affect human vision and produce the effect of different colors, as shown in the accompanying drawing of the spectrum.

Visible wavelengths range from about 700 nanometers (nm, billionths of a meter) which is red,

White light can be separated into its components in several ways. Here a special-effects filter—a Samigon Kolor-Trix®—shows that the visible colors in sunlight are red, orange, yellow, green, blue and violet.

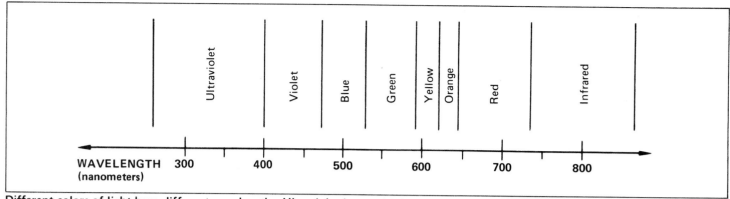

Different colors of light have different wavelengths. Ultraviolet is not visible to humans but will expose the film in your camera. Infra-red is invisible to humans and does not expose most films. Special IR films respond to infra-red wavelengths.

to about 400nm which is blue.

Wavelengths longer than about 700nm are called infra-red (IR) and are not visible but can be felt as heat. Special IR films respond to these wavelengths. Wavelengths shorter than about 400nm are called ultraviolet (UV). All commonly available films respond to UV. Film can be exposed by UV wavelengths which are invisible to the eye.

Color Vision—The eye responds only to three colors: Red, blue and green which are called the *primary* colors. All other colors are perceived by a mental process which notices the relative proportions of the primary colors and produces the mental sensation of the appropriate color. For example, red and blue together cause the visual sensation of purple. Red and green combined cause the yellow sensation.

Complementary Colors—From a photographic standpoint, white light is composed of the three primary colors in approximately equal proportions because only those three colors are necessary to create the visual sensation of white. All other visible colors can be made by combining the three primaries in various amounts.

If one of the three primary colors is removed, leaving the other two, additional colors result. Called *complementary* colors, they are important to photography.

PRIMARY COLORS	COMPLEMENTARY COLORS
Red	Cyan (Blue + Green)
Green	Magenta (Blue + Red)
Blue	Yellow (Red + Green)

ATMOSPHERIC EFFECTS ON LIGHT

Light from the sun passes through atmosphere to reach the earth. This causes changes in the light which affect photos and the way we take them.

Scattering—Sunlight is scattered by molecules of air and also by smoke and dust particles. *Scattering* means light rays deviate from straight-line paths.

Clean air such as the upper atmosphere scatters short wavelength blue light more than longer wavelengths. Therefore blue light is *extracted* from sunlight and scattered all over the sky. Some of the scattered blue reaches the earth.

This is light from the sky, rather than direct light from the sun. This light is blue, which is why the sky looks blue.

Dust, smoke and water particles (fog) are larger than air molecules and therefore scatter or reflect *all* wavelengths of light. Scattered sunlight from these particles looks white because it contains all wavelengths. The sky near the horizon often looks white instead of blue because when we look toward the horizon we are looking through the lower atmosphere which contains dust and smog.

Because of atmospheric scattering, light from the sky is blue, colder-looking, and has a higher color temperature than sunlight. A subject photographed in shade is illuminated only by skylight and the photo sometimes has a blue cast. This happens more often in high mountains because the air is clearer and therefore skylight is bluer.

The amount of light scattering by air is greater when sunlight passes through more air. At noon, sunlight travels through the least amount of air to reach the earth. At sunrise and sunset, sunlight angles through the air to reach where you are, and therefore

As sunlight travels toward the earth, atmospheric scattering takes blue light-waves out of the sunlight and scatters them all over in the sky in a series of multiple reflections from air molecules. Light from the sky is strongly blue.

travels through more air. Because of the longer path, there is more scattering of the direct rays of the sun, but it is mainly blue wavelengths which are scattered. Therefore at morning and evening sunlight has lost more blue than at any other time of day and looks more red-colored as a result. The blue light that is extracted from sunlight becomes skylight.

Light is also scattered from point to point on the earth. If you photograph a distant scene, light rays from the scene are scattered on the way to the camera. Light rays originating in bright areas of the scene are misdirected and land on the film in areas which should be dark. This reduces the contrast between light and dark areas of the image and also reduces the image sharpness.

Haze—Atmospheric *haze* is the result of light scattering. When the air is clean, most of the scattering happens to blue light which is why distant scenes look blue. When the air is polluted, blue-light scattering still happens. There is also considerable scattering of longer wavelength green and red light. When the air is not clear, we are separated from distant scenes by a white haze.

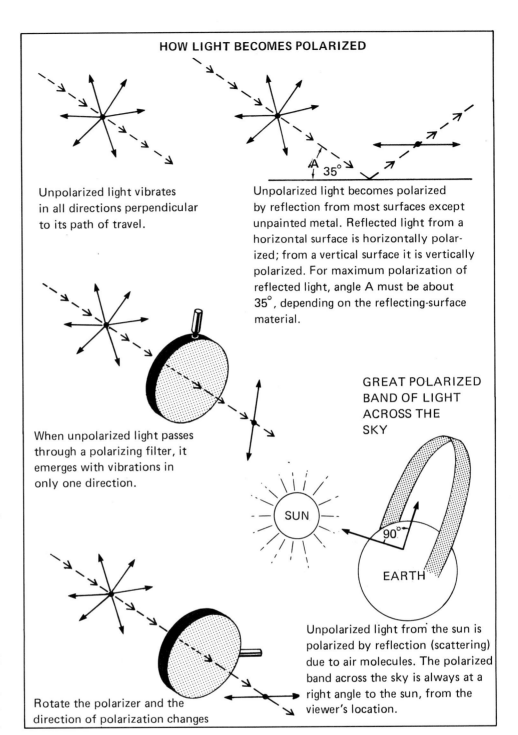

HOW LIGHT BECOMES POLARIZED

Unpolarized light vibrates in all directions perpendicular to its path of travel.

Unpolarized light becomes polarized by reflection from most surfaces except unpainted metal. Reflected light from a horizontal surface is horizontally polarized; from a vertical surface it is vertically polarized. For maximum polarization of reflected light, angle A must be about 35°, depending on the reflecting-surface material.

When unpolarized light passes through a polarizing filter, it emerges with vibrations in only one direction.

GREAT POLARIZED BAND OF LIGHT ACROSS THE SKY

Rotate the polarizer and the direction of polarization changes

Unpolarized light from the sun is polarized by reflection (scattering) due to air molecules. The polarized band across the sky is always at a right angle to the sun, from the viewer's location.

POLARIZATION

Light travels along ray paths with a wave motion similar to waves on water, with an important difference. Water waves can move only up and down on the surface of the water. Light waves can move or vibrate in all directions perpendicular to their path of travel. Unpolarized light vibrates in all directions. Polarized light vibrates mainly in one direction such as side-to-side, up-and-down, or any other angle.

Light is polarized by reflection from most surfaces except unpainted metal. Unpolarized light reflecting off a horizontal surface becomes horizontally polarized with mainly horizontal vibrations. Light reflecting off a vertical surface becomes vertically polarized. Light reflecting off tree leaves is polarized at a different angle by each leaf, because each leaf

filters. These transmit light polarized in one direction, such as vertical, and block light polarized at 90 degrees, such as horizontal. Polarizing filters are mounted in special holders which allow rotation of the *polarizer* so the angle of polarization can be changed. We use polarizing filters to select or control light reaching the film according to its polarization. Sometimes the result is amazing!

This photo was made with two kinds of light: Light reflected from the scene and light reflected or scattered toward the camera by air between camera and scene. Scattered light from the air molecules is mainly blue and puts a blue haze between camera and the distant parts of the scene. Light actually reflected from the terrain is also scattered during passage through the air, so it lands on the film in the wrong places. Notice how dark the shadows are near the camera and how they get lighter as you look farther away.

This is a photo of the Great Polarized Band across the sky. Taken with a fish-eye lens with a 180-degree field of view and a polarizing filter between lens and camera. Polarizing filter rotated to darken the polarized area. If you shoot with the polarized part of the sky in view, you can darken it by using a polarizing filter over the camera lens.

has a different angle than its neighbors.

Light is polarized most by reflection when it makes an angle of about 35 degrees with the surface. Smaller and larger angles cause less polarization.

Skylight is polarized by reflection from particles in the air. Maximum polarization is at an angle of approximately 90 degrees to the direction of the sun from where you are. When the sun is low on the horizon, a band of polarized skylight is high in the sky along a line from north to south. When the sun is directly overhead, a band of polarized skylight runs around the horizon.

This happens only on clear days with blue sky. If it is overcast or if the air is filled with haze, the polarization effect is greatly reduced.

Light can be polarized by special *polarizing screens* or *polarizing*

Filters are almost always used in front of the camera lens and change the light entering the lens in some way. A few lenses have built-in filters.

MOUNTING FILTERS

The most commonly used filters are round, either colored glass or a colored gelatin layer with glass on both sides. They are attached to the lens in one of three ways.

Screw-in Filters—Nearly all camera lenses have a screw thread in front of the lens, on the inner surface of the extended lens barrel, called a *filter ring* or *accessory ring*. A filter or a sunshade can be mounted into this filter ring. Part of the specification of each lens is the diameter of the filter ring. Common diameters are 48mm, 52mm, and 55mm, but there are many sizes.

Filters are specified by a description of their optical properties *and* their thread diameter. Obviously, to mount a threaded filter into a threaded lens, the thread diameters must be the same.

Screw-in filters are handy, quick to install, and their surfaces get some protection from the threaded metal ring around the filter because it extends a small distance in front and back of the filter element. The forward extension repeats the lens thread, so filters can be *stacked* by screwing one into another.

Screw-in filters usually allow use of the standard lens hood for your camera lens, whether it is clip-on, threaded or built-in.

The most common filter type for 35mm SLR's is the screw-in variety.

Some special-effect filters and polarizers are made in two parts. The knurled ring screws into the camera lens. The wide ring at the front holds the filter and can be rotated independently of the knurled mounting ring.

Step-up and Step-down Rings—If all of your lenses have the same filter-thread diameter, buy filters of that size. Lenses in the middle of the range of focal lengths usually have filter-thread diameters of the same size or nearly so. However lenses of larger maximum aperture use larger glass elements and often require larger filters. Also short and long focal lengths usually require larger filters.

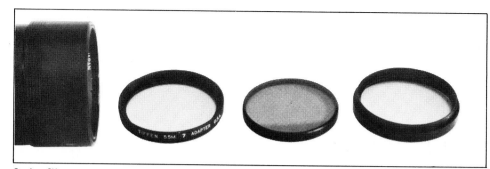

Series filters use two pieces of hardware to hold a filter. The adapter ring usually screws into the camera lens, although some slip on or bayonet in place. The plain unthreaded filter in a metal band drops into a cavity. A retaining ring screws into the adapter ring and forms the front part of the filter-holding cavity. The retaining ring repeats the series-size thread at the front so you can stack accessories or install a series-threaded lens hood. A series-threaded lens hood can usually be used to retain the filter in the adapter ring.

A step-up ring mounts a larger-diameter filter on a smaller-diameter lens. This fits between a 55mm lens and a 62mm filter.

Step-down rings go the other way. This one fits a 55mm filter on a 62mm lens. If the lens is a wide-angle, vignetting is likely.

A *small* change in filter-thread diameter can be accommodated by using *step-up* or *step-down* rings. These have two different thread diameters. One diameter screws into the lens and another diameter accepts a filter.

The name is always taken from the point of view of the lens. That is, a step-up ring mounts a larger filter than the lens itself. A step-down ring mounts a smaller filter.

Typical sizes for step-up rings are 46-48mm, 49-52mm and 55-62mm. The first diameter is the lens size; the second is the filter size. Normally, no problem is caused by using a filter larger than the lens.

Typical sizes for step-down rings are 48-46mm and 52-49mm. A filter smaller than the lens may reduce the light around the edges of the picture—called *vignetting*. This is more likely with wide-angle lenses than normal or telephoto focal lengths. If the shot is important, test first.

A lens hood screwed into a step-up or step-down ring may cause vignetting, even though the lens hood is designed for the lens focal length. This is because the step ring spaces the hood farther from its normal mounting position on the lens.

By planning ahead, you can buy filters to fit your larger lens and use them with smaller lenses by purchasing inexpensive step-up rings. This is better than doing it the other way.

SERIES FILTERS

The basic idea of series filters is similar to using screw-in filters with step-up rings to fit several smaller lenses. However the hardware is different.

Series filters are mounted in a plain metal ring with no threads. They come in standard diameters and each diameter is intended to cover a range of lens sizes. Series-filter diameter is indicated by a *series number* such as 7 or 8, sometimes written in Roman numerals VII or VIII.

Attaching a series filter to a lens requires two additional metal pieces. An *adapter ring* screws into the lens. It has a threaded cavity into which you drop the series filter. The filter is held in place by a threaded *retaining*

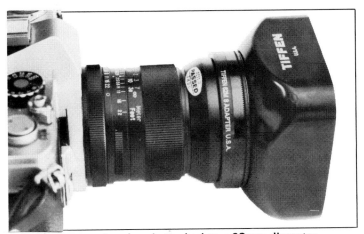

A Series-8 square lens hood attached to a 62mm-diameter wide-angle lens using a Tiffen 62M-8 adapter and retaining ring. A series-8 filter is held in place by the retaining ring.

Some lens accessories, such as this multiple-image lens, are series threaded and attach to camera lenses by a series adapter. To fit this accessory to lenses with different filter-thread diameters requires only a different adapter ring.

ring. Retaining rings repeat the thread pattern so you can drop in a second filter and hold it in place with a second retaining ring.

Lens hoods are available in series sizes to screw into the front thread of a retaining ring. An alternate way to hold a series filter in place is to screw a hood into the adapter ring instead of a retaining ring. Check each hood or sunshade with your lenses to make sure there is no vignetting.

Among all this hardware, the only thing that changes to fit different lenses is the adapter ring. Adapter rings are specified by lens-thread diameter on one side and a series number on the other. If you are using a series 7 filter with a lens that has a 55mm filter-thread diameter, buy a series 7 adapter ring with 55mm threads. All of your filters and retaining

MILLIMETER SIZE RANGE OF SERIES-TYPE ADAPTERS	
Series Number	Approximate Millimeter Range
5	17 to 36
6	27 to 49
7	40 to 62
8	40 to 77
9	56 to 84

rings will be series 7 size. If you also have some lenses with 52mm filter threads, all you need is another adapter ring—series 7 on the front and 52mm threads on the back. You also need series 7 lens hoods: Wide-angle for your wide-angle lenses; normal for your normal lenses; and telephoto or narrow-angle for your telephoto lenses.

Filters with a series number don't fit all lenses, but they fit a large range. See the accompanying table.

If you have lenses that can't be covered by a series filter set you own, you can also buy step-up and step-down rings in series sizes to go up or down by one series number—7 to 8, or 8 to 7, for example.

You can do things like this: Screw a Series 7-55mm adapter into your lens with 55mm filter threads. Screw a series 7 to 8 step-up ring into the Series 7 adapter mounted on the lens. Now you can use Series 8 filters, retaining rings and lens hoods.

If you use series-type step-down rings so you can use smaller-than-normal filters, you risk vignetting the image.

Some lenses are manufactured with series threads on the front so they accept a series-threaded retaining ring or hood directly—

without using a series adapter on the lens. Series VIII retaining rings and lens hoods screw directly into the Hasselblad 50mm Distagon, for example, and the Canon FD 85mm to 300mm zoom lens accepts Series IX hardware directly without an adapter.

Some lens accessories, such as multi-image auxiliary lenses—commonly called "filters"—are manufactured with series threads. To fit these devices onto most camera lenses, a series adapter is used. For this purpose, the adapters are usually step-up and the accessory is larger in diameter than the lens. Because there is no chance of vignetting when the accessory is larger, the range of available millimeter-to-series-thread step-up adapters is large. You can buy 48mm to series VIII, for example, which is 48mm to 63mm, approximately.

GELATIN FILTERS AND FILTER HOLDERS

Thin sheets of gelatin are available at camera shops as an inexpensive substitute for glass filters. Gelatin is fragile, must be handled with care and can not be cleaned with liquid cleaners as you would a glass surface.

Gelatin filters come in standard sizes such as 2, 3, or 4-inches

square, or may be cut to size from larger sheets. They are mounted using rectangular filter holders which are available in series sizes. Some manufacturers make rectangular gelatin-filter holders with thread sizes to screw directly into a lens. See page 157.

You can trim a gelatin filter to a round shape and hold it onto the front of a lens by pushing it gently into the filter ring. Or, put it into a round series-size filter holder. Some photographers cut gelatin filters to filter only part of the picture—such as the sky, for instance.

Some photographers use colored Cellophane or similar materials at the risk of visible optical defects in the picture.

FILTER FACTORS

Most filters reduce the amount of light entering the lens, affecting some or all of the visible colors. This reduces exposure of the film if the camera controls are not changed to restore normal exposure.

An advantage of metering behind the lens is that, in most cases, it automatically adjusts exposure for filters and other lens accessories so you don't have to make any exposure adjustment.

It's a great convenience to put accessories on the lens and then

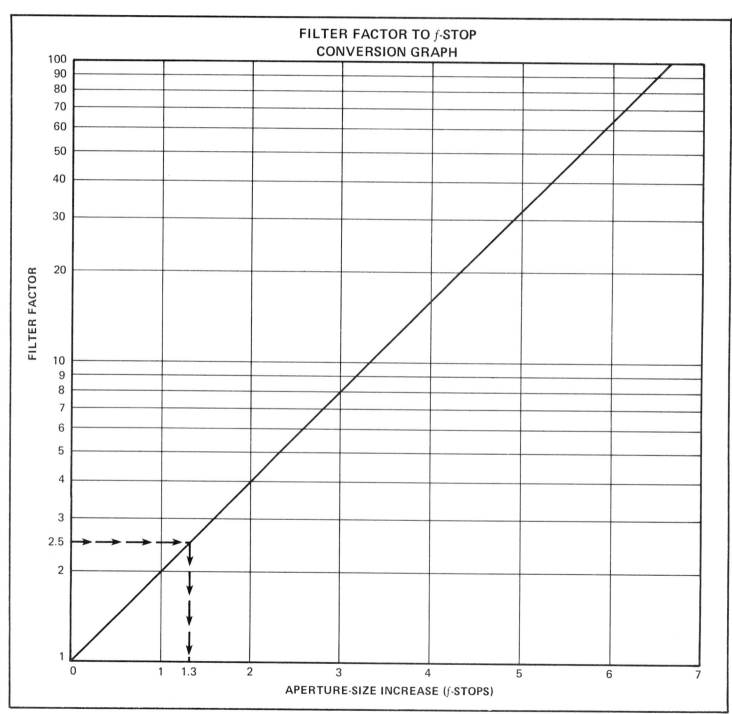

take the picture as the camera's built-in meter suggests. You don't have to worry or fuss with filter factors and light loss due to accessories. Most of the time behind-the-lens metering will serve you well, but there are a few exceptions: With some cameras using semi-spot metering, inaccurate metering results when a polarizing filter is used over the lens. In some cameras, the color sensitivity of the light-measuring sensor is not uniform and therefore some colors can upset the reading. Usually this occurs at the red end of the spectrum and readings through a dark red filter may not be accurate. You can check your camera by testing exposures through dense filters of different colors. Of course no behind-the-lens exposure meter will read accurately when viewing a non-average scene, whether there are accessories on the lens or not.

When You Don't Meter Behind the Lens—Accessory light meters give exposure settings for the case where no filter is used over the lens. When a filter is to be used, the photographer needs to know how much to increase exposure to compensate for the light loss due to the filter. This is given as *filter factor.*

HOW TO APPLY FILTER FACTORS

A filter factor is normally engraved on the metal ring surrounding the filter or given in the filter instructions. It is a factor, for example 2X where the symbol "X" means *multiply by* and the number is the multiplication factor. When using a 2X filter factor multiply exposure by 2.

If you decide to increase exposure by increasing shutter-open time, multiply shutter-open time by the filter factor. For example, if the filter factor is 2 and normal exposure time *without* the filter is 1/250, use 1/125 with the filter.

If you decide to increase exposure by opening aperture, it's not quite as simple. A filter factor of 2X calls for twice as much exposure—one step larger aperture.

4X calls for an increase of 2 f-stops, and 8X calls for 3 f-stops. Finding aperture changes for filter factors in between those easy ones can be done mathematically, but it is difficult for most of us. Use the accompanying conversion graph.
For Math Experts—To find the f-stop exposure increase for any filter factor:

$$f\text{-stop} = \text{Log}_2 \text{ (Filter Factor)}$$

HOW TO USE THE FILTER FACTOR TO f-STOP CONVERSION GRAPH

Remember, you only apply filter factors when you are not using your camera's built-in exposure meter.

If that's the case, and you decide to increase aperture rather than shutter-open time, use the graph on page 110.

Find filter factor on the vertical scale. From that point, project horizontally to intersect the line on the graph. From that intersection, drop straight down to the horizontal scale of f-stops. Read the number of f-stops and set the camera as close as you can.

Example: Normal exposure without a filter is 1/60 at f-16. You can not meter behind the lens to see the effect of a filter you plan to use, so you must use the filter factor, which is 2.5X. Using the conversion graph, find the aperture-size increase—approximately 1-1/3 f-stops. Change aperture from f-16 to f-11 for one full stop and then continue in the same direction for 1/3 stop. You end up at f-8 plus 2/3 stop. f-8 plus 1/2 stop will normally be close enough.

LIGHT-CONVERSION FILTERS

A recurring problem in color photography is to make one light source look like another—to the

film. This is done by light-conversion filters which make large changes in the color balance of the light. Here are some common light sources and types of color film:

LIGHT SOURCES
Daylight
Tungsten, 3400K
Tungsten, 3200K
Tungsten below 3200K
Fluorescent
TYPES OF COLOR FILM
Daylight, 5500K
Tungsten Type A, 3400K
Tungsten Type B, 3200K

Filters are available when needed to match each of these light sources, and others to any of the listed film types.

For example, daylight has a lot more blue than tungsten light. A filter to alter daylight so it looks like tungsten light must remove a lot of blue. Therefore the filter looks orange-colored when viewed against white light.

You can choose a filter very simply by consulting the table on page 131. Or you can do it scientifically by getting into the *mired* system.

MIRED SYSTEM

When using a filter to change the apparent color of a light source, it is convenient and usually accurate to think of it as changing the color temperature of the light source. If a filter changes daylight at 5500K to look like tungsten light at 3400K, it has changed the color temperature, reducing it by 2100K.

By some mathematical maneuvers, a system has been developed that tells us what filter is needed for any desired color-temperature change. The first step is to change all color temperatures into different numbers called *mireds.*

$$\text{Mireds} = \frac{1,000,000}{\text{Color Temperature (K)}}$$

A mired number has the same meaning as the equivalent color temperature. It's just another way of specifying the color of incandescent light.

Examples: To convert the color temperature of daylight, 5500K, into a mired number,

$$\text{Mireds} = \frac{1,000,000}{5500}$$

$$= 182$$

To convert a color temperature of 3400 into mireds,

$$\text{Mireds} = \frac{1,000,000}{3400}$$

$$= 294$$

The effect of a filter that converts daylight into 3400K, when stated in mireds is to *increase* the mired number from 182 to 294, a change of +112 mired units. This is exactly equivalent to a color-temperature *decrease* of 2100K as calculated earlier.

There are advantages in doing this: It is difficult to predict the effect of a color change when stated in color temperature because it depends a lot on the color temperature you start with. A change of 100K at 5000K is not the same as a change of 100K at 1800K. When using mired units, a change of 10 mireds has about the same effect anywhere in the visible spectrum. In other words, 10 mireds is 10 mireds.

Also, 10 mireds is about as small as you need to worry about. Smaller changes are usually not perceptible.

Decamired Units—Because 10 mired units is the minimum perceptible color change, some filter manufacturers use *decamired* units, each of which is 10 mired units. A change of 10 mired units is the same as a change of 1 decamired unit. The simplification is that *one decamired unit* is as small as you need to bother with.

Decamired filter sets are available in decamired steps of 1.5, 3, 6, 12, and so forth. These can be stacked to give any number of decamired units you want, within 1.5 units. Or you can consider decamired numbers as a code which really means 15 mireds, 30 mireds, 60 mireds, and so forth.

POSITIVE AND NEGATIVE MIRED UNITS

When dealing with changes in color temperature, it is necessary to know two things: How much is the change, and in which direction? If the change is given in mireds or decamireds, the algebraic sign (+ or −) is important because it indicates the direction of the change. Decamired filters sometimes use a letter symbol to indicate the direction of the color shift. R means shift toward red; B means toward blue. This table summarizes the methods.

METHODS OF STATING A CHANGE IN COLOR TEMPERATURE	
LIGHT BECOMES MORE RED:	**LIGHT BECOMES MORE BLUE:**
Decreased color temperature	Increased color temperature
Positive mired change	Negative mired change
Positive decamired change	Negative decamired change
Letter symbol: R	Letter symbol: B

For Math Advocates—*Mired* is an acronym for *micro-reciprocal-degrees:* The reciprocal of degrees K, multiplied by one million.

STACKING MIRED FILTERS

When two or more filters are stacked, add the mired or decamired numbers, paying attention to + or − signs.

HOW TO FIND THE COLOR TEMPERATURE OF A LIGHT SOURCE

To choose light-conversion filters using the mired system, you must know the color temperature the film needs and the color temperature of the light source. Learning about the film is easy—check the data sheet. You can measure color temperature of the light with a color-temperature meter, which is the best way. Some color-temperature meters show the needed filter in decamired units with letter symbols, such as R3 and you just use the indicated filter.

The table on page 114 helps you guess at color temperature of the light and this will often be close enough.

WHAT IF YOU DON'T HAVE ANY MIRED FILTERS?

If you have *any* light-conversion filters, you have mired filters but they may not be labeled as such. Most filter makers use the *Wratten* numbering system to identify filters. The table on page 114 gives mired numbers for some Wratten filter types.

HOW TO SELECT LIGHT-CONVERSION FILTERS

1. Determine the color temperature of the source and convert to mireds. Or get mireds directly from a meter or page 114.

2. Check the film data sheet to learn the color temperature the film is balanced for. Convert to mireds, or look up on the table on page 114.

3. Figure conversion-filter mired rating with this formula:

Conversion mireds
= Film mireds − Source mireds

4. Select a filter with the desired mired shift from the table on page 114. If necessary, stack filters and add their mired ratings.

Subject will be lit by skylight only rather than a combination of sunlight and skylight. Using a Gossen Sixticolor Color Temperature Meter to test color temperature of the light shows an R-3 decamired filter is needed to correct the excess blue in the light—in other words, 30 mireds shift toward red.

Subject photographed without a light-conversion filter looks blue and cold.

Subject photographed as recommended by the Gossen meter. Skin tone looks more nearly normal.

APPROXIMATE COLOR TEMPERATURE, MIRED AND DECAMIRED VALUES FOR COMMON LIGHT SOURCES AND FILMS

SOURCE	COLOR TEMPERATURE (K)	MIRED	DECAMIRED
Setting Sun	1500 to	667	67
	2000	500	50
Burning Candle	1800	556	56
Household Tungsten Lamps:			
40 Watt	2600	385	39
75 Watt	2800	357	36
100 Watt	2900	345	35
200 Watt	3000	333	33
3200K Photo lamps	3200	313	31
3200K Color Film	3200	313	31
3400K Photo lamps	3400	294	29
3400K Color Film	3400	294	29
Clear Aluminum-filled flash bulbs	3800	263	26
Clear Zirconium-filled flash bulbs	4200	238	24
Blue Photoflood lamps	4800	208	21
Direct Sunlight	5000	200	20
Theatrical arc lamps	5000	200	20
Standard photographic daylight	5500	182	18
Daylight Color Film	5500	182	18
Blue flash bulbs	5500	182	18
Electronic flash	6000	167	17
Sky—heavy overcast	6500	154	15
Sky—light overcast	7500	133	13
Sky—hazy blue	9000	111	11
Sky—clear	12,000 to	83	8
	20,000	50	5

MIRED NUMBERS FOR WRATTEN FILTER DESIGNATIONS

MIRED SHIFT	WRATTEN NUMBER	COLOR CHANGE
+242	86	
+131	85B	
+112	85	
+81	85C	
+67	86B	
+52	81EF	
+42	81D	TOWARD RED
+35	81C	
+27	81B	
+24	86C	
+18	81A	
+9	81	
−10	82	
−21	82A	
−24	78C	
−32	82B	
−45	82C	
−56	80D	
−67	78B	TOWARD BLUE
−81	80C	
−112	80B	
−131	80A	
−196	78AA	
−242	78	

Example: Using 3400K photo lamps (294 mireds) with daylight film (182 mireds), calculate the needed conversion:

Conversion mireds
= 182 − 294
= −112 mireds

The table on this page shows an 80B filter has a mired shift of −112. This is the standard filter to convert 3400K light for use with daylight color film. It suppresses some of the red light in the tungsten source and makes the light look more blue. The filter is blue-colored when held against white light and makes a shift toward blue which is always done by *minus* mired values.

Please notice that the calculation gives a minus answer because it subtracts 294 from 182. If you fail to watch the sign, you may do it exactly backwards. If you end up mistakenly with +112 as the conversion, that leads you to a red-shift with an 85 filter. You don't want that because an 85 filter is used to convert daylight to look like 3400K.

HOW TO USE THE LIGHT-CONVERSION FILTER GRAPH

On the Light-Source Color Temperature scale on the graph, find the color temperature or mired value of the light source. From this point, project horizontally over to intersect the curve labeled with the type of film in use.

From the intersection, drop a perpendicular to the horizontal axis. Read the Conversion Filter in mireds. If the needed conversion is a common filter, it is indicated. **Example**: Light source is photographic daylight (5500K or 182 mireds. You are using color film balanced for 3200K (313 mireds). From the intersection with the 3200K film curve, drop a perpendicular to the conversion filter scale and read +131 mireds. This is an 85B filter—normally used to convert daylight for use with 3200K film.

THINK MIREDS

Most photo literature uses tables to show which filters to use for what light-conversion job and doesn't bother you with any mireds. That is a simple and direct

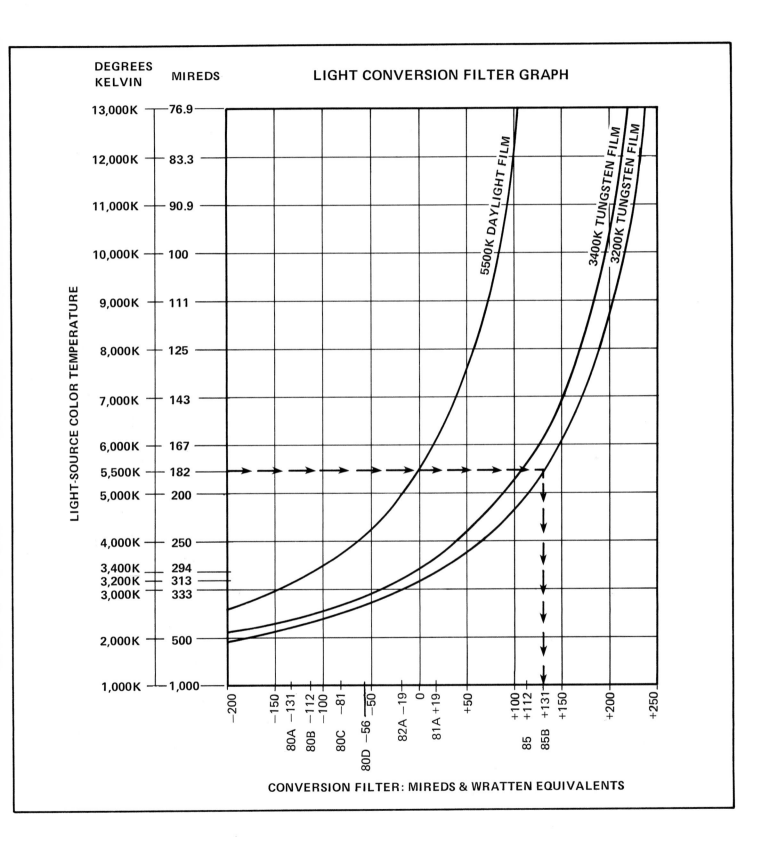

Daylight film used with tungsten lighting makes skin tone too orange.

Same lighting converted to daylight using a B-12 decamired filter which is approximately the same as a Wratten #80B. Either filter could have been used.

This is a Tiffen B-12 filter photographed against a white background in daylight. Disregard the darker blue—light passed through the filter twice to make the darker color.

method to use one filter for one job, but it doesn't help you to use that handy +131 mired filter for any other jobs.

When you are shooting a landscape with color film on an overcast afternoon, try adding +131 mireds of warm glow to your picture. You may like the effect. Mireds are mireds and you don't have to use light-conversion filters according to rigid one-purpose rules. Once you start thinking mireds, you'll improve a lot of color pictures.

LIGHT-CONVERSION FILTER EFFECTS ON COLOR-FILM SPEED

Light-conversion filters have no effect on the speed of color films. However film manufacturers publish data that makes it seem that way.

Every color film has a particular ASA rating when used with the light type the film is designed for. For example, Kodachrome 64 is a daylight slide film with an ASA film speed of 64. If you use it under tungsten light, you must use the correct light-conversion filter if you want realistic colors and skintones. When using that filter, light equivalent to daylight comes into the camera. Set the film-speed dial on the camera to ASA 64, just as you would with daylight, balance the exposure display and make the picture. When metering behind the lens with a built-in exposure meter there is never any reason to change the film-speed setting of the camera except when you deliberately want to get more or less exposure than normal.

When film makers give a different film speed for daylight film used with tungsten light and a light-conversion filter, they are merely telling you the filter factor in a different way. With behind-the-lens metering, we ignore filter factors and different film speeds published

for different kinds of light.

Here's an example. For Kodachrome 64, Kodak's current data says it has these film speeds:

With daylight	ASA 64 with no filter
With 3400 K	20 with an 80B filter
With 3200K	16 with an 80A filter

With behind-the-lens metering, ignore the lower film speeds associated with light-conversion filters. Dial in ASA 64 whether you use a conversion filter or any other kind of filter.

If You Use a Separate Hand-Held Accessory Light Meter — That's when you use the lower film speeds. With color-film speeds adjusted downward for a specific light-conversion filter, the adjusted film speed does the same thing as a filter factor—it gives more exposure.

LIGHT-BALANCING FILTERS

Light balancing is the same as light conversion except the mired shift is smaller. If you change 3200K light to match 5500K film, that's conversion. If you change 3150K light to match 3200K film, that's *balancing*.

Any small change in color temperature for either technical or artistic effect is called *light balancing*. As a rule of thumb, if you use a mired shift of less than 50, it is balancing rather than conversion.

Both light-balancing and light-conversion filters affect all colors of the visible spectrum—some more than others to get the desired change in color quality of the light.

Earlier, I suggested using +131 mireds, an 85B filter, to warm up a cold-looking outdoor scene. You may think the effect is too strong. If so, check the table on page 114 to find filters that shift toward red but have a less noticeable effect. Maybe you will prefer an 86C or an 81D. If you use one of these, you are light balancing. All of the information about mireds and filters applies to light balancing. The distinction is sort of academic but you will see light balancing discussed as a separate branch of filtering in some photo literature.

OPTICAL DENSITY

The effect of most filters is to reduce the amount of light passing through the filter. This is measured and expressed in several ways:

Transmission or *Transmittance* (T) is the amount of light that comes through the filter.

Opacity (O) relates to how much light does not come through the filter. It is defined as the reciprocal of transmittance.

O = 1/T

Density (D) is the logarithm of opacity. It is another way of stating how dark the filter is, or how much light does not come through.

D = Log_{10} O.

Filters with a higher density suppress more of the light.

Some filters are specified by optical density, which is difficult to understand because it involves logarithms. All of us can understand what's happening if a filter transmits 25% of the light, so we need a table to convert optical density

DENSITY CONVERSION TABLE		
OPTICAL DENSITY	TRANSMISSION (PERCENT)	EXPOSURE STEPS
0	100	0
0.05	89	
0.1	79	
0.2	63	
0.3	50	1
0.6	25	2
0.9	12.5	3
1.0	10	
1.2	6.25	4
1.5	3.13	5
1.8	1.56	6
2.0	1.00	
3.0	0.1	10
4.0	0.01	13.3

These numbers form a pattern which you can remember and never refer to this chart again. An optical density of 0.3 is equal to one exposure step. Each additional density of 0.3 is another step. A density of 0.9 is 3 steps. A density of 2.7 is 9 steps. Divide density by 0.3 to find the number of exposure steps.

back to easily understandable percentages of transmission.

Once density is translated into how much the light is reduced, we can convert that amount of light loss into exposure steps, remembering that each time the light is cut by 50%, that's one step.

NARROW-BAND FILTERS

A class of color filters that does not affect all colors of the spectrum is called *Color Compensating* (CC). These are intended mainly for use in color printing. Color films have three emulsion layers, each sensitive to one of the three primary colors. To control the end result in color printing, it's best to control each emulsion layer separately and that calls for narrow-band filters which affect only primary and complementary colors.

NOMENCLATURE OF CC FILTERS

CC filters have a very logical system of nomenclature:

Each filter is identified by the symbol **CC**, followed by a number, followed by a letter which is the initial letter of a primary or complementary color.

Example: CC05R. The number is optical density with the decimal omitted. This filter has a density of 0.05. The higher the density, the darker the color of the filter. The density number given is the density of that filter to the color it suppresses. An R (red) filter looks red when viewed against white light. It suppresses both blue and green (cyan) and the density of 0.05 is to cyan color.

CC filters are available in 6 colors —3 primary and 3 complementary— with density ranging from about 0.025 up to 0.5 in each color.

In addition to use in color printing, CC filters are used over camera lenses for several purposes: They make changes in the light for artistic reasons. CC filters are often specified to correct for reciprocity failure of color films—discussed later. And CC filters are often specified as the remedy for exposing color film with fluorescent lights.

COLOR-COMPENSATING FILTERS

VISUAL COLOR OF CC FILTER	COLOR SUPPRESSED BY FILTER
Red	Cyan (Blue + Green)
Blue	Yellow (Red + Green)
Green	Magenta (Blue + Red)
Cyan	Red
Yellow	Blue
Magenta	Green

CC filters are identified by the initial letter of their visual color—R for Red, and so forth. However their optical density is to the complementary color—an R filter blocks Cyan.

Filter used was a Vivitar CFD, photographed here under fluorescent light.

Fluorescent lighting gives unnatural skin tones and colors. Shutters in background are white.

Same scene shot through a general-purpose correction filter for fluorescent light and daylight color film. Color correction is not exact but more nearly acceptable than without filter.

CORRECTING COLOR-QUALITY OF FLUORESCENT LIGHTS

Fluorescent lamps don't make light by incandescence and they don't produce a spectrum like tungsten sources. The light looks OK to our eyes but colors don't look natural on color film. Correction is by recipe, using CC filters according to the type of fluorescent light and the type of color film in use.

Often the photographer can't find out what kind of fluorescent lamps are installed in ceiling fixtures and sometimes more than one kind is used in the same room. For people who don't want to bother with recipes and trying to learn what kind of lamps are illuminating the room, most filter makers offer "Fluorescent" filters that work pretty well. There is one filter for use with daylight film and another for tungsten film. Both to be used with whatever kind of fluorescent light you happen to find.

CC FILTER CORRECTIONS FOR COLOR FILMS EXPOSED UNDER FLUORESCENT LIGHTS

For more precise color correction when photographing under fluorescent lights, you can use CC filters to tailor the filtering to the kind of fluorescent lamps in use and the film type. See the accompanying table which gives Kodak recommendations for Kodak color films. This assumes that all of the fluorescent lamps installed in the room are the same type—such as Cool White, Warm White, or whatever they are. Often they are mixed and it is difficult to get up near the ceiling so you can read the labels on the lamps.

If you are serious about it, you can also get filtering recommendations from manufacturers of fluorescent lamps. They may not agree with the film manufacturers. If color quality is vital to your photo, and you must shoot under fluorescent lighting, you should make some test exposures using the accompanying table as a starting point.

COLOR-PRINTING FILTERS

A set of filters with the same color range and nomenclature system as CC filters is used to change the color of the printing light when making color prints. These are called *CP filters*. They are intended for use *between* the light source and the negative being printed, so they affect the color of the light but not the image being formed. Therefore they are not of suitable optical quality to be used in the image-forming path, such as over the lens of a camera, or below the negative in an enlarger.

TRI-COLOR FILTERS

Another set of narrow-band filters is used to prepare color photos for reproduction by printing presses. This involves making *color separations*. To do this, *separation filters* or *tri-color filters* are used; one to separate each primary color. These are very dark filters with filter factors of about 6X; one red, one blue and one green.

These filters are useful as contrast filters with b&w film and for special effects with color film. The Wratten type numbers for tri-color filters are:

Red	25 or 29
Blue	47 or 47B
Green	58 or 61

A lot of other filter types are very close to those listed and satisfactory for b&w contrast filtering. A good technical book about filters is *Kodak Filters for Scientific and Technical Uses,* available through your camera shop. It shows nearly all filter types with curves and transmission data.

FILTERS FOR BLACK AND WHITE FILM

All readily available b&w film is *panchromatic* which means it responds to all colors even though colors are reproduced as shades of gray. Although panchromatic b&w film responds to all visible colors,

FILTERS FOR USE WITH FLUORESCENT LIGHTING						
KODAK FILM TYPE	**TYPE OF FLUORESCENT LAMP**					
	DAYLIGHT	**WHITE**	**WARM WHITE**	**WARM WHITE DELUXE**	**COOL WHITE**	**COOL WHITE DELUXE**
Daylight and Type S Professional	40M + 30Y	20C + 30M	40C + 40M	60C + 30M	30M	30C + 20M
Tungsten, Type B (3200K) and Type L Professional	85B + 30M + 10Y	40M + 40Y	30M + 20Y	10Y	50M + 60Y	10M + 30Y
Type A (3400K)	85 + 30M + 10Y	40M + 30Y	30M + 10Y	NO FILTER	50M + 50Y	10M + 20Y

For precise color correction when shooting with fluorescent lighting, Eastman Kodak recommends starting with these filters. Test with the actual lighting to be used, then make any needed changes in filtering.

Tungsten film, designed for the warm glow of indoor incandescent lighting, makes outdoor scenes look blue.

Correct by using an 85B orange-colored filter.

it doesn't always reproduce them with the same relative brightnesses as we see them in real life. Therefore an article of clothing—or anything else—may look lighter or darker in the picture than it did as you saw it.

For more natural-looking brightnesses in b&w photos made with *pan* films, Kodak recommends:

Wratten filter 9 (yellow) with daylight illumination.

Wratten filter 11 (yellow-green) with tungsten illumination.

Kodak doesn't manufacture glass-disc filters in screw-in frames but you can get several brands of these filter types in screw-in mounts at your camera shop.

CONTRAST FILTERS FOR BLACK & WHITE FILM

Because b&w film doesn't show us colors, we often want to change the *contrast* in brightness between two objects in the picture. The two objects are different colors in real life but they look the same shade of gray on film. Red roses among green leaves are a standard example of this problem. Photographed without a filter, they are about the same shade of gray and it is difficult to see the rose among the leaves.

The Rule for Contrast Filters— *With b&w film a color filter lightens its own color, and darkens all other colors.*

If you hold a color filter against white light and it looks green, that's because mainly green light comes through. If you use this filter to expose b&w film, everything in the scene that looks green will be recorded on the film with more brightness, everything else looks darker.

If you like to shoot b&w film, you can have fun with contrast filtering. With different shades and different colors, you can produce dramatic effects. Some of the filters you use can also serve other purposes, such as light conversion.

There aren't any firm procedures. Look at the scene through filters you own, ignore colors and

120

Photographed in b&w, a red rose is about the same shade of gray as the surrounding green leaves.

A red filter lightens the rose and darkens the leaves so there is more contrast and the rose more prominent.

A green filter lightens the leaves and darkens the rose. Any red and green filters will have these effects. Filters with deeper colors and higher filter factors will have more pronounced effects in changing contrast.

concentrate on brightnesses, and you can sometimes predict the effect. Think about what you want to make brighter on the print and use a filter to accomplish that.

Contrast filtering doesn't always work the way you expect. This is usually because human vision does not respond to colors in the same way film does. Some fabric dyes and printing inks are made with optical brighteners which produce short-wavelength light near the UV end of the spectrum. Film is much more sensitive to these wavelengths than the eye. In black-and-white these dyes and inks may appear brighter than you think they should. On color film, the color may be entirely wrong.

DARKENING BLUE SKIES WITH B&W FILM

This is really another form of contrast filtering. Landscapes, boating scenes and similar outdoor pictures are much more dramatic if the sky is dark, particularly with bold white clouds standing out against the dark sky.

Because of light scattering, the sky is blue. To make the sky darker, use filters that exclude blue light. You have probably noticed that light cloud formations seem to disappear when photographed in b&w, without a filter. Often this is a disappointment. To get a scene that looks like what you saw, you need some filtering.

If you have an 85 or 85B filter to convert daylight for use with tungsten film, try it for sky-darkening effect. It works about as well as the 15 and you can use the filter for more than one purpose.

Water usually reflects the sky. Darken it the same way.

FILTER SELECTION TO DARKEN SKIES WITH B & W FILM	
To preserve original appearance	8 filter (yellow)
Mild darkening effect	15 (deep yellow)
Strong darkening effect	25 or 29 (dark red)

When I took this picture, *I saw* filmy white clouds against blue sky. With no filter, the film didn't record much difference between cloud brightness and sky brightness.

To preserve the original appearance of the scene, I shot it with a light-yellow 8 filter. This looks like what I saw when I took the picture. Yellow filter blocked some of the blue light from the sky and made it darker.

For more sky darkening, I used a red 25 filter. If the camera is pointing at the right place in the sky, you can also use a polarizing filter for sky darkening in b&w.

HAZE-FILTER SELECTION WITH B & W FILM	
Increase haze	57 filter (blue) or any of the 80 series
More haze than you see	Use no filter
To preserve original appearance	8 (yellow)
Medium haze cutting	15 (deep yellow) or any of the 85 series
Strong haze cutting	25 or 29 (dark red)
Maximum haze cutting	Use IR film and special IR filter

HAZE CUTTING WITH B&W FILM

This is still another form of contrast filtering. Haze is caused by light scattering in the atmosphere. The air alone scatters blue light most, green light next most, then red, and scatters infra-red the least. Using filters that block blue and transmit red reduces the effect of atmospheric haze. If you want to *increase* haze, do the reverse. Use a filter that passes blue and blocks red.

Please notice that the heirarchy of haze cutters is the same as those used for sky darkening. If you don't have these filters, try what you have. Any red, orange or yellow filter will cut haze. None of these filters, except IR, will cut white-looking haze caused by dust, smoke and fog because the scattered light is white.

UV FILTERS

Both color and b&w films respond to ultraviolet light that we can't see. This is the reason you see more haze than you expect in photos made without a filter.

If your goal is only to remove the UV and not otherwise change the photo, use a special UV filter. These look clear, have no effect on visible colors, and don't change the exposure settings in the camera. Normally they are labeled UV.

All *glass* filters cut UV significantly. If you use any other filter, you don't need to use the UV also.

Top left; no filter. Top right; yellow filter. Bottom left; red filter. Bottom right; blue filter *increases* haze effect.

SKYLIGHT FILTERS

Intended for color film with the subject in open shade, skylight filters reduce blue a small amount. This corrects for the blue color of light from the sky and improves skin tones in color photos. The effect is more noticeable at high altitude and at the beach because both have clear air. Held against white light, skylight filters have a faint pink color. They are usually labeled Skylight, sometimes 1A, and do not affect exposure settings.

A Skylight filter used with color film also cuts UV. Used with b&w film, it cuts UV and cuts haze a small amount.

HAZE FILTERS

Some makers offer "Haze" filters for color and b&w film. These are intended to remove haze you see in the picture that you *didn't* see in the scene—caused by UV. Before buying a Haze filter, look at it. If it is clear or nearly clear, UV and Skylight filters do the same job.

LENS-PROTECTING FILTERS

Some makers offer a clear "lens cap" which cuts UV but its advertised purpose is to protect the lens without requiring removal to take a picture. If you own a Skylight, UV or Haze filter, you can use it for that purpose.

If you buy one, I suggest the Skylight for all of these purposes. It gives a slight warming effect with color film but the effect is usually either pleasing or not noticed.

NEUTRAL-DENSITY FILTERS

With color or b&w film, you may want to reduce the amount of light coming through the lens. This allows longer exposure times or use of larger aperture to get less depth of field.

Neutral-density filters are gray so they don't change the color balance of the light. They reduce all colors in equal proportion.

The reduction in light is stated in two ways: By a filter factor such as 2X, or by a density number such as 0.6. The method is usually obvious in the filter nomenclature.

If you use one for either of the purposes mentioned above, you want to know how much longer

USING NEUTRAL-DENSITY FILTERS TO INCREASE EXPOSURE TIME OR APERTURE		
FILTER NOMENCLATURE	MULTIPLY EXPOSURE TIME BY:	OPEN LENS APERTURE BY (*f*-STOPS):
ND .1	1.25	1/3
ND .2	1.6	2/3
ND .3 or 2X	2	1
ND .4	2.5	1-1/3
ND .5	3.1	1-2/3
ND .6 or 4X	4	2
ND .8	6.25	2-2/3
ND .9 or 8X	8	3
ND 1.0	10	3-1/3
ND 2.0	100	6-2/3
ND 3.0	1000	10
ND 4.0	10,000	13-1/3

Glass screw-in ND filters with filter factors greater than 8X are hard to find. Camera dealers can supply Eastman Kodak gelatin ND filters in *densities* up to 4.0.

you can expose, or how many stops you can open the lens and end up with correct exposure. This table does the figuring for you but *does not include* the effect of reciprocity failure due to dim light on the film.

Special Combination Filters — In some special applications, there is need for both a neutral-density filter and a color filter of some kind, such as for light conversion. Some filter makers offer a single filter to do both jobs. Typical nomenclature is 85BN3: An 85B filter combined with an ND 0.3 filter with an optical density of 0.3. For best picture quality, one filter is better than two because there are fewer air-glass surfaces to produce reflections and flare.

RULES FOR STACKING NEUTRAL-DENSITY FILTERS

If the filters are specified by density, add the numbers. ND 0.3 and ND 0.6 are equivalent to ND 0.9.

If the filters are specified by filter factors, multiply the numbers. ND 2X and ND 4X are equivalent to ND 8X.

A trick you can do with neutral-density filters is make people disappear. This shot, without a filter, was made at 1/30 second and *f*-16 with Panatomic X film.

Using an ND 2.0 filter and closing the lens to *f*-22 gives an exposure time of about 6 seconds, not allowing for reciprocity failure. I estimated an exposure time of 30 seconds and bracketed from there. (See table on page 134.) The gentleman seated on the wall remained stationary long enough to record on film, as did the people on the far corner, waiting for the bus. Slow-moving traffic and pedestrians made some smears in the intersection. While I was taking this picture, people walked in front of the camera, looked into the lens, asked me what I was doing, offered to take my picture, and otherwise assisted. None of them held still long enough to make an image.

Reflection of old building in face of new one spoils the picture, so it is eliminated by using polarizer to make reflection disappear. Notice polarizer does not remove small reflection in windows of distant building because that reflection is not at the correct angle to polarize the reflected light.

POLARIZING FILTERS

Polarizing filters are gray-colored and reduce the light one f-stop or a little more just because they are gray. They also suppress polarization at one angle and transmit light polarized "the other way." That means, if it transmits vertically polarized light it blocks horizontally polarized light.

These filters can be rotated in their mounts, so you can change the angle of polarization they suppress or transmit. With an SLR camera, put the polarizer on the lens, look through the viewfinder and rotate the filter for the desired effect.

Removing Glare—Polarizers remove surface glare from nearly everything except unpainted metal surfaces. The effect may seem miraculous. They do this on any surface that polarizes light by reflecting it. Glare from windows, shiny furniture, leaves and many other surfaces can be removed or reduced just by rotating the polarizing filter so it blocks the angle of polarization caused by the reflecting surface.

DARKENING SKIES WITH COLOR FILM

Using yellow or red filters to darken blue skies works with b&w film, but with color film it gives you a yellow or red photo. Blue skies can be darkened on color film by using a polarizing filter. It doesn't always work because you have to point the camera at that part of the sky which is sending polarized light toward the camera. The effect is maximum when you point the camera at 90 degrees to the direction of the sun from where you are.

HOW TO FIND THE POLARIZED AREA IN THE SKY

Extend your forefinger and thumb so they make a right angle with each other. Point your forefinger at the sun. Your thumb points to the polarized part of the sky. Rotate your hand and your thumb indicates a band across the sky where the light is polarized.

Sometimes it Doesn't Work—When the sky is white, due to haze or clouds, there isn't any polarized band. Polarizers generally improve landscapes but often you must compromise because one rotational angle of your polarizer makes the sky a nice dark blue but another

A polarizer will darken blue sky if you point the camera toward the right part of the sky—the polarized band.

makes foliage or the terrain look better. That's because the angle of the reflecting surface determines the polarization angle of the reflected light. Look at a tree through a polarizing filter, rotate the filter and you will see surface glare moving around from leaf to leaf because the leaves have different angles.

POLARIZING THE LIGHT SOURCE

In a studio setup, maximum control of glare results from using a polarizing screen over the lights and a polarizing filter over the camera lens. Large plastic polarizing screens to fit over light sources are available from specialty sources such as Edmund Scientific Com-

pany. Using this set-up is largely trial-and-error. Adjust the angles until you get the desired result, or as close to it as you can.

Light from some parts of a blue sky is polarized and can be used as a polarized source. If you notice glare from unpainted metal being removed by a polarizing filter over your camera lens, it's because the metal surface is illuminated by polarized light. Metal doesn't change polarization of the light due to reflection—it reflects light without changing it.

HOW TO SET EXPOSURE WITH A POLARIZING FILTER

With *most* cameras, use a polarizing filter just as you would any other kind. Meter behind the lens *after* you have set the polarizer for the desired effect. The camera meter observes the total light loss—partly due to the gray color and partly due to rejection of light with some angle of polarization—and the camera exposure calculator suggests camera settings. These will normally be OK.

Typical polarizers have a filter factor of about 2.5X due to the gray color alone. Additional light loss occurs, depending on the polarization angle of the light reaching the filter and the rotational angle of the filter itself. However the additional light loss may not be important when setting exposure. It depends on the subject of interest in the photograph. If you are shooting a portrait against the sky, your main concern is light on your subject and light reflected from your subject. This is usually not polarized and will not be reduced by the filter. If you set the filter angle to make the sky darker but the light reflected from your subject's face doesn't change, the exposure setting of your camera shouldn't change either.

On the other hand, if you are photographing an object reflecting a lot of polarized light, the camera setting should be different if you use a filter to suppress the

polarized portion of the reflected light.

As you can imagine, experienced photographers learn to cope with this ambiguity—they bracket.

Metering Problem with Semi-Spot-Metering Cameras—Some cameras with semi-spot metering use a small angled surface to reflect *some of* the light in the viewing system so the light doesn't reach your eye but reaches a light sensor instead. This causes a small darkened area in the center of the viewfinder screen which shows the area being metered by the camera's *semi-spot* meter. The reflector is a special material that allows part of the light to pass through while reflecting the other part. In addition to doing this, the reflector also polarizes the reflected light.

What that means is, the reflector *will reflect* light of all polarizations except one. Light of that particular polarization is *suppressed* by the reflector. This can cause inaccurate meter readings and poorly exposed pictures when using a polarizing filter.

Typically the semi-spot reflector suppresses horizontally polarized light. When a polarizing filter is used over the lens to reject vertically polarized light, and the semi-spot filter in the optical system rejects horizontally polarized light, very little light reaches the sensor in the camera. It will ask you to open up the lens until it sees the right amount of light. At the film, this is overexposure because the film receives horizontally polarized light that the sensor didn't see.

There are several ways to deal with the problem. One is to rotate the polarizing filter on the camera lens until it has *minimum* effect on the meter in your camera. Set the camera exposure controls with the filter in that position, while the camera light meter is measuring approximately the same amount of light that will expose the film. Then rotate the filter for the desired effect and take the picture without changing exposure settings.

Water looks blue because it reflects the sky. A polarizer removes most of the reflection, changing both the color and character of water. It also removes reflected glare from various surfaces in scenic views.

Another is to set the polarizer for the desired effect, meter that way, then bracket one-half and a full step toward *less* exposure because you know the camera reading tends to give overexposure.

Another way is to meter without the polarizer, install the polarizer and use the filter factor to adjust exposure. This works well un-

less the subject of interest is reflecting a lot of polarized light.

All of these methods are a compromise or a guess in some way. For important shots, bracket. If you are shopping for a camera, don't let this minor problem with polarizers steer you away from semi-spot metering. In my opinion, the precision of semi-spot

Tungsten light on one side and daylight on the other is a problem. This was shot with tungsten film so daylit side looks blue. Cover half of subject's face, then cover the other half and notice the change in skin tone.

Best solution is to use 85B filter. This makes daylit side have near-normal skin tone. Tungsten side is too warm-looking, but warm is better than cold.

metering in every other application far outweighs the ambiguity when using polarizers over the lens. Buy the metering system you prefer, but don't base your decision on what the meter does when using a polarizing filter.

Leica offers a special polarizing filter which solves the metering problem. It blocks light at some angle of polarization, depending on rotation of the filter. Then it de-polarizes the light that does come through so it will be metered properly. "De-polarization" means it causes the light to vibrate in all directions again. This doesn't affect film exposure because the film doesn't "care" how the light is polarized.

How about the SLR Mirror?—You may be wondering if the moving mirror in an SLR also polarizes by reflection. It doesn't because it is front-surfaced with metal, unlike household mirrors which have metal behind the glass. The front-surfaced metal mirror in your SLR has no effect on polarization of the light it reflects.

HOW TO FIND THE POLARIZING ANGLE OF YOUR FILTER

I find it interesting and occasionally useful to know what a polarizing filter is doing—that is, what angle of polarization it is passing or blocking. To calibrate your polarizer, view reflected sunlight on a non-metallic horizontal surface when the sun is about 45 degrees above the horizon. Stand so the reflecting surface is between you and the sun. Rotate the polarizer for maximum reduction of reflected light from the horizontal surface and you have it set to block horizontally polarized light. At that setting it passes vertically polarized light. Mark the top of the rim of the polarizer with a dab of paint or fingernail polish and you have it calibrated. Some polarizers have a handle on the rim, used to rotate the polarizer. The position of the handle is supposed to indicate the polarization angle of the filter.

Once you have the filter calibrated, use it to explore scenes and objects around you. You'll learn a lot about polarized light in a very short time.

USING CROSSED (STACKED) POLARIZERS

Two polarizers, stacked, make a very good neutral-density filter with a controllable amount of light loss. When both are set at the same angle, the filter factor is about 4X or 5X. When one is rotated 90 degrees, so the two polarization angles are crossed, much less light gets through. In between, you can get virtually any amount of light you want.

MIXED LIGHTING

Photos taken with two light sources of different color temperature usually show the effect. No film or film and filter combination can be balanced for two different color temperatures.

For example, a portrait subject illuminated on one side by tungsten room light and on the other by daylight through a window cannot be photographed properly. If you balance the film for tungsten, the side illuminated by daylight looks cold and blue. If you balance the film for daylight, the side illuminated by tungsten looks too warm and red.

As a rule, *warm is better than cold.* When faced with such a choice, use film or a film-and-filter combination so you get correct skin tone under daylight. The other side will be warmer-looking but that's the best you can do.

SPECIAL-EFFECT FILTERS

Don't overlook using filters you already own for special effects with color film. Shoot an industrial scene through a red filter; a forested valley through green; a snow scene through blue. The results are sometimes surrealistic, sometimes artistic, sometimes awful.

A variety of screw-on lenses that do optical tricks is available, often called "filters." These make star effects around light sources, create multiple images, soften images for portraiture, create a zone of good focus near the camera and another in the far distance, and similar effects. There are also special "filters" which change color when you rotate the rim. I call all of these *lens accessories* because they really are not *filters.*

HOW TO CARRY YOUR FILTERS

If you carry only a few filters in your camera bag, the plastic containers in which filters are sold offer good protection. But they take a lot of space and are sometimes difficult to open quickly.

Filter cases give quick access with minimum fumbling and unscrewing. But they are bulky and don't hold many filters.

If you carry more than four filters, I recommend these filter caps. Screw all your filters together, then protect the ends with the caps. To remove one filter, unscrew the stack where the filter is.

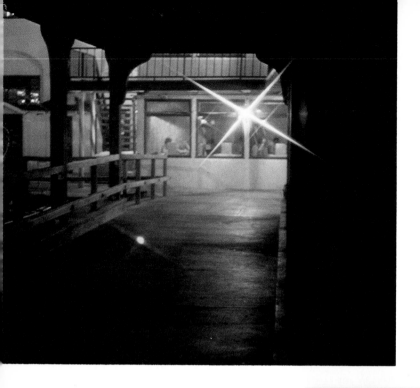

Probably the most useful special-effect accessory is a star filter. It puts points of light around any small bright light source. These photos were made with a Hoya Vario-Cross accessory which can be adjusted to change the angles of the points of light.

Star-effect filters are handy to add interest to an otherwise ordinary scene.

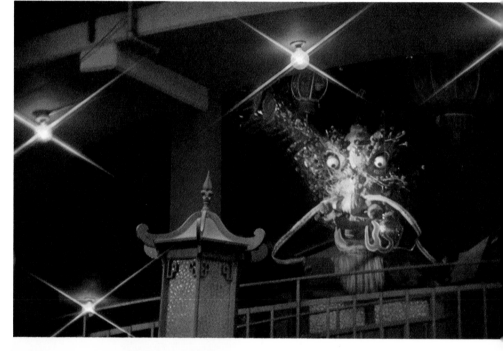

Occasionally the star effect is overdone.

SELECTION CHART FOR COMMONLY-USED FILTERS

FILM TYPE	DESIRED RESULT	LIGHT ON SCENE	VISUAL COLOR OF FILTER	HOYA	TIFFEN	VIVITAR	BDB FILTRAN	FILTER FACTOR (Approx.)
Any	Reduce UV exposure of film	Day	Clear	UV	Haze 1	UV-Haze	UV/Haze	1X
	Reduce amount of light 2 stops without affecting colors	Any	Gray	NDX4	ND 0.6	ND-6	ND4X	4X
	Reduce amount of light 3 stops without affecting colors	Any	Gray	NDX8	ND 0.9			8X
	Soften facial lines in portraits, soften lines in any image	Any	Clear	Diffuser	Diffusion Filter #1	Soft Focus	Soft Focus	1X
	Increase softening effect	Any	Clear	Soft Spot	Diffusion Filter #3			1X
B & W	Darken blue sky and sea, lighten clouds for contrast	Day	Light Yellow	K2	6	K2	Yellow	1.5X
	Stronger sky/cloud contrast, lighten yellow and red	Day	Dark Yellow		9	G-15		2X
	Outdoor portraits, natural reproduction of foliage	Day	Green	X1	11	X1	Green	2X-4X
	Improve contrast of distant landscapes, penetrate haze	Day	Orange	G	16	O2	Orange	3X
	Exaggerate sky/cloud contrast, dramatic landscapes	Day	Red	25A	25A	25(A)	Red	8X
Day-Light COLOR	Reduce blue effect of open shade, overcast days, distant mountain scenes, snow	Day	Very Faint Pink	1B	SKY 1A	1A	Skylight 1A	1X
	Warmer color in cloudy or rainy weather or in shade. More effect than Skylight filter	Day	Pale Orange	81C	81C	81C	R1-1/2	1.5X
	Reduce red color when shooting daylight film in early morning or late afternoon.	Day	Light Blue	82C	82C		B 1-1/2	1.5X
	Use with daylight film for shooting with clear flashbulbs at night or indoors	Clear Flashbulb	Blue	80C	80C	80C	B6	2X
	Normal color when exposing daylight film under 3400K tungsten tungsten lighting	Tungsten	Blue	80B	80B	80B	80B	3X
	Normal color when exposing daylight film under 3200K tungsten lighting	Tungsten	Dark Blue	80A	80A	80A	80A	4X
	Reduce blue-green effect of exposing daylight film under fluorescent lighting	Fluorescent	Purple	FL-D	FL-D	CFD	DAY FL	1X
Tungsten COLOR	More natural color with tungsten film exposed by daylight in morning or late afternoon	Day	Amber		85C		R3	2X
	Natural color with tungsten Type A film exposed by mid-day sunlight	Day	Amber	85	85	85	85	2X
	Natural color with tungsten Type B film exposed by mid-day sunlight	Day	Amber	85B	85B	85B	85B	2X
	Reduce red effect of shooting tungsten films under ordinary household incandescent lights	Incandescent	Light Blue	82C	82C		B 1-1/2	1.5X
	Reduce blue-green color effect of shooting tungsten film with fluorescent lighting	Fluorescent	Orange		FL-B	CFB	ART FL	1X

NOTE: Filters made by different manufacturers are not represented to be exact equivalents even though labeled the same or designated for the same purpose. These filters should be approximately equivalent and satisfactory for the indicated uses. Filter factor may vary with brand.

FILMS

The basic choice is between color and black-and-white. In both types, there are negative films which must be developed and then printed to make a positive image. For color pictures, there are also color slides which are the same film you exposed in the camera, made into a positive image by processing in the lab.

Effect of Film Speed—Higher ASA film-speed ratings mean the film needs less exposure but the resulting picture is more likely to show visible grain. Lower film speeds usually mean sharper images and less grain.

Nomenclature—Among Kodak color films, those with names ending in -*chrome* are slide films. Kodachrome films can be processed only in a commercial laboratory. Ektachrome films can be processed by individuals in a home darkroom.

Kodak color films with names ending in -*color* are negative films from which prints must be made to get a positive image.

Several other film manufacturers use similar nomenclature.

Film Storage and Expiration Dating—Amateur films can be stored at room temperature until the expiration date printed on the box, with gradual deterioration in image quality, film sensitivity and color rendition. Up to the expiration date, these effects are minimal.

Some professional films require refrigeration except when actually in the camera. Follow the film data sheet instructions. Amateur

SOME 35mm FILMS							
	ASA SPEED/CONVERSION FILTER				**ASA SPEED/CONVERSION FILTER**		
Film Type	Daylight	Tungsten 3400K	Tungsten 3200K	Film Type	Daylight	Tungsten 3400K	Tungsten 3200K
COLOR SLIDE FILM				COLOR NEGATIVE FILM			
Kodachrome 25	25/none	8/80B	6/80A				
Kodachrome 64	64/none	20/80B	16/80A	Kodacolor II	100/none	32/80B	25/80A
Kodachrome 40	25/85	40/none	32/82A	Kodacolor 400	400/none	125/80B	100/80A
5070 Type A				Kodak Vericolor II	100/none	32/80B	25/80A
				Professional, Type S			
Ektachrome 64	64/none	20/80B	16/80A				
Daylight (ER)				3M Color Print Film	80/none	25/80B	20/80A
Ektachrome 200	200/none	64/80B	50/80A	Fujicolor F-II	100/none		32/80A
Daylight (ED)				Fujicolor F-II 400	400/none		125/80A
Ektachrome 160	100/85B	125/81A	160/none				
Tungsten (ET)							
Agfachrome 64	64/none	20/80B	16/80A	BLACK & WHITE			
Fujichrome R 100	100/none		32/80A				
				Kodak Panatomic-X	32	32	32
				Kodak Plus-X	125	125	125
				Kodak Tri-X	400	400	400
				Ilford PAN F	50	50	50
				Ilford FP4	125	125	125
				Ilford HP4	400	400	400

films benefit from storage under refrigeration because the gradual deterioration is halted or slowed. Film deterioration stops completely if the film is kept frozen.

Store film in unopened factory containers whether at room temperature or at reduced temperature. If refrigerated, allow 2 or 3 hours at room temperature before opening the factory carton, to avoid water condensation on the film. Separate the individual film boxes to be sure all boxes reach room temperature.

Avoid storing film in high temperatures, such as automobile glove boxes and trunk compartments. The floor of most modern cars should also be avoided due to exhaust-system heat.

After exposure, process film as soon as possible. If processing must be delayed more than a day or so, store the film at reduced temperature in sealed containers to avoid humidity changes. Before processing, follow the thawing-out procedures just mentioned.

RECIPROCITY-FAILURE CORRECTION

When exposure times are unusually long or short, reciprocity failure may occur. With b&w film, correction is more exposure and sometimes a changed development procedure. With color film, correction is more exposure and sometimes use of color filters over the lens to prevent color changes.

Reciprocity-failure corrections are given in the accompanying table but they are subject to change by the film manufacturer. Your best guide is the film data sheet.

TYPICAL EXPOSURE INCREASE AND FILTERING TO CORRECT RECIPROCITY FAILURE IN COLOR FILMS

FILM TYPE	INDICATED EXPOSURE TIME (Seconds)										
	1/50,000	1/25,000	1/10,000	1/1000	1/10	1/2	1	2	10	64	100
Kodachrome II 5070, Type A	†		None No Filter	None No Filter	1/2 Stop No Filter		1 Stop CC10M		1-1/2 Stop CC10M		2-1/2 Stop CC10M
Ektachrome 64 (Daylight)			1/2 Stop No Filter	None No Filter	None No Filter		1/2 Stop CC15B		1 Stop CC20B		NR
Ektachrome 200 (Daylight)			1/2 Stop No Filter	None No Filter	None No Filter		None No Filter		NR		NR
Ektachrome 160 (Tungsten)				None No Filter	None No Filter		1/2 Stop CC10R		1 Stop CC15R		NR
Kodachrome 25			None No Filter	None No Filter	None No Filter		1 Stop CC10M		1-1/2 Stop CC10M		2-1/2 Stop CC10M
Kodachrome 64			None No Filter	None No Filter	None No Filter		1 Stop CC10R		NR	NR	NR
Fujichrome R-100				None No Filter		None No Filter	1/3 Stop CC5C	2/3 Stop CC5C	2/3 Stop CC10C	1-2/3 Stop CC20C	2 Stop CC20C
Kodacolor II	1 Stop CC20B	1/2 Stop CC10B	None No Filter	None No Filter	None No Filter		1/2 Stop No Filter		1-1/2 Stop CC10C		2-1/2 Stop CC10C + 10G
Kodacolor 400			None No Filter	None No Filter	None No Filter		1/2 Stop No Filter		1 Stop No Filter		2 Stop No Filter
Vericolor II Professional Type S			None No Filter	None No Filter	None No Filter		NR		NR		NR
Fujicolor F-11				None No Filter		None No Filter	1/3 Stop No Filter	2/3 Stop No Filter	1 Stop No Filter	1-1/3 Stop No Filter	1-2/3 Stop No Filter
Fujicolor F-11 400				None No Filter	None No Filter		1 Stop No Filter		2 Stop No Filter		3 Stop No Filter

NR — Not Recommended
†Blank spaces indicate data not published by manufacturer. Where blank is *between* published data estimate correction
All data subject to change by film manufacturer

	IF INDICATED EXPOSURE TIME IS:	USE ONE OF THESE CORRECTIONS (NOT BOTH)		AND CHANGE DEVELOPING TIME:
		Increase Aperture	Exposure Time	
Panatomic-X	1/100,000	1 stop	Use Aperture Change	20% more
Plus-X	1/10,000	1/2 stop	Use Aperture Change	15% more
Tri-X	1/1,000	None	None	10% more
	1/100	None	None	None
	1/10	None	None	None
	1	1 stop	2 seconds	10% less
	10	2 stops	50 seconds	20% less
	100	3 stops	1200 seconds	30% less

TYPICAL EXPOSURE INCREASE FOR RECIPROCITY FAILURE OF KODAK BLACK & WHITE FILMS

When shooting outdoors under circumstances you can't control, depend on the film to have enough exposure range and give a realistic color rendition of the actual scene. The film often does its job better than the photographer does his.

MAGNIFICATION

There are two ways to get more magnification than normal. One is to use accessories between lens and camera so the lens is positioned farther from the film. The additional distance between lens and film is called *extension* and, in this book, the method is called *magnification by extension.*

The other method is to use special *close-up* or *supplementary* lenses on the front of the camera lens. Basically, these change the focal length of the camera lens.

In this discussion, magnification by extension will be covered first because it is generally more useful and can provide higher magnifications than the other method. It is also more difficult and more complicated, particularly at higher magnifications. Increasing image size by use of close-up lenses is easy and uncomplicated but the method is not suitable for higher magnifications. Discussion of close-up lenses begins on page 151.

HOW TO ESTIMATE THE MAGNIFICATION YOU NEED

Magnification (M) is the height of the image on film divided by the height of the subject. The 35mm film frame is about 24mm tall by 36mm wide, approximately 1-inch tall and 1.5-inch wide.

Example: You are holding the camera for a horizontal frame. A 10"-tall subject fills the frame, meaning the image is about 1" tall. Magnification is approximately 1 inch/10 inches. This is 1/10 expressed as a fraction, 0.1 expressed as a decimal, or 10%. The image is 10% as tall as the subject.

A variety of accessories and methods are used to get higher-than-normal magnification in the camera. These include mounting the lens backwards as on the camera at left and special macro lenses with unusually long focusing movement as on the second camera from the left. In the center is a bellows to fit between lens and camera, extension tubes to fit between lens and camera, close-up lenses and other gadgets.

MAGNIFICATION BY EXTENSION

With an accessory between lens and camera to give more extension, the total distance between lens and film has three parts:

There is some distance between the lens-mounting flange on the camera body and the film. Sometimes called the *flange focus*, it is approximately equal to the thickness of the camera body. It never changes and you never do any figuring with that number.

An accessory inserted between lens and camera gives some *added extension (X)*. This is an important number and you'll use it a lot.

Even though a lens is mounted on the forward end of some extension device, if the lens is mounted in the normal way, it can still focus. The focusing movement positions the lens closer to or farther away from the film, using a screw thread inside the lens. When a lens is focused at infinity, it is positioned as close to the film as the internal screw thread (helicoid) will allow. This is the assumed setting of the lens focus control when figuring lens extension and magnification. If the lens is then focused on nearer subjects, the lens moves forward physically, and total extension is greater.

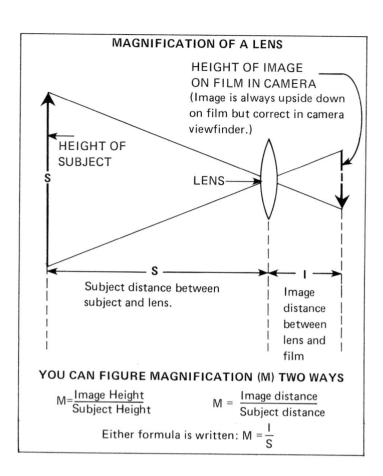

MAGNIFICATION OF A LENS

HEIGHT OF IMAGE
ON FILM IN CAMERA
(Image is always upside down
on film but correct in camera
viewfinder.)

HEIGHT OF
SUBJECT

LENS

Subject distance between
subject and lens.

Image distance between lens and film

YOU CAN FIGURE MAGNIFICATION (M) TWO WAYS

$$M = \frac{\text{Image Height}}{\text{Subject Height}} \qquad M = \frac{\text{Image distance}}{\text{Subject distance}}$$

Either formula is written: $M = \frac{I}{S}$

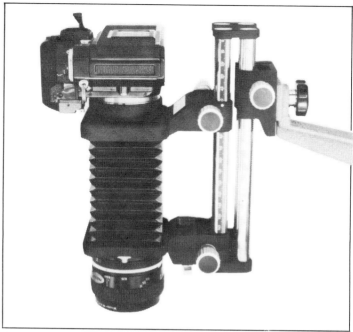

One way to get additional distance (extension) between lens and camera is to put camera on one end of a bellows and the lens on the other end. Increasing the distance between lens and film increases image magnification.

In this discussion, the words *added extension* and the symbol X mean the distance between lens and camera body due to inserting an accessory.

For Math Addicts—Subject distance (S) between lens and subject, image distance (I) between lens and film, and focal length (F) of the lens follow this rule:

$$\frac{1}{S} + \frac{1}{I} = \frac{1}{F}$$

Focal length is a fixed property of a lens or combination of lenses and doesn't change. Therefore if S becomes smaller, I becomes larger, and the reverse. If subject distance S is infinity, the value of I/S becomes zero and I = F. When the subject is at infinity, image distance is equal to the focal length of the lens. Image distance never becomes smaller than F. When S = I subject and image are the same size, magnification is 1, S = 2F, and I = 2F.

HOW TO FIGURE THE LENS EXTENSION YOU NEED

First, decide the amount of magnification you want as discussed earlier.

Then use this formula:

X = M x F

X is added extension between lens and camera

M is the magnification you need

F is the focal length of the lens

Example: You intend to photograph a bug that is 1/4" (0.25") long. Because of its legs, it is a little wider than it is long, so you decide to fill the one-inch dimension of the frame with the 0.25" dimension of the bug. You are using a 50mm lens.

The magnification you need is:

$$M = \frac{I}{S}$$
$$= \frac{1''}{0.25''}$$
$$= 4$$

The added extension you need with a 50mm lens is:

X = M x F
= 4 x 50mm
= 200mm

I'll discuss hardware in a minute but *anything* you use to move that lens forward by 200mm will give an image of that bug which is 4 times larger than real life.

Please notice that using a lens of shorter focal length reduces the amount of added extension. For example, if the lens focal length were 35mm, added extension would be only 140mm for the same magnification.

LENS-EXTENSION HARDWARE

There are two kinds of hardware.

Extension Tubes — Simple metal tubes with no glass inside are equipped with mounts on the ends so one end of the tube attaches to

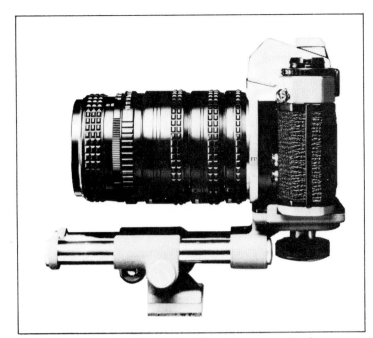

This is a set of automatic extension tubes, meaning that the tubes connect the levers on the lens to the camera body so full-aperture metering and automatic diaphragm operation are preserved. Tubes 1 and 2 are connected together, at left. You can see some of the moving parts in tube 3. Some extension tubes do not preserve the automatic features of lens and camera.

Here, the camera lens is extended from the camera body by all three extension tubes of a set. The shortest, tube 1, is nearest the camera. Tube 3 is nearest the lens. You can use extension tubes singly or in combination, depending on how much magnification you need.

the camera and the other end attaches to the lens. These are called *extension tubes,* or *extension rings.* They come in sets and can be stacked. The standard set is usually 3 tubes. When all 3 are stacked, the total length is 50mm or 55mm. This will give a magnification of 1 with a 50mm or 55mm lens. If the total is 50mm, the 3 tubes will have individual lengths such as:

Tube 1 — 8mm
Tube 2 — 16mm
Tube 3 — 26mm

In addition to the set of 3, longer individual tubes are available for still higher magnifications, such as 50mm, 75mm and 100mm tubes. Lengths vary among brands.

The advantage of using extension tubes is simplicity and relatively low cost. The main disadvantage is that magnification comes in steps according to tube length. If you need the magnification of a tube whose length is 15mm, you can't get it with only an 8mm and a 16mm tube.

However you can come fairly close. Remember that the formulas given here *assume* the lens is focused at infinity. If you focus the lens to the nearest possible subject distance, the lens itself is moved physically farther from the camera. The amount of *focusing movement,* whatever it is, adds to the amount of fixed extension due to use of extension tubes.

It varies among brands, however most 50mm lenses have a focusing movement of about 5mm. Therefore with an 8mm extension tube and the lens racked forward another 5mm, the effective lens extension becomes 13mm which may be close enough to the desired 15mm mentioned earlier.

When a lens is mounted directly on the camera, the distances marked on the focus control mean something. When the lens says it is focused at infinity, it really is. When it says it is focused at 18 inches, it really is.

When you add extension between lens and camera, the distances marked on the focus scale are no longer correct. With added extension, the lens is actually focused much closer than the scale indicates. Focusing at infinity is impossible, even though the lens scale says it is. Therefore you can think of the lens focusing movement as a way to add more lens extension, *to get some desired amount of magnification,* never mind what the focus scale says.

Some camera makers offer fixed extension tubes and one with variable length, called a *focusing extension tube,* a *helicoid extension tube,* or something similar. These have a minimum length of around 20mm and extend an additional 10 to 15mm. This gives a lot more flexibility and the tube lengths are chosen so you can get nearly any magnification you want, greater than about 0.5.

Bellows—A bellows mounts the camera on one end and a lens on the other. Extension due to the bellows can be varied from a minimum of about 25mm up to a maximum of 300mm, depending on brand. With a 50mm lens, this gives a maximum magnification of about 6. All magnifications are available,

	ADDED EXTENSION (X) in millimeters										
	DESIRED MAGNIFICATION(M)										
FOCAL LENGTH OF CAMERA LENS (mm)	0.1	0.2	0.3	0.4	0.5	0.6	0.7	0.8	0.9	1	1.5
20	2	4.8	6	8	10	12	14	16	18	20	30
24	2.4	4.8	7.2	9.6	12	14.4	16.8	19.2	21.6	24	36
28	2.8	5.6	8.4	11.2	14.0	16.8	19.6	22.4	25.2	28	42
35	3.5	7	10.5	14	17.5	21	24.5	28	31.5	35	52.5
50	5	10	15	20	25	30	35	40	45	50	75
55	5.5	11	16.5	22	27.5	33	38.5	44	49.5	55	82.5
85	8.5	17	25.5	34	42.5	51	59.5	68	76.5	85	128
100	10	20	30	40	50	60	70	80	90	100	150
150	15	30	45	60	75	90	105	120	135	150	225
200	20	40	60	80	100	120	140	160	180	200	300
300	30	60	90	120	150	180	210	240	270	300	450
400	40	80	120	160	200	240	280	320	360	400	600
500	50	100	150	200	250	300	350	400	450	500	750

	DESIRED MAGNIFICATION(M)									
FOCAL LENGTH OF CAMERA LENS (mm)	2	2.5	3	4	5	6	7	8	9	10
20	40	50	60	80	100	120	140	160	180	200
24	48	60	72	96	120	144	168	192	216	240
28	56	70	84	112	140	168	196	224	252	280
35	70	87.5	105	140	175	210	245	280	315	350
50	100	125	150	200	250	300	350	400	450	500
55	110	138	165	220	275	330	385	440	495	550
85	170	213	255	340	425	510	595	680	765	850
100	200	250	300	400	500	600	700	800	900	1000
150	300	375	450	600	750	900	1050	1200	1350	1500
200	400	500	600	800	1000	1200	1400	1600	1800	2000
300	600	750	900	1200	1500	1800	2100	2400	2700	3000
400	800	1000	1200	1600	2000	2400	2800	3200	3600	4000
500	1000	1250	1500	2000	2500	3000	3500	4000	4500	5000

with a minimum of about 0.5, just by changing the length of the bellows.

Most bellows have a scale showing the amount of extension and also the magnification at various extensions with a 50mm lens or a 55mm lens. If the scale shows magnification with a 50mm lens and you happen to be using one, you don't have to do any arithmetic. Crank the bellows out until the scale shows the magnification you need.

Combining Bellows and Extension Tubes—If you need to, you can put extension tubes between bellows and lens. You'll be getting a powerful lot of magnification if you do, so take precautions against vibration. See page 157 for general information about making setups.

HOW TO USE THE
ADDED EXTENSION TABLE

This table gives approximate added extension for various lenses and magnifications. Find the focal length of the lens you are using, at the left side of the table. Follow the row of numbers across the table until you enter the column directly below the desired magnification. Read added extension in that square.

Example: Using a 85mm lens, what added extension is needed for a magnification of 0.4? The 85mm row intersects the 0.4 magnification column at 34mm. This is close to minimum extension of a bellows. A 1 extension tube with a focusing extension tube will get you there.

SETUP DISTANCES FOR MAGNIFICATION BY EXTENSION

The accompanying graph helps you figure every distance you need to make a setup. Here's how:

1. Decide the amount of magnification you need.

2. Construct a vertical line from the desired magnification so the line intersects all four curves.

3. From each curve, project horizontally over to the distance scale. Read four distances and record them in the form shown below.

4. Multiply each distance taken from the graph by the focal length of the lens you are using.

5. After multiplying by lens focal length to get *actual* setup distances, make the setup using these distances. Find best focus by moving the camera while looking through the viewfinder. Final distances may vary a small amount from the distances you calculated.

FINDING FOCUS WITH LENS EXTENSION

When you use added extension to increase magnification, the point of good focus is some definite distance in front of the lens. Sometimes it's hard to find. The lens focusing control affects both focused distance and magnification. If magnification is critical, you can't move the focus control because that changes magnification.

As you will see in a minute, at higher magnifications you reverse the lens. This causes the lens focusing control to do nothing, so it isn't any help at all.

One approach is to assume that the focus point is out there somewhere; chase back and forth with the camera until you find it. This works, but with the camera on a tripod it's awkward and aggravating. It's also undignified if anybody is watching. A good bellows has an adjustment that moves the entire setup—camera, bellows and lens—a few inches in either direction to help you find focus, but even this is sometimes not enough.

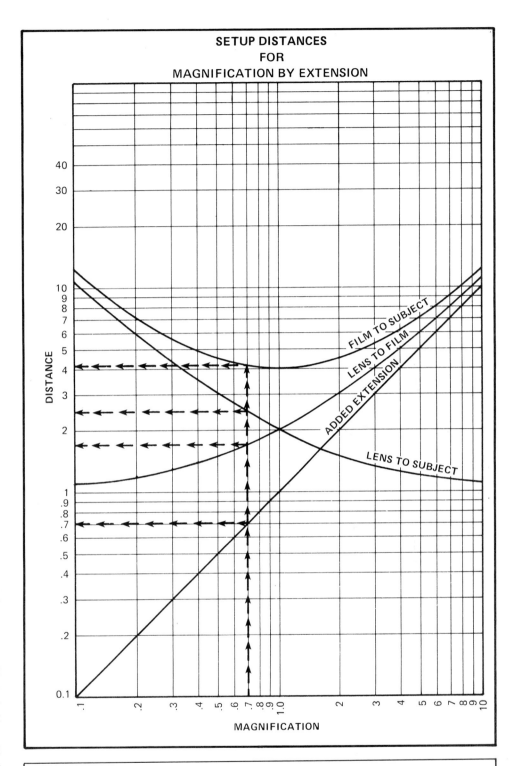

EXAMPLE		
Distances Taken From Graph:	Multiply By Lens Focal Length	Actual Setup Distances
Film to Subject — 4.2	x 50mm	210mm
Lens to Subject — 2.4	x 50mm	120mm
Lens to Film — 1.7	x 50mm	85mm
Added Extension — 0.7	x 50mm	35mm

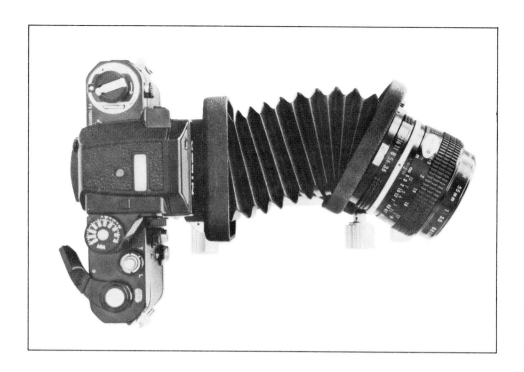

This Nikon bellows is unusually versatile. In addition to extending, it also tilts and shifts the lens.

The best way is to plan the setup in advance. Know the approximate distance you will need between lens and subject and arrange the equipment so it's about right the first time.

HOW TO SET EXPOSURE WITH LENS EXTENSION

When a lens is moved farther from the film than its infinity-focus position, light on the film is reduced. Even with ordinary camera lenses, light on the film is reduced just by focusing the lens from infinity to a nearby subject, but the amount of light loss is small and can be ignored.

When a lens is extended with tubes or bellows, the light loss becomes significant and affects exposure.

If you are measuring light using the camera's built-in meter, usually light loss is automatically corrected and you don't have to do anything special. Focus, balance the exposure display and make the picture.

When the Light is Too Dim—With large extension, the light may be too dim to read with the camera meter. In that case, the general

procedure is to find an exposure setting that would work without any added lens extension, then correct that exposure setting to compensate for the light loss due to extension.

There are several ways to find the exposure that would be used without extension. Use a separate accessory exposure meter. Use another camera without extension devices. Take the extension off your camera, measure the light, then put the extension device back on.

Deciding on the Correction—This gets complicated. The correction you make depends on the type of lens you are using and whether you have it mounted normally or reversed front-to-back. There are three cases:

A normal lens with entrance and exit pupils of approximately the same size.

A telephoto or wide-angle (retrofocus) lens with entrance and exit pupils of different size, not reversed.

A telephoto or wide-angle lens reversed.

These three situations are discussed individually in following sections.

EXPOSURE CORRECTION FACTOR FOR NORMAL LENSES

Be sure you understand that if you can measure the light with the camera's built-in meter you don't need to make any exposure corrections due to use of lens extension.

If you can't measure the light inside the camera, determine the exposure you would use without extension and then correct it using the Exposure Correction Factor (ECF).

$$ECF = (M + 1)^2$$
M is magnification

Example: Due to lens extension, magnification is 1.8.

$$ECF = (1.8 + 1)^2$$
$$= (2.8)^2$$
$$= 7.84$$

This can be rounded off to 8. Exposure with this amount of extension must be 8 times as much as if no extension were used. To correct, multiply shutter-open time by 8 and use the nearest available setting.

Or you can make the correction by using larger aperture, remembering that each step increase of aperture size multiplies exposure by 2. Use 3 *f*-stops larger aperture because $2 \times 2 \times 2 = 8$.

HOW TO USE THE EXPOSURE-CORRECTION-FACTOR GRAPH

This graph applies to normal lenses from about 40mm to 55mm focal length.

To use this graph, determine image magnification and find that value on the magnification scale. From that point, construct a vertical line to intersect both curves. From each intersection, plot a horizontal line over to the Exposure-Correction-Factor scale. Read both numbers, but apply *only one* of them as the correction.

Example: You are set up for magnification of 4.5 and the light is so dim you can't use the camera's built-in meter. Use a separate exposure meter to determine normal exposure as though no extension were being used. Then correct the normal exposure *either* of two ways.

Multiply shutter-open time by 30, *or* increase aperture by approximately 5 *f*-stops.

Check the film data sheet to see if this gets you into reciprocity failure of the film. If so, apply that correction on top of this one.

You can take part of the correction in shutter speed and the remainder in aperture. For instance, multiply shutter-open time by 15 and open aperture one stop.

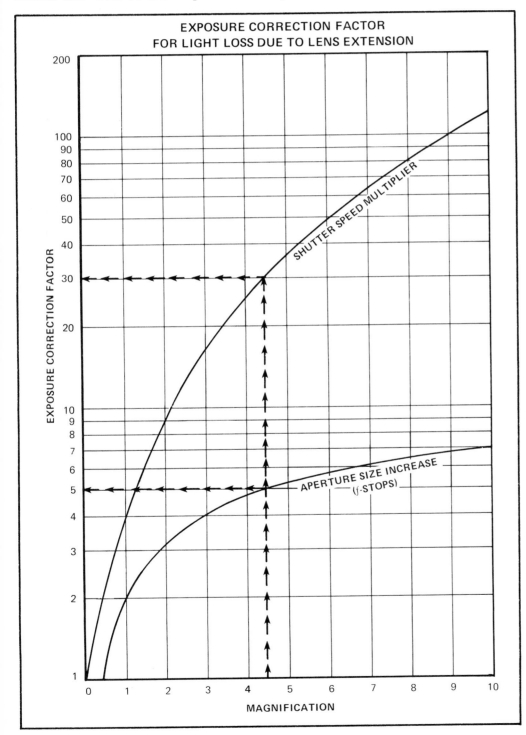

EXPOSURE CORRECTION FACTOR FOR LIGHT LOSS DUE TO LENS EXTENSION

SHUTTER SPEED MULTIPLIER

APERTURE SIZE INCREASE (*f*-STOPS)

EXPOSURE CORRECTION FACTOR

MAGNIFICATION

Use this graph only for lenses with focal lengths from 40mm to 55mm.

For Math Prodigies:

Exposure Correction Factor
(Shutter-Speed Multiplier)
$$= (M + 1)^2$$
Aperture Increase in f-Stops
$$= Log_2 (M + 1)^2$$

EFFECTIVE APERTURE

An alternate approach to compensate for light loss due to lens extension is to take the view that extension causes the lens to *act like* the aperture size is reduced. Suppose the lens is set at f-2.8 but lens extension reduces light on the film to that amount which would come through a lens at f-8 with no extension. The combination of extension and lens at f-2.8 can be considered a lens set at f-8. The smaller aperture is called *Effective Aperture* (EA).

$$EA = f \times (M + 1)$$
f is the f-stop set on the lens
M is the magnification

Example: The aperture ring on the lens is set at f-2.8 and there is enough extension for a magnification of 1.8. These numbers are the same as the earlier example shown on page 140.

$$EA = f\text{-}2.8 \times (1.8 + 1)$$
$$= f\text{-}2.8 \times 2.8$$
$$= f\text{-}7.84$$

The idea of effective aperture is useful when using flash with lens extension.

DEPTH OF FIELD AT HIGH MAGNIFICATION

Bellows extended for a magnification of about 2.

Bellows extended to 180mm, which is nearly as much extension as the bellows can make, gives magnification of about 4. Depth-of-field problem becomes apparent. Lens is focused at surface of cloth. Where cloth is raised up because of needle puncture, image is out of focus.

Lens focused at needle. Cloth is out of focus above needle and below.

Lens focused above needle. Notice spot on thread where focus is sharp, and band of good focus along the cloth just above the needle.

This series shows use of tilt-and-shift feature of bellows. This is an embossed section of a leather book cover. Focus is good at left, but not at right because surface is angled in respect to lens.

Lens on bellows is tilted to left. This angles plane of best focus so image is sharp, but tilting lens caused image to move to right in frame.

Leaving lens tilted for best focus, shift feature of bellows was used to move lens sideways to bring desired image back into center of frame.

HOW TO USE FLASH WITH NORMAL LENSES AND LENS EXTENSION

Use the flash guide number to figure the lens aperture the flash needs. You can't set that f-number on the lens and get correct exposure because, with lens extension, a lens acts like it has smaller aperture—the Effective Aperture (EA). Therefore the f-number the flash is "asking" for is the Effective Aperture of the lens.

Knowing EA, the trick is to figure what the *actual* f-stop setting of the lens should be. This depends on the magnification.

Example: Your flash has a guide number of 25 feet and you plan to position it 3 feet from the subject. Using the flash guide number,

$$f = \frac{GN}{Distance}$$
$$= \frac{25 \text{ feet}}{3 \text{ feet}}$$
$$= f\text{-8, but this is Effective Aperture}$$

You are using enough extension for a magnification of 1.8. To find the actual f-number setting of the lens,

$$f \text{ actual} = \frac{EA}{(M + 1)}$$
$$= \frac{f\text{-8}}{(1.8 + 1)}$$
$$= \frac{f\text{-8}}{2.8}$$
$$= f\text{-2.8}$$

When you set the lens at f-2.8, it will act like f-8 because of the extension and you should get proper exposure with the flash.

If the shot is important, bracket.

You can "eyeball" pupil measurements with sufficient accuracy to calculate pupilary magnification. Here, I read the exit pupil as 9/16" and the entrance pupil as 7/32". Converting to decimals and dividing, I get P = 2.57. Lens maker's data says it's 2.56.

EXPOSURE-CORRECTION FACTOR FOR TELEPHOTO AND RETROFOCUS LENSES

Retrofocus (wide-angle) and telephoto lenses have pupils of different size. When the smaller pupil of a lens is toward the film less light reaches the film than the preceding calculations indicate. When the larger pupil is toward the film, more light gets through.

Pupilary Magnification—Exposure correction due to extension of lenses with pupils of unequal size requires determining the *ratio* of pupil sizes, called *pupilary magnification* (P).

$$P = \frac{\text{Diameter of Exit Pupil}}{\text{Diameter of Entrance Pupil}}$$

How to Find Pupilary Magnification—A few lens makers publish the information. You can measure it with sufficient accuracy. Hold the lens against the light and set it to an aperture smaller than wide open. Use a scale held across front and back of the lens to measure the diameter of the two pupils.

For telephoto lenses, P is less than 1. Wide-angle lenses have P greater than 1. Normal camera lenses have P equal to or close to 1.

How to Figure the Correction—Of course you won't be doing this if you can measure the light with the camera meter. If you can't, measure it some other way and calculate an exposure setting that would work with no extension. Then modify that exposure, multiplying it by the Exposure Correction Factor for Pupilary Magnification (ECF$_p$). Don't use two correction factors. Use ECF *or* ECF$_p$.

$$ECF_p = \left(\frac{M}{P} + 1\right)^2$$

To find Effective Aperture for this situation (EA$_p$):

$$EA_p = f \times \left(\frac{M}{P} + 1\right)$$

f is the f-stop set on the lens. To find f actual for use with flash:

$$f \text{ actual} = \frac{EA_p}{\left(\frac{M}{P} + 1\right)}$$

These are the same formulas used before except M is replaced by M/P. When P is 1, M/P is the same as M, and these formulas revert to those given earlier. In other words, when using a normal lens with a pupilary magnification of close to 1, use the earlier formulas.

Examples: Due to lens extension, magnification is 1.8 using a telephoto lens with pupilary magnification of 0.5. To find the exposure correction factor:

$$\begin{aligned}
ECF_p &= \left(\frac{M}{P} + 1\right)^2 \\
&= \left(\frac{1.8}{0.5} + 1\right)^2 \\
&= 21
\end{aligned}$$

Assume the lens is set at f-8. Effective aperture is:

$$\begin{aligned}
EA_p &= f\left(\frac{M}{P} + 1\right) \\
&= 8\left(\frac{1.8}{0.5} + 1\right) \\
&= f\text{-37}
\end{aligned}$$

Assume this setup is used with flash. The guide-number calculation calls for an effective aperture of f-16. To find f actual, the lens setting:

$$\begin{aligned}
f \text{ actual} &= \frac{EA_p}{\left(\frac{M}{P} + 1\right)} \\
&= \frac{16}{\left(\frac{1.8}{0.5} + 1\right)} \\
&= f\text{-3.5}
\end{aligned}$$

This is the setup used to make the needle-and-thread pictures you saw earlier. The two levers between lens and rails control tilt and shift. For magnifications higher than 1, the lens was reversed using a reversing ring (arrow). The ring has a bayonet fitting on one side which fits the bellows. On the other side, the ring is threaded to match the filter threads of the lens. Front of lens screws onto the reversing ring and then becomes rear of lens.

REVERSING THE LENS

In ordinary photography, subject distance is much larger than image distance. As magnification is increased, subject distance becomes smaller and image distance becomes larger. At a magnification of 1, they are equal. At magnifications greater than 1, image distance is longer than subject distance.

Lenses are designed and corrected for aberrations on the assumption that subject distance is longer than image distance.

At magnifications larger than 1, image quality is improved by reversing the lens on the camera. This puts the longest optical distance on the same side of the lens as the designer expected, even though it becomes image distance instead of subject distance.

Devices to mount a lens backwards are called *reversing rings,* sometimes *reverse adapters.* They attach to the lens by screwing into the filter-mounting threads on what is normally the front of the lens. The reversing ring attaches to the lens mount on the camera body or lens-extension devices in the normal way for the camera.

When mounting in reverse, the back of the lens becomes the front. All lens automatic features are lost. Aperture control is manual. On a reversed lens of conventional design, the focusing ring has no optical effect. It merely moves the lens barrel in and out while the glass elements stay in the same position. I set the focus control so the lens barrel overhangs in front to serve as a lens shade.

EXPOSURE-CORRECTION FACTOR FOR REVERSED LENSES

When a lens is reversed, the exit pupil is at the front. Even so, in the formulas used here, pupilary magnification (P) does not change. It is always determined by dividing the diameter of the exit pupil by the diameter of the entrance pupil, *assuming the lens is mounted normally on the camera.*

When you can't measure the light with the camera meter, determine an exposure setting that would work without lens extension and then multiply by the Exposure Correction Factor for Reversed Lenses (ECF$_r$):

$$ECF_r = \left(\frac{MP + 1}{P}\right)^2$$

To find Effective Aperture with reversed lenses (EA$_r$):

$$EA_r = \frac{f}{P} \times (MP + 1)$$

f is the f-stop set on the lens.
To find f actual for use with flash:

$$f \text{ actual} = \frac{(EA_r) \times (P)}{(MP + 1)}$$

Notice that these formulas also revert to the simple versions given earlier for ECF with normal lenses, if P is 1. This says you can reverse normal lenses without worrying about a different correction factor.

Examples: Due to lens extension, magnification is 1.8 using a retrofocus lens with pupilary magnification of 1.5. For better image quality, the lens is reversed.

$$ECFr = \left(\frac{MP + 1}{P}\right)^2$$
$$= \left[\frac{(1.8)(1.5) + 1}{1.5}\right]^2$$
$$= 6$$

Assume the lens is set at f-11. Effective aperture is:

$$EAr = \frac{f}{P}(MP + 1)$$
$$= \frac{11}{1.5}\left[(1.8)(1.5) + 1\right]$$
$$= f\text{-}27$$

Assume this set-up is used with flash. The guide-number calculation calls for an effective aperture of f-16. To find f actual, the lens setting:

$$f \text{ actual} = \frac{(EA_r)\ (P)}{MP + 1}$$

$$= \frac{(16)\ (1.5)}{(1.8)\ (1.5) + 1}$$

$$= f\text{-}6.5$$

ADDITIONAL EXTENSION DUE TO REVERSING THE LENS

When a lens is reversed, the extension is usually changed. One reason is the reversing ring itself. If it is 10mm thick, that puts an additional 10mm of extension between lens and camera body.

Another source of additional extension is the recess in the front of the lens—between the filter thread and the glass elements of the lens. When reversed, the depth of this recess becomes part of the mechanical extension of the lens.

This is complicated by the fact that lens extension is measured from film to a lens node that we can't see. With normal lenses, the lens-to-film distance is measured to a point approximately in the center of the glass elements of the lens. Reversing normal lenses does not have a major effect on extension unless there is a deep recess between the front element and the filter-mounting thread.

With telephoto lenses, reversing the lens may actually reduce the amount of extension because the node you measure from becomes closer to the film. With retrofocus lenses, the reverse may occur. These effects are unpredictable without knowing the exact location of the nodes.

If you reverse a lens and don't get the magnification you need, change extension experimentally until it is correct.

This centimeter scale is angled away from camera at an angle of about 45 degrees. You can estimate depth of field by noticing where the millimeter lines start to blur at each end of the zone of good focus. Because of the geometry, actual depth of field is about 70% of observed depth on the scale. For example, if you think good focus is from 14 to 16, a distance of 20mm, depth of field is 20mm x 0.7 = 14mm. This was taken with a 55mm macro lens set for a magnification of about 0.5.

DEPTH OF FIELD AT HIGH MAGNIFICATION

As magnification increases, depth of field decreases drastically and becomes a major problem in many photos. The point of best focus is usually near the middle of the depth of field. This would be a very good arrangement were it not for the fact that the total depth is so small you often can't include a three-dimensional subject within the depth of field.

You have to decide where to put the limited depth of field in each case, depending on what the subject is and how you want to show it. Often it is best to put good focus near the front of the subject and let the rear parts of the subject drift off into poor focus.

For magnifications from about 0.1 up to about 3, the formulas given here will be satisfactory. They show that depth of field (DOF) increases with larger f-numbers, meaning smaller aperture size. This does not consider the effect of diffraction at smaller apertures which may fuzz up the picture and cancel any benefit from using small aperture size.

At a magnification of about 0.75, depth of field is visibly reduced.

Magnification is 1.0. In my judgment, looking at the print, depth of field is between the two arrows—a distance of 1mm. Using the geometrical correction because of the angle of the scale, this becomes 0.7mm depth of field. Using the DOF_n equation given in this section, calculated depth of field is 0.67. Lens is set at f-5.6.

After making the setup, change aperture while looking through the camera to find the best compromise.

At magnifications higher than about 3, this subject becomes more complicated, and is not discussed here. A good reference is Kodak publication N-12B, *Photomacrography*, available through your camera shop.

For a Normal Lens—With a normal lens having a pupilary magnification of approximately 1, DOF_n is found by:

$$DOF_n = \frac{2fC(M+1)}{M^2}$$

f is the f-stop setting on the lens

C is the diameter of the circle of confusion

M is magnification

DOF_n as calculated will be in the same units used for C. To find DOF_n in millimeters, enter C in millimeters. A reasonable standard of sharpness is C = 0.001 inch or C = 0.03mm, which is the same.

For a Telephoto or Retrofocus Lens—Pupilary magnification (P) must be taken into account.

$$DOF_p = \frac{2fC(M+P)}{P(M)^2}$$

For a Reversed Telephoto or Retrofocus Lens—The formula changes because P is measured as though the lens were not reversed. P remains the same but the formula changes when the lens is reversed.

$$DOF_r = \frac{2fC(MP+1)}{P(M)^2}$$

Examples: In these examples, C is 0.03mm, M is 2, f is f-11. Assume the normal lens is an ordinary 50mm lens of the type usually sold with SLR cameras. The latter two examples use the same short-focal-length retrofocus lens with P = 1.5. In these examples, notice the improvement in depth of field when the retrofocus lens is reversed.

NORMAL LENS:

$$DOF_n = \frac{2fC(M+1)}{M^2}$$

$$= \frac{2(11)(0.03)(2+1)}{2^2}$$

$$= 0.5mm$$

RETROFOCUS LENS MOUNTED NORMALLY

$$DOF_p = \frac{2fC(M+P)}{P(M)^2}$$

$$= \frac{2(11)(0.03)(2+1.5)}{1.5(2)^2}$$

$$= 0.38mm$$

RETROFOCUS LENS REVERSED

$$DOF_r = \frac{2fC(MP+1)}{P(M)^2}$$

$$= \frac{2(11)(0.03)[(2)(1.5)+1]}{1.5(2)^2}$$

$$= 0.44mm$$

SUMMARY OF EQUATIONS: MAGNIFICATION BY EXTENSION, PUPILARY MAGNIFICATION AND REVERSED LENSES			
	With Normal Lens (P = approximately 1)	With Telephoto or Retrofocus Lens	With Reversed Telephoto or Retrofocus Lens
Exposure Correction Factor	$ECF = (M+1)^2$	$ECF_p = \left(\frac{M}{P}+1\right)^2$	$ECF_r = \left(\frac{MP+1}{P}\right)^2$
Equivalent Aperture	$EA = f(M+1)$	$EA_p = f\left(\frac{M}{P}+1\right)$	$EA_r = \frac{f}{P}(MP+1)$
Lens Setting To Get Desired EA	f actual $= \frac{EA}{(M+1)}$	f actual $= \frac{EA_p}{\left(\frac{M}{P}+1\right)}$	f actual $= \frac{(EA)(P)}{(MP+1)}$
Macro Depth of Field	$DOF_n = \frac{2fC(M+1)}{M^2}$	$DOF_p = \frac{2fC(M+P)}{P(M)^2}$	$DOF_r = \frac{2fC(MP+1)}{P(M)^2}$

or of the glass and the v

ime on both sides of the

ie light rays don't even k

eal world, compound lei

ted together to reduce ir

cementing, there are tw

natter how tightly the d

her. After cementing, tl

s are replaced by two air

cement is clear and the

ement is very close to th

A printed page is a good test for flatness of field. This photo made with a 50mm macro lens on a 25mm extension tube. Notice sharpness and blackness of type at the corners of the frame.

of the glass and the velc

e on both sides of the ir

light rays don't even kne

world, compound lense

together to reduce inte

ementing, there are two

ter how tightly the dry

r. After cementing, the

e replaced by two air-ce

ment is clear and the ve

ient is very close to that

Same camera setup except lens was not a macro. It's an ordinary 50mm f-1.8 lens of the type normally sold with the camera. Notice image is not as sharp at the corners.

MACRO LENSES

Special lenses are available in 50mm and 100mm focal lengths for use at high magnification. These are usually called *macro* lenses, sometimes *micro* lenses. Macro lenses are specially corrected for flatness of field and are therefore suitable for copying documents, stamps, photos, slides and similar kinds of photography where the subject is flat and out-of-focus edges would be very apparent.

Because good correction for flatness of field is difficult to maintain at large apertures, macro lenses typically won't open up as much as normal 50mm and 100mm lenses. Maximum aperture is usually around f-3.5 or f-4. This is not a major disadvantage because most photos are taken at apertures smaller than f-3.5.

These lenses are built with long-travel helicoids so the focusing movement is half the focal length. Without any added extension, these lenses give magnification of 0.5 just by cranking the lens out to its limit of travel.

Some macro lenses come with a special extension tube whose length is half the focal length of the lens. When this tube is inserted between lens and camera, the magnification range is 0.5 to 1, depending on where the focus control is set. Thus a magnification range from about 0.1 up to 1 is available with this lens and its accompanying extension tube.

Some lens makers don't furnish a special extension tube with the macro lens and suggest use of an accessory set of three tubes instead. With a 50mm macro lens, tube 3 of the set will give a magnification of 1 or a little more. With a 100mm macro lens, the entire set of three tubes is required to reach a magnification of 1.

ZOOM LENSES WITH A "MACRO" SETTING

Zoom lenses are available with a special control or lever which allows closer focusing than normal. This gives an increase in magnification—up to around 0.2 or 0.3.

The conventional definition of *macro* is a magnification of 1 or more, so calling these lenses "macro" is an accomplishment of the advertising department rather than the lens designer.

Typically, these lenses are not specially corrected for flatness of field. They are intended for casual use in photographing non-flat objects such as flowers and bugs where poor flatness of field will not be obvious in the resulting picture.

These should not be taken seriously as "macro" lenses and should properly be called "close-focusing" zoom lenses or something similar.

CHOOSING A LENS FOR USE WITH EXTENSION

If image quality is important, the best choice is a macro lens. The 50mm is convenient to use and it's a normal lens so you can reverse it without getting into complicated exposure calculations when you are not metering inside the camera.

At high magnifications, the working distance between the lens and subject becomes very short and getting light on the subject may be a problem.

If so, the 100mm macro will help because it allows more working distance between lens and subject. It also requires twice as much extension for the same magnification as a 50mm lens.

If flatness of field is not important, use a normal 50mm or 55mm lens. Among these lenses, those with maximum aperture of f-1.8 or f-2 will make a better picture than those with larger maximum aperture.

If you use all available extension and still can't get enough magnification, switch to a lens with shorter focal length. Reverse it for improved image quality and increased depth of field.

When using a telephoto or retrofocus lens, don't go to extremes. Stay as close to 50mm as you can. If light is a problem, mount the lens so the larger pupil is toward the film. For best depth of field, mount it so the smaller pupil is toward the film.

WHEN THE FLASH IS VERY CLOSE TO THE SUBJECT

In some high-magnification shots it will be necessary to put the flash very close to the subject. Flash guide numbers are based on the inverse square law which assumes that doubling distance reduces the amount of light to 1/4. This law applies only to *small* light sources which make an expanding beam of light—ideally a point source.

Large light sources are caused to make an expanding beam of light by a reflector behind or a lens in front of the source, or both. They behave like small sources when the subject being illuminated is farther away than ten times the maximum dimension of the source. If a flash-bulb reflector is 6 inches in diameter, you can use the flash guide number satisfactorily if the subject is more than 60 inches from the flash. An electronic flash with a 2-inch-long window follows the inverse square law when the subject is more than 20 inches away.

If you get closer, what happens is unpredictable because it depends on how the beam is formed by the lens or reflector. In some cases, getting closer puts *less* light on the subject.

If you must use a flash closer than ten times its longest dimension, it may be necessary to find good exposure by experimenting.

Another way is to cover the flash lens with a piece of white cloth or tissue so it becomes a diffused source of nearly uniform brightness all over its surface. This requires about one step more exposure due to light loss because of the cloth or tissue. However you can use it very close to the subject and use the flash guide number to figure exposure—adding one exposure step.

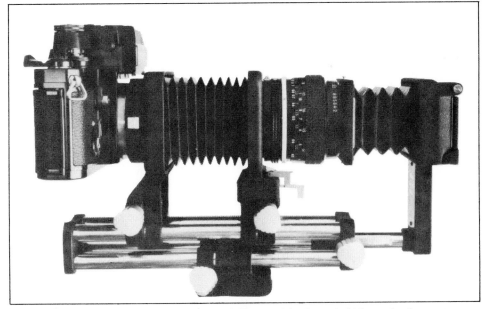

This slide-duplicating setup uses a Nikon bellows with tilt and shift on the front standard, 55mm Micro-Nikkor lens, and slide-duplicating attachment. A micro or macro lens is important in slide duplicating to get flatness of field—the subject is a flat slide. The bellows-tilt feature is not needed, but shifting the lens at magnifications higher than 1 is very useful.

Using a slide duplicator to *change* something is fun and worthwhile. Here, a slide was enlarged and cropped by shifting the lens. Copied onto daylight slide film, with daylight as the illuminant. Contrast increased and color changed, both of which sometimes improve the result.

DUPLICATING SLIDES

If you actually want duplicates, you are better off making as many shots as you need when you photograph the scene. Commercial-lab copies of a slide usually suffer reduced quality.

The best part of owning your own equipment is to make slides which are *not* duplicates of the original. You can add or change colors by filters, you can sandwich two slides and copy the result. You can combine photographs with your own hand-made backgrounds, color patches, line art, or whatever. You can improve composition by doing some cropping in a slide-duplicating setup.

There are two slide-duplicating methods. If you copy a slide onto color-slide film, it's a positive-to-positive procedure because there is no intervening negative. This gives increased contrast in the copy and sometimes a slight but noticeable color change. The color change can be prevented or reduced by testing and correction with CC filters, but not much can be done about the contrast increase unless you use a special film.

Kodak Ektachrome slide-duplicating film is designed to reduce contrast build-up when making positive-to-positive copies of slides. It is available in 36-exposure cartridges for 35mm cameras. It is also available in 100-foot rolls.

Color labs offer prints and transparencies made by a positive-to-positive process. More expensive but usually worth the difference is a procedure using an intervening negative, called an *internegative.* The internegative is a special film designed to reduce contrast gain. Also, a commercial lab should have worked out filtering so there is minimum color change in the copy.

What the commercial lab doesn't offer is the creative fun of making slides on purpose that aren't duplicates of the original. To do this, there are two kinds of equipment you can use on your camera.

A bellows slide duplicator is a special slide holder that attaches to the front of a bellows. A second, small bellows fits between the slide and the lens on the end of the bellows, to exclude stray light.

Changing the length of the main bellows alters lens-to-film distance and changes magnification. Changing the length of the small bellows varies lens-to-subject distance so you can locate the slide at the plane of best focus at the magnification you are using.

You don't want magnification less than 1, or the copy will not fill the image area of the slide. At magnifications larger than one, the effect is to crop off the edges of the original slide. Most slide holders allow some movement of the slide you are copying so you have some control over the cropping.

Another type of copying equipment uses fixed extension tubes. One is a special unit that fits between lens and slide, and holds the slide. To get a magnification of 1, use standard extension tubes between lens and camera. The instructions with the slide holder tell you how much extension to use. This kind of slide copying is less flexible because you can't change magnification. It is also less expensive.

Some accessory slide copiers are one unit that fits on the camera and holds the slide. A lens is built in. The type also gives a magnification of 1.

All of these slide copiers use a frosted-glass pane on the front of the slide to give a diffused and uniform illumination of the slide. Load the camera with 35mm film balanced for daylight. As an illuminant, use daylight or an equivalent source such as electronic flash. A good daylight source is light from the sun *and* the sky reflected off a white sheet of paper. You should be able to get enough light on the film for normal exposure times, so you avoid reciprocity failure.

MAGNIFICATION WITH CLOSE-UP LENSES

Accessory lenses which attach to the camera lens like filters are a handy and uncomplicated way to increase magnification. They are commonly sold in sets of three, labeled **1**, **2** and **3**. A **10** lens is also available. When so labeled, the number is the *power* of the close-up lens, expressed in *diopters*.

$$\text{Diopters} = \frac{1}{\text{Focal Length in Meters}}$$

To figure magnification with these lenses, you need to know the lens focal length, not diopters. To make the conversion, use this formula:

$$\text{Focal Length (mm)} = \frac{1000}{\text{Diopters}}$$

Example: Find the focal length of a 2-diopter close-up lens.

$$F = \frac{1000}{2}$$
$$= 500mm$$

Stacking Close-up Lenses—To get a desired magnification, it is often necessary to stack close-up lenses. To find the focal length of two diopter-rated close-up lenses, add the diopter ratings, then convert to focal length as shown in the preceding example. Put the highest-power lens (highest diopter number) nearest the camera lens to get best picture quality.

Other Ways to Specify Focal Length of Close-Up Lenses—Some camera makers offer close-up lenses

Close-up lenses are quick and easy to use, requiring no exposure correction or fiddling around. They make acceptable images of non-flat things in nature such as bugs and flowers and are entirely satisfactory for many purposes. Depth of field is often a problem when using higher magnification, no matter how you do it.

whose nomenclature indicates focal length rather than diopters. This saves you the bother of converting.

Canon offers a set of lenses of which one is labeled S240. This is a supplementary lens with a focal length of 240mm. Pentax labels close-up lenses with a letter and number, such as S25, where the number is the lens focal length in *centimeters.*

Subject Distance—With the camera lens set at infinity, subject distance is always the focal length of the closeup lens as shown in the accompanying table. Under the same condition, image distance is the focal length of the camera lens.

When you focus the camera lens closer than its infinity setting, image distance increases because of the focusing movement, subject distance decreases and image size becomes larger. Therefore the focal length of the close-up or *supplementary* lens is the longest distance you will need between lens and subject. You may decide to move closer to get the desired image size.

glass surfaces are replaced h faces. A lens cement is clea light in the cement is very (glass. Such a glass-cement b less noticeable to light and be less.

LENS COATINGS

For years lens designe between the desirability of aberrations and the undesir tion at the multiple lens su lens elements which could limited by the amount of r tolerable.

If you need flatness of field, a close-up lens may not be satisfactory.

Close-up lenses usually come in sets of three and screw into filter threads on front of camera lens.

FOCAL LENGTH OF CLOSE-UP LENSES		
LENS POWER IN DIOPTERS	**FOCAL LENGTH**	
	mm	inches (approx)
1	1000	40
2	500	20
3	333	13
1 + 3	250	10
2 + 3	200	8
1 + 2 + 3	167	6.7
10	100	4

MAGNIFICATION WITH ACCESSORY CLOSE-UP LENSES

Camera Lens	Close-Up Lens	Maximum Subject Distance		Minimum Subject Distance		Magnification	
		mm	inches	mm	inches	MIN	MAX
50mm	1	1000	40	333	13	0.05	0.17
	2	500	20	250	10	0.10	0.22
	3	333	13	200	7.9	0.15	0.28
	3+1	250	10	167	6.2	0.20	0.33
	3+2	200	7.9	143	5.6	0.25	0.39
	3+2+1	167	6.2	125	4.9	0.30	0.45
	10	100	3.9	83	3.3	0.5	0.67

HOW TO FIGURE MAGNIFICATION WITH CLOSE-UP LENSES

With the camera lens set at infinity, magnification (M) is easy to figure:

$$M = \frac{\text{Focal Length of Camera Lens (mm)}}{\text{Focal Length of Close-up Lens (mm)}}$$

Example: You are using a combination of 1 + 3 close-up lenses stacked on the front of a 50mm camera lens. These close-up lenses have a combined focal length of 250mm.

$$M = \frac{50mm}{250mm}$$

$$= 0.2$$

When the camera lens is focused nearer than infinity, magnification *increases* and subject distance *decreases*. Therefore magnification calculated as above is the *minimum* you will get with that combination of close-up and camera lens.

Please notice that magnification increases with longer-focal-length camera lenses. If you use a 200mm lens instead of a 50mm lens, the minimum magnification will be four times as much, using the same close-up lens on the front.

Split-field lenses are close-up lenses with half of the lens cut away. They give two zones of sharp focus—one at the focal length of the close-up part, the other where the camera lens is focused through the cut-away portion of the close-up.

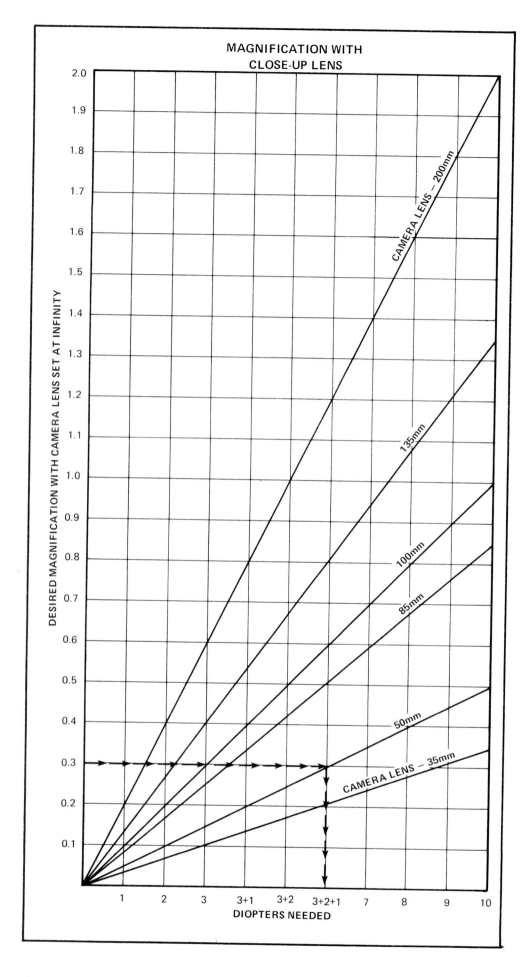

MAGNIFICATION WITH CLOSE-UP LENS

HOW TO USE THE MAGNIFICATION GRAPH FOR CLOSE-UP LENSES

From the desired magnification value on the left side, project over to the line labeled for the camera lens you are using. From that intersection, drop down to the bottom scale. Read diopters needed.

Example: To get a magnification of 0.3 with a 50mm camera lens, you need 6 diopters of close-up lens on the front of the camera lens. With a conventional set of close-up lenses, stack 3 + 2 + 1.

This photo was made with a +2 split-field lens positioned so it affected the left part of the frame. 200mm camera lens was focused on the rose in the distance. Rose in foreground was about 20 inches from close-up lens. Closest focus of 200mm camera lens without attachments is about 8 feet, so the only way this picture can be made is by use of the split-field attachment. Magnification of flower is 200mm/500mm = 0.4 approximately, on the negative. Further enlargement was used to make this print.

SETTING EXPOSURE WITH CLOSE-UP LENSES

In practice, using close-up lenses does not change exposure enough to require any correction unless you are using them at magnifications considerably higher than 0.5. Normally there is no problem in getting enough light to use the camera's built-in meter. Set exposure in the normal way.

DEPTH OF FIELD WITH CLOSE-UP LENSES

At magnifications greater than about 0.1, depth of field is determined mainly by image magnification and pupilary magnification, no matter how the increased image magnification is obtained. The formulas given earlier for magnification by extension also apply to magnification by use of close-up lenses. Consider the close-up attachment as a gadget that changes lens focal length and reduces image quality.

Because close-up lenses are usually not well corrected for aberrations, the image is usually degraded although sometimes the effect is not obvious. By fuzzing up the picture, the apparent depth of field is reduced and is less than you calculate.

A practical way to use close-up lenses is put them on and look through the camera. Using smaller aperture will improve depth of field—but not as much as you may want. It gets progressively worse with higher magnification. You may be able to improve the picture by moving or angling your camera or subject. Most likely, you will have to focus on the part you are interested in and let the rest of the picture be out of focus.

Depth of field can be improved by using smaller aperture, if you can get enough light on the subject.

A lens made of one piece of glass can not be corrected for aberrations. Less expensive close-up lenses are usually a single piece of glass. Some makers offer these lenses

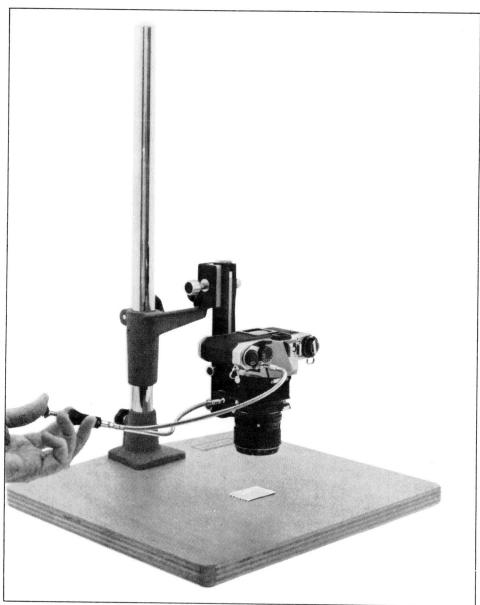

If you do a lot of copying or high-magnification photography, a good copy stand is virtually a necessity. For occasional use, a tripod will do. Several brands of bellows use a double cable release to preserve aperture automation, as shown here. One branch of cable release stops down lens to selected aperture. Then other branch operates camera shutter button.

made with two or more glass elements and corrected for some aberrations. These cost more but make a better picture. Canon, for example, offers close-up lenses in two price ranges. The more expensive have two lens elements, called *doublets.*

SETTING UP FOR HIGH MAGNIFICATION

Camera shake will be a problem. Magnification increases image size and blur due to camera movement—both in equal amounts. Use a stable support whenever possible—a tripod or a copy stand. Guard against floor vibrations being transmitted through the tripod or table legs to spoil your photo. With magnifications higher than 1, use rubber pads under table legs and tripod legs. You may have to choose a time during the day—or night— when there is the least vibration from traffic, people or machinery.

Lighting will be a problem. Experiment with different lighting angles to bring out the details you want to show. You'll need lots of light. If you use incandescent sources, heat may damage the subject being photographed. Flash is a good solution to the heat problem, but otherwise more difficult to use.

Unless you are using very high magnification, sunlight directly on the subject will be enough. If you work when the sun is not overhead, you can usually make a setup that keeps shadows off the subject. The small high-intensity lamps used for reading or on desks are a good bright source. I have used convex mirrors to reflect a light source onto the subject. I have even surrounded the working area with table lamps gathered from all over the house, shades removed. When you are using a lot of light, a lens hood is good insurance.

Using the lens focus control will change both focused distance and magnification. It's better to set the focus control for the desired magnification and move the entire camera forward or back to find best focus. If you make the equipment setup with this in mind, you'll be glad you did. It helps to know the approximate lens extension and subject distance in advance. See page 139 for this information when using lens extension; page 152 for subject distance when using close-up lenses.

When ready to shoot, lock up the mirror in advance if the camera has a mirror lock-up control. Use a cable release to trip the shutter, or use the camera self-timer mechanism.

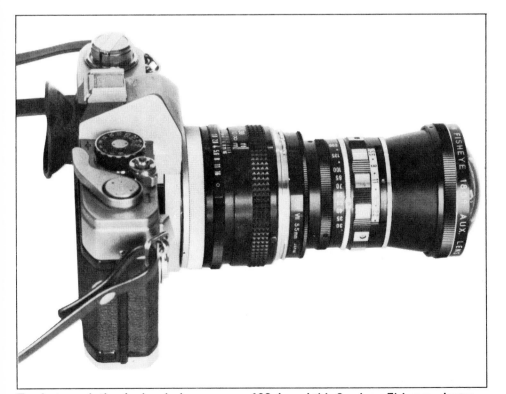

To photograph the sky hemisphere on page 106, I used this Samigon Fish-eye adapter which attaches to the front of a normal camera lens. For the polarized shot, I put a polarizer between fish-eye adapter and camera lens.

To do the people-disappearing trick on page 124, you'll probably use a Kodak gelatin ND filter. This Kenko technical filter holder, distributed by Kalt Corp., is a good one.

INDEX